MW00611270

Hervé Tullet's
Art of Play

Library of Congress Cataloging-in-Publication Data available.

ISBN 978-1-7972-0611-0

Manufactured in China.

Design by Sandrine Granon.
Translation by Mirabelle Korn.

10 9 8 7 6 5 4 3 2 1

Chronicle books and gifts are available at special quantity discounts to corporations, professional associations, literacy programs, and other organizations. For details and discount information, please contact our premiums department at corporatesales@chroniclebooks.com or at 1-800-759-0190.

Chronicle Books LLC
680 Second Street
San Francisco, California 94107
www.chroniclebooks.com

Hervé Tullet's
Art of Play

Images and Inspirations
from a Life of Radical Creativity

by Hervé Tullet
and Sophie Van der Linden

essays by Leonard S. Marcus
and Aaron Ott

CHRONICLE BOOKS
SAN FRANCISCO

Contents

Game On: Inside Hervé Tullet's *Press Here*

by Leonard S. Marcus

Once in a blue moon a new book comes along that is also a new kind of book. *Press Here* belongs on that small, select shelf. First published in France in 2010, published in the United States one year later, and subsequently translated into more than thirty-five languages, Hervé Tullet's best-known children's book does not so much tell a story as ignite a happening: an immersive play experience for acting out in the moment. It is a bold and merry work of conceptual art, a series of arrangements of balloon-bright dots set against a white background that, Tullet suggests, any reader has the power to transform simply by following the friendly instructions the artist has provided, such as: "Rub the dot on the left . . . Gently. Well done! . . . Try shaking the book . . . just a little bit." A beguiling game of let's-pretend unfolds as, with each page turn, a new arrangement of dots appears in seeming response to the reader's latest intervention. Page after page, Tullet winks at the reader and the reader winks back.

Interactivity in children's books is hardly a new proposition. Pop-ups and other moveable books with paper pull-tabs that animate a character or scene flourished in late nineteenth-century Europe. Not long after that, the new science of developmental psychology focused attention on the benefits for young children of learning by doing and of being treated as collaborators in their education. Artists and writers responded by devising ingenious ways for children to assume a more active role at story time. In *Pat the Bunny*, Dorothy Kunhardt provided for young sensory learners' keenness to sample the textures of whatever they see. In *Goodnight Moon*, Margaret

Wise Brown invited the young to say "goodnight" to the familiar things of their world. In *The Very Hungry Caterpillar*, Eric Carle (like Bruno Munari before him) designed a toylike environment with die-cut holes to poke through and different-size pages to manipulate: a fine-motor skills challenge as well as a chance to dream. And in the scroll-like wordless *Anno's Journey*, Mitsumasa Anno painted a richly elaborated landscape in which each reader could find a different story.

In 2010, a front-page *New York Times* story solemnly announced the death of the picture book, a victim, the reporter said, of newfangled digital alternatives and ambitious parents' determination to push "real" books onto their children at the earliest possible age. Time has generally confirmed the latter trend but not the predicted demise of the picture book. Electronic versions of picture books have proven to have almost no market appeal and, if anything, have served as stark reminders of the more intimate, bond-strengthening pleasure of holding a well-crafted picture book in hand and sharing it with a child. It is hard not to see the phenomenal worldwide popularity of *Press Here* as some sort of sly triumph over the digitization of everything. As Hervé Tullet has so beautifully demonstrated, no batteries or costly devices are required for meaningful interactivity: only the meeting of one playful imagination with another.

Celebrate Making

by Aaron Ott

And so a single thread can set the world in motion.
—Joan Miró [1]

For many artists, the blank page, the empty canvas, the bare material at the beginning of any of work can be frightening, threatening—even mocking. For Hervé Tullet, there is only freedom, opportunity, and discovery. As Joan Miró once stated, "A line might take shape in the void, an anonymous gesture might define a new visual universe, or an object found on a beach might provoke a poetic spark." [2]

Tullet is an artist compelled to make constantly, an artist overflowing with seemingly simple ideas and gestures that lend themselves naturally to work brimming with joy and movement. Unburdened by preconceptions or expected outcomes, Tullet approaches every moment as an opportunity for discovery. He is an artist who traces his own practice through those of a wide variety of others, engaging what suits his interests or whims while eliminating the irrelevant. He calls forth the collage and bricolage of the Cubists, the directness of Art Brut, the play of Fluxus, the contemplation of Conceptualism, and the invitation to participate extended by Social Practice. Tullet is an artist interested in these histories and the tools they offer, but he does not limit himself to them. His work is not an assimilation or appropriation of the art of these predecessors and peers or that of children, which, far from commandeering, he champions. Rather, Tullet is an artist driven to celebrate the act of making, to privilege the inherent creativity in everyone, and to bring about a world where imagination, originality, and joy are integrated into every aspect of our culture.

Tullet's success and popularity as a children's book author has at times masked the actual depth of his production. It has also led some critics to assume mistakenly that his audience is only the young and to brand his work as "childlike." At once patronizing and pejorative, this label disregards the art historical impact of "untrained" artists, like those who directly influenced Art Brut, but also radically underestimates the inherent value found in the creative freedom of a child's mindset.

When we reframe "childlike" as celebratory, we discover an unadulterated connection to play and joy, and a means to reorient our focus toward the act of cultural creation and not its outcomes, successful or otherwise. Here, Tullet elevates chance and spontaneity as the core of his visual language; the subject of the resulting work is the creative process itself.

In his 1927 book *Children's Drawings*, Georges-Henri Luquet, a pioneering scholar of children's art, declared, "Children draw for fun. For them, drawing is just like other games and is interspersed among them"—a conviction worth consideration and reiteration today. [3] As a society, we might consider taking our cue from Tullet's embrace of this sentiment in his development of a kind of making that foregrounds aesthetic curiosity and discovery as equally important as any objective outcome. It is a stance that brings Tullet into alignment with Miró's assertion that "with a painting, in fact, we shouldn't care whether it remains as it is, but rather whether it sets the germs of growth, whether it sows seeds from which other things will spring." [4]

The lines, dots, splotches, and scribbles that define the core of Tullet's visual vocabulary reflect a confident yet curious hand, thoughtfully focused mind, and discerning eye. Though influenced by the likes of Jean Dubuffet, Tullet is not interested in the anti-aesthetic of Art Brut but in the glorious, unabashed beauty of joy. Tullet's work is ultimately less Art Brut and more what we might call *Art Intuitif*. Created within a framework of emotional awareness and instinctive mark-making, Tullet's work offers us a kind of nourishment, a kind of humanitarianism and social consciousness that embraces the innate creative spirit in all humans regardless of culture or status.

Tullet's studio practice is not an isolated endeavor. It is nothing without the inspiration and activation of others. Though Hal Foster suggests in *Brutal Aesthetics* that "Dubuffet insisted on presence and participation in his work," this engagement was subordinate to the work itself. [5] Dubuffet himself asserted, "The painting will not be viewed passively; scanned as a whole by an instantaneous glance, but relived in the way it was worked out; remade by the mind and, if I may say so, *re-acted*." [6] Thus, Dubuffet reduces participation to active apperception of the already complete artwork.

Instead, Tullet directly engages his audiences by offering them access to his distinct techniques. For example, one of Tullet's "workshops" or scripts might read as follows:

LINES:

• *Take a sheet of paper and draw a series of horizontal lines.*

• *On another sheet, draw vertical lines.*

• *Pierce a small hole in one of the sheets with a pair of scissors. Then tear a hole of any shape to create a window.*

• *Now place your window frame over the other sheet. See how the lines play with each other? When you find a design you like, you may glue the sheets together.*

Here, Tullet continues the legacy of numerous Fluxus artists, including Dick Higgins, Yoko Ono, and Alison Knowles, who circulated their experiments in chance operations in the form of do-it-yourself scores, prompts, and directions. Beyond these particular projects, Hannah Higgins, one of the foremost scholars on Fluxus, proposes that there is a performative element to all Fluxus creation, stating explicitly: "The audience has to do something," often physically, not merely mentally, "to complete the work." [7] The question of aesthetics aside, what unites Tullet and these Fluxus progenitors is a resolutely pro-action platform realized through the participatory scaffolding of their work.

Tullet carries forth and extends this generous tradition by providing guidelines for artmaking as part of an inspirational lifestyle grounded in creativity. He is a kind of magician-teacher in this way. Yet no sleight of hand is at play and no illusion transpires. What takes shape rises from intuition, an interest in chance, play, and even a bit of chaos. The often-remarkable results are unpredictable and unforeseen. Tullet proves that when our "magic"—our unshackled creative capacity—is embraced, especially through community and play, the results are a shared experience far greater than the sum of its constituent parts. His work is both a collective enterprise—diffused through encouragement and invitation—and highly personal. As an individual, he is driven by an insatiable desire to see what might be next, what may yet happen that hasn't happened yet. The operation of discovery Tullet actively cultivates in his own work and endorses for others is a singularly sacred experience for the artist. The unexpected is a forceful attraction, exerting an irresistible magnetic pull on Tullet. He assumes nothing more than the capacity for art to spring forth and achieve an affirmational vision for us all and our communities.

Tullet is a truly inspirational artist, speaker, and performer, encouraging audiences to become cultural producers of their own. He sees acts of artistic expression as essential to our creative nature. Tullet recognizes and counters the notion that artists are rarified geniuses, creative masters crafting works well beyond common capacity—a myth perpetuated by many cultures, including our own. Instead, Tullet openly reveals the simplicity with which he operates, encouraging others to drop their guard and express themselves in similar ways. This undertaking, admittedly not without risk, often yields striking and poignant works from artist and audience alike.

Ultimately, Tullet's studio is a creative laboratory. Like an alchemist, Tullet takes simple elements—primary colors, simple shapes, spontaneous gestures—and through aggregation and experimentation assembles works that explore and redefine our sense of creative capacity. Depth and complexity arise from happenstance and whimsy, and a stirring, playful, energized choreography of linework emerges. Nothing less than notions of freedom form the

gravitational center of his work as Tullet celebrates the constructive potential of all people.

When I mediate on Tullet's work, I sometimes recall the words of the artist Ed Templeton: "I think as a child you're always drawing, coloring, and doing crafts. And that is totally normal and seems to be what you do as a kid. And I think what, kind of the weird tragedy is, you become an adult, you 'grow up,' and lose that. You stop creating; you stop involving yourself in the joy of color and creation. I just feel like I was lucky enough to never really lose that." [8] Templeton says what Tullet shows us: that instead of stifling creativity, we should normalize it; that we should not stand for the "tragedy" of sequestering our imaginations but should encourage and hold dear artistic expression throughout our lives. Tullet proves that retaining this joy in color and creation is not actually a question of luck. It is up to us to choose, and among the best ways to start is to follow the lead of Tullet.

1. Joan Miró and Yvon Taillandier, *Joan Miró: I Work like a Gardener* (New York: Princeton Architectural Press, 2017), 34.

2. Ibid, 10.

3. Georges-Henri Luquet, *Children's Drawings*, trans. Alan Costall (London: Free Association Books, 2001), 3.

4. Miró and Taillandier, *Joan Miró: I Work like a Gardener*, 46.

5. Hal Foster, *Brutal Aesthetics: Dubuffet, Bataille, Jorn, Paolozzi, Oldenburg* (Princeton, NJ: Princeton University Press, 2020), 11.

6. Jean Dubuffet, "Notes for the Well-Read," in *Jean Dubuffet: Towards an Alternative Reality*, ed. Mildred Glimcher, 77 (New York: Pace Publications, 1987).

7. Hannah Higgins, *Fluxus Experience* (Berkeley: University of California Press, 2002), 25.

8. *Beautiful Losers*. Directed by Aaron Rose and Joshua Leonard. Performed by Thomas Campbell, Cheryl Dunn, Shepard Fairey, Harmony Korine, Geoff McFetridge, Barry McGee, Margaret Kilgallen, Mike Mills, Steven "Espo" Powers, Aaron Rose, Ed Templeton, and Deanna Templeton. Sidetrack Films in Association with Black Lake Productions, 2008. DVD.

A Journey from Voiceless to Leading Voice

*I'm obsessed with the journey, the path,
reinventing oneself, leaving oneself open,
always being in search of something . . .*

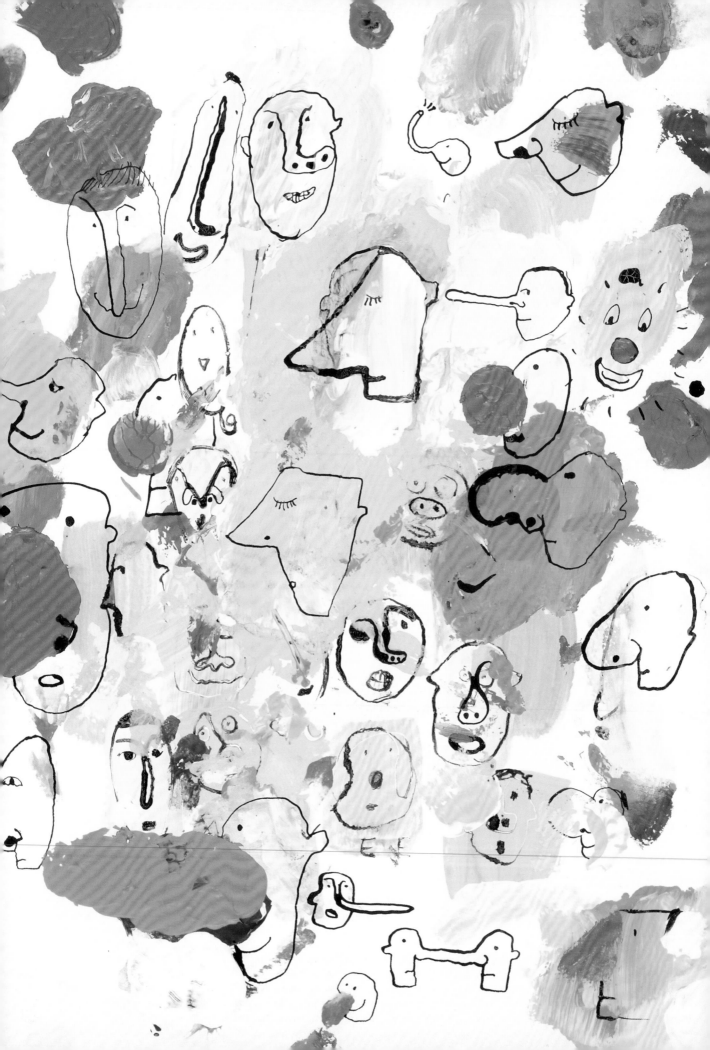

Childhood

April 2020. A full lockdown period of the Covid-19 pandemic. Hervé Tullet posts a video on Facebook titled "Boredom Dom Dom" in which he acts out the boredom of a recluse in his New York studio. The sequence shows him entering the room, trying to engage with something, typing a little on his computer, playing a few notes on his piano, messing about with his paintbrushes, peering through a hole in a piece of paper, frenetically emptying his bin of rejected sketches, murmuring but not really speaking. Finally he spins around and throws a neon yellow glove up at the ceiling. He watches it fall limply back down, then shrugs and exits, Charlie Chaplin style. The artist is mainly addressing children, and he imitates their behavior. But with his body language—arms hanging by his sides, head leaning forward, feet stamping the floor as he turns in circles—he goes beyond imitation: He *is* a child. Because, once upon a time, Hervé was exactly that child. The bored child. The infans (from the Latin, meaning "one who does not yet speak") who hasn't yet become aware of existing.

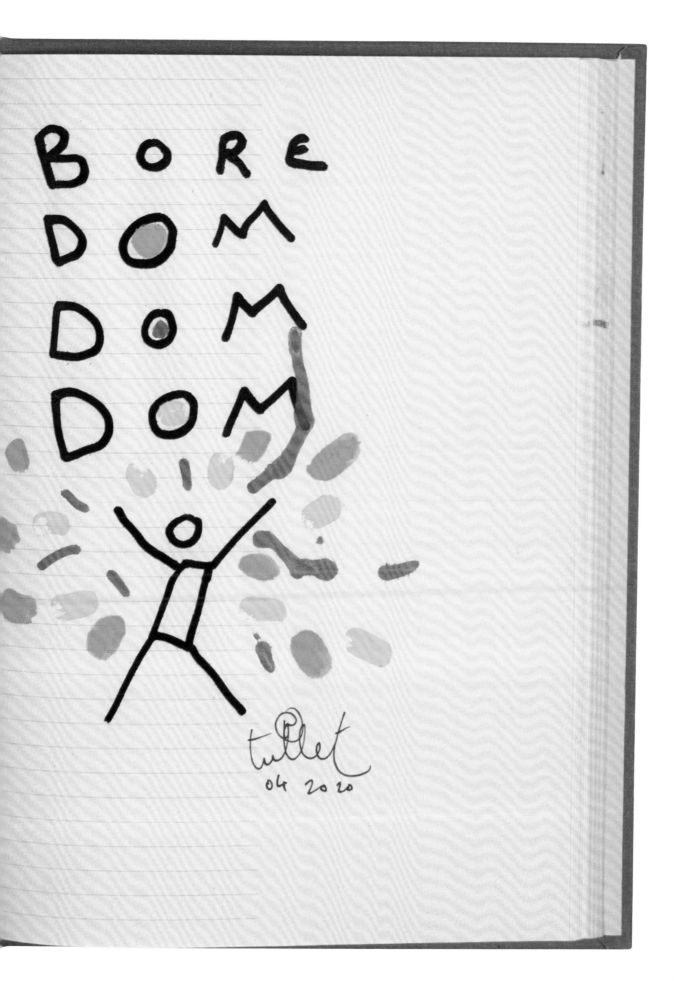

Hervé was born in 1958 in the town of Avranches, in the department of La Manche in Normandy, France. But, starting at the age of six months, he grew up in Paris. So much for the civil record. The roots of his life go back further. We need to begin his story earlier, probably on a day in August 1944, when, a few miles from Avranches, his mother was caught in the terrible Battle of Mortain. It was one of the first and most important battles of the liberation of France during World War II. Hervé's mother had been raised in the countryside, the daughter of a rag-and-bone man, but she had seen her father shot dead by the army a few days earlier. During the bombing she took cover in a mine and ate raw potatoes to survive. Later she would be housed with strangers, and most likely mistreated. She would never speak of this period—not even to her son—but the pain of the deadly war remained rooted deep inside her.

My mother lost herself during the war.

Mortain was a small industrial town. Hervé's grandmother was the matriarch, a stout-hearted working class widow. After the war she brought up her five children energetically, despite destitution and misery. Nearby, in Saint-Aubin-de-Terregatte, Hervé's paternal side of the family had been farmers for generations.

As a young woman, Hervé's mother worked in a hotel, where she was fascinated by the bourgeoisie to whom she served tea. Hervé's father, for his part, worked at a grocer's but was fired over some illicit activity. So the young married couple decamped to Paris. They lived in a single room, then two, then three, and finally five. They always moved within the same city block, in a working-class neighborhood between rue Chaudron and rue du Faubourg Saint-Martin, between the train tracks of the Gare de l'Est and the Saint-Martin canal, between the Stalingrad and Jaurès metro stops. The couple were suspicious of everything, avoiding friendships out of fear they would lead to requests for money. They opened their own little business in this impoverished neighborhood.

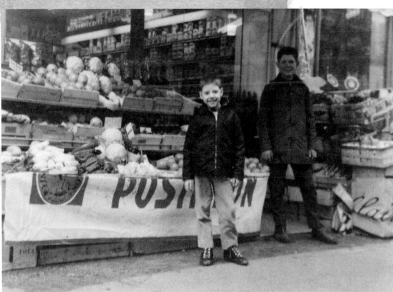

Taking care of a baby under such circumstances wasn't easy. Hervé's babysitter was a nanny who mistreated him, then an aunt who dabbled in prostitution. He became a child who didn't talk to his parents and asked no questions, but who sensed, in his deepest and most secret self, the suffering of the war. Which was driven home one day by an explosion that rang through Paris. It might have been tied to the Algerian War, or simply a familial altercation. But in any case the shock has remained with him to this day.

I felt forgotten, silent, muted, unable to see myself.

Still, growing up in his parents' grocery store, Hervé lacked nothing. He liked cakes, he manned the checkout counter when he wasn't at school, and on Mondays, his day off, he helped his father snip and fill out the coupons that helped them make ends meet. He amused himself by creating fake parking tickets. The Bois de Vincennes was the only place the family ever went on Sunday outings, and Easter Monday was the only day of the year when they ate in a restaurant.

Hervé's father worked constantly, getting up in the middle of the night to buy goods from the huge wholesale market in the suburb of Rungis. His mother remained faded, lost. So Hervé was a little boy who simply lived. He might well have been the kid from Robert Doisneau's photographs, playing in the streets of Paris and, out of boredom or hope, setting his paper boat afloat in the gutter, though it would never arrive where he wanted it to.

Training

Public school wasn't to be a path to success, even though Hervé was a good student—or, more exactly, a student who didn't call attention to himself. Here, too, his memories are vivid: a school built during the Fourth Republic, with its daily distribution of a glass of milk. The cafeteria consistently offered soup, mash, and roast beef, except on Fridays, when omelets were served. The authoritarian teachers dealt ruler blows liberally, and the director, afflicted by poliomyelitis, admonished students by trapping their heads under his arm and rubbing their crowns forcefully.

For secondary school Hervé's mother found a Catholic school, private but subsidized by the state, whose name revealed its social ambitions: L'école des Francs-Bourgeois, located on rue Saint-Antoine, close to Place de la Bastille. Hervé studied there through high school, and it was there that a more insidious and dangerous type of violence found him in the form of a manipulative director. Hervé made an easy target, either because of his social origins or his mother's humility. Academically he stayed afloat, but not without constant struggle. He never had more than one friend at a time.

The only bright spot arrived late, in his second year of high school. His French teacher announced at the start of the year, "In every class, there's always one student who's interested in surrealism." Hervé raised his hand. Surrealism thus became his mission for the year. For the first time in his life he felt what it's like to take owner-ship of something. Another of his teachers, a layman, was a revolu-tionary exiled from Franco's Spain, deeply engaged in politics, vicious and funny. He invited Hervé to question the conventional patterns that his family and schooling had so far presented as absolute rules. Politics, revolution, art, poetry, surrealism . . . a path out of domestic boredom and daily austerity was being drawn.

Painting, 1979.

I started reading Sartre, Gide, Camus, without believing that I understood them.

The metro ride to school was a place of freedom and reverie—as Hervé gazed at his reflection in the train windows—but also of danger. Eight stations harbored pitfalls and men to avoid, but also bright spots: the newspaper kiosks stocking *Libération*, *Rock & Folk*, and *Actuel*. Hervé hung timidly on the edge of the emerging counterculture that these magazines presented. Though the library remained inaccessible and intimidating, he wished at least to be the type of student who read even if he couldn't be the type of student who succeeded.

The library scared me: What book should I choose? And what was the real purpose?

Hervé's interest in surrealism prompted him to experiment with automatic drawing. The results were enigmatic black-and-white figures with distorted profiles, sometimes pierced through. In the graphic motifs, splotches and lines already played a central role. One of Hervé's teachers took an interest in the drawings. Hervé handed them over confidently and even wrote a speech to go with them. Alas, the teacher took the drawings, had them analyzed by psychologists, and published them under the fictional name Jean-François in a small book of reflections on education, *School? To the Post!* (*L'École? Au Poteau!*, P. Téqui, 1976.) Teenage Hervé counted this among his worst experiences. He didn't recognize himself in the intrusive and artificial analyses of his creations. From then on he shunned drawing as a form of self-expression and avoided such exercises as much as possible.

Automatic drawings, 1976.

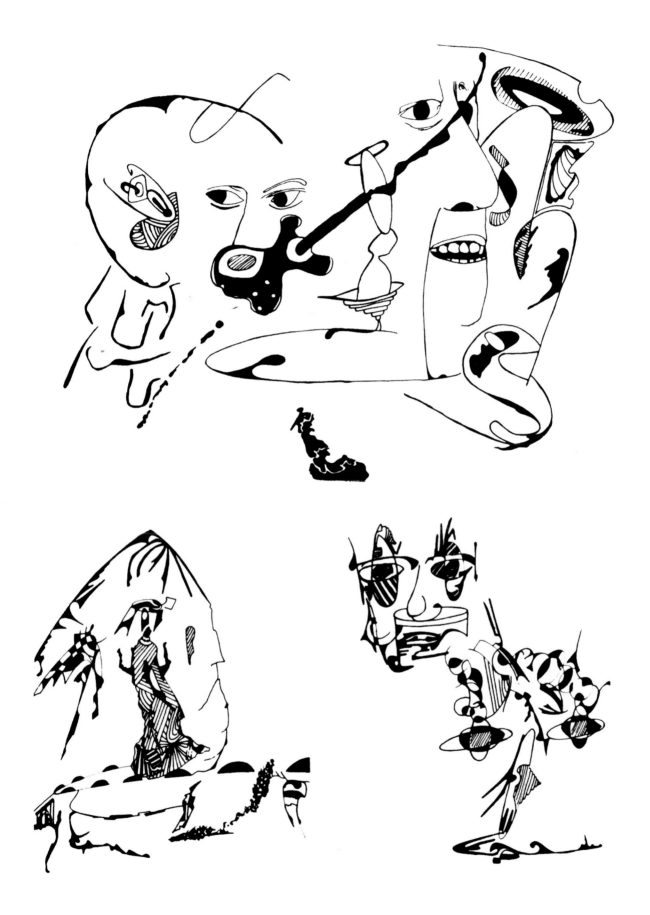

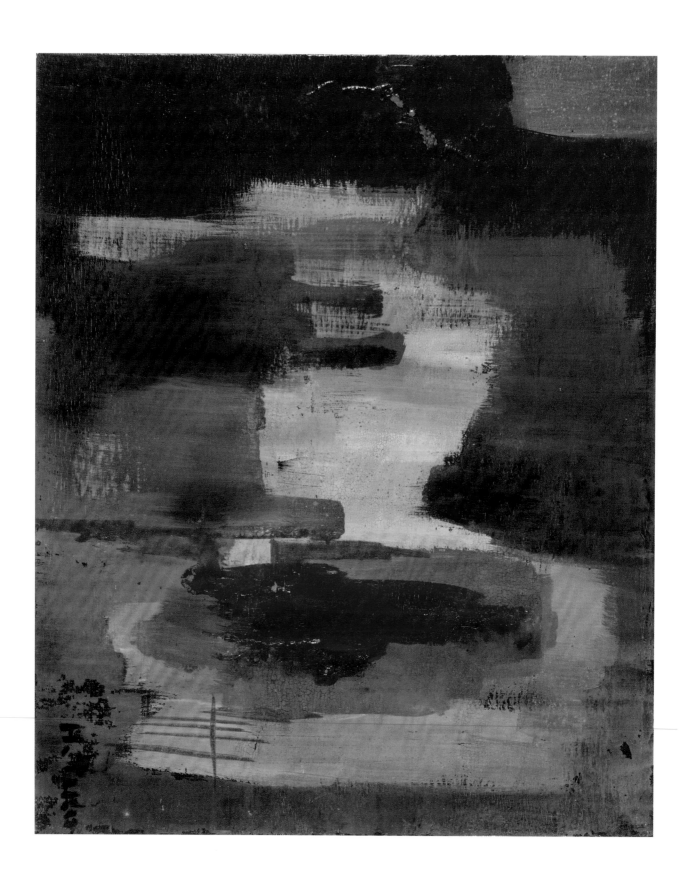

I didn't like the idea of being someone who expressed themselves through drawing.

During Hervé's last year of high school, as he cemented himself as an "average" student in the eyes of his teachers and failed the French portion of his baccalaureate exam, he took a step that would undoubtedly determine his future. Finally, he dared. He dared set foot inside Rœderer, an art school in Place des Vosges. He dared tell them that he drew and asked about post-baccalaureate programs. He inquired carefully whether they accepted students who hadn't passed the exam. The answer was yes. Several months later, though, Hervé finally nailed the test. He enrolled at Rœderer immediately to prepare for the entrance exams of the bigger art schools. On the way to his first day of school, he repeated to himself all the incorrect ways of speaking that he'd been brought up with, which he knew he must now avoid as much as possible.

Unfortunately, he would fail the big art school exams, but at Rœderer he met Jean-Loup, a funny guy with a big personality. The two became a team. They tackled school assignments with gusto, worked together, emulated each other, and went out together after school. In the evenings they devoted themselves to experiments in the plastic arts. Like the colander that cast shadowy projections, but also sculptures: bits of wood collected from the neighborhood joiners' workshops, which the two friends crafted to create plays of light. Finally, Hervé was emancipating himself from his origins.

Renouncing drawing, he devoted himself instead to painting. Francis Bacon, Maria Helena Vieira da Silva, and Jean Fautrier inspired compositions where elongated bodies and darkened faces forged their path against strongly contrasting hues. Hervé's heavy colors clashed and fought against each other in the thick strokes of oil paint.

Painting, 1978.

My painting didn't yet express enough of the pain that was inside me.

Then a private school, the Union Centrale des Arts Décoratifs (Central Union of Decorative Arts), or UCAD, accepted Hervé into their Visual Communication program. Guided by great teachers such as the painter Yves Millecamps, he pursued painting. Thanks to Millecamps, one of his acrylic paintings was shown at the autumn salon. Walking the line between figurative work and the escape of abstraction and geometry, Hervé depicted his own silhouette in the doorway of an enigmatic room where an unknowable mystery seemed to hide. He signed the painting "H. Watson."

At UCAD he formed a new duo with a classmate, Sophie, and this connection became the beating heart of his training. They always worked together and played together, like table tennis partners. Through competing with one another they became highly productive; their work more than doubled, it multiplied. Ideas and realizations abounded, and their two-way exchange became a motor, pulling them away from certain courses that they didn't consider relevant and away from the rest of their classmates. Their classmates, in turn, excluded Hervé and Sophie from their final exhibition, until the jury called them back. But the two of them were already elsewhere. They'd been headhunted by advertising agencies and had ideas popping out of their two-headed brain. Hervé and Sophie got themselves recruited as junior artistic directors before they'd even officially finished their training. Alone no longer—himself, but also half of a pair—Hervé finally succeeded in escaping the pattern of failure that had plagued him since childhood.

Painting, 1980.

Autome, autoportraits.

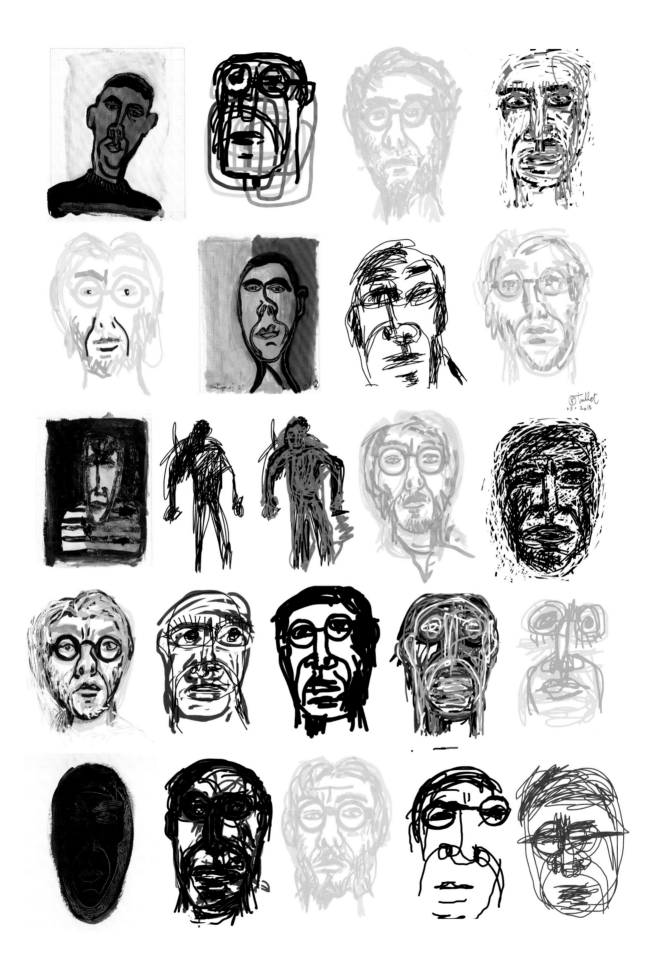

The Advertising Years

It was the early 1980s, and advertising was booming in Paris. The traditional advertisement had been succeeded by the modern ad, which used a global, modern, and creative approach. Agencies were structured, identifying many target profiles, inventing new jobs, and embarking on projects with big budgets. The industry was young and open; it accepted diverse personalities and was driven by creativity. Boldness was prized, as in the campaign by the billposting company Avenir, which announced in a triptych of successive ads that the model would take off the top, then the bottom, of her bikini. At the same time, the filmmaker Étienne Chatiliez was using artistic means to sell the affordable shoes made by the brand Éram.

It was a competitive atmosphere for a young person who wanted to provoke and play with the audience.

Hervé existed in positive tension with this world, which valued creation and was perpetually seeking ideas. As an artistic director, he was the one who birthed the ideas, who gathered a team around a project and coordinated the different specialists, such as storyboard artists, graphic designers, and photographers. Hervé conceived of projects at top speed, pencil in hand, writing thoughts down as soon as they emerged. By using storyboards and preparatory drawings intensively, the future artist became adept at rapidly and instinctively producing images, without hesitation or prudence.

But the responsibility of being the artistic director was heavy; if he sent one of his people on a wild goose chase, it was expensive and weighed down the project. He also had to manage people's initiative and give structure to their collective work. This required standing up to a team, to clients, to star photographers, to young, ambitious wolves. None of this came naturally to Hervé, since this was a world driven by a powerful class structure that you could either endure from the outside or internalize.

Advertising was a tough industry, without pity, that offered itself only to the audacious and the lucky. One example of this was a campaign run by the media man Thierry Ardisson, *Les 4 heures de la pub*

(The four hours of advertising), during which he shut up a creative team in a hotel to stimulate lightning-fast creativity.

Hervé worked intensely and made good money. He had a lot of campaigns in his portfolio, but at the end of the day few of them were public projects, and few were "beautiful" campaigns whose notoriety or artistic significance would provide satisfaction.

Over the course of the 1980s, the industry ran out of air and was brought up short by new, more predatory ways of thinking, which took creativity hostage and imposed the rules of profitability. Marketing took the lead.

At the same time, Hervé observed the arrival of computers, which changed his work completely, removing the collective dimension by putting all the tools in the artistic director's hands. He now had to act as the graphic designer and the photographer, who themselves became mere executors of his vision.

In 1986 Hervé met the journalist Marie-Odile Briet. His first illustrations were for a noted publication she coauthored with François Reynaert and Valérie Hénau, *Pour en finir avec les années 80: Petite sociologie des snobismes de l'époque* (Wrapping up the 80s: A short sociology of the snobberies of the era), published by Calmann-Lévy in 1989. For the first time this novice illustrator confronted the book, its internal coherence, its sequential structure of pages. He asked himself questions about what style and tone he should convey with his images. This publication was a first step toward his work as an illustrator, a turning point between advertising and publishing.

One of the many crises in the advertising world finally came for Hervé's job. About to become a father for the first time, he made his decision: He would give it a go as a freelance illustrator. In January 1992 he obtained his freelancer's ID number, and in April of that year Léo, the first of his three children, was born.

I didn't want my child to see me working in advertising.

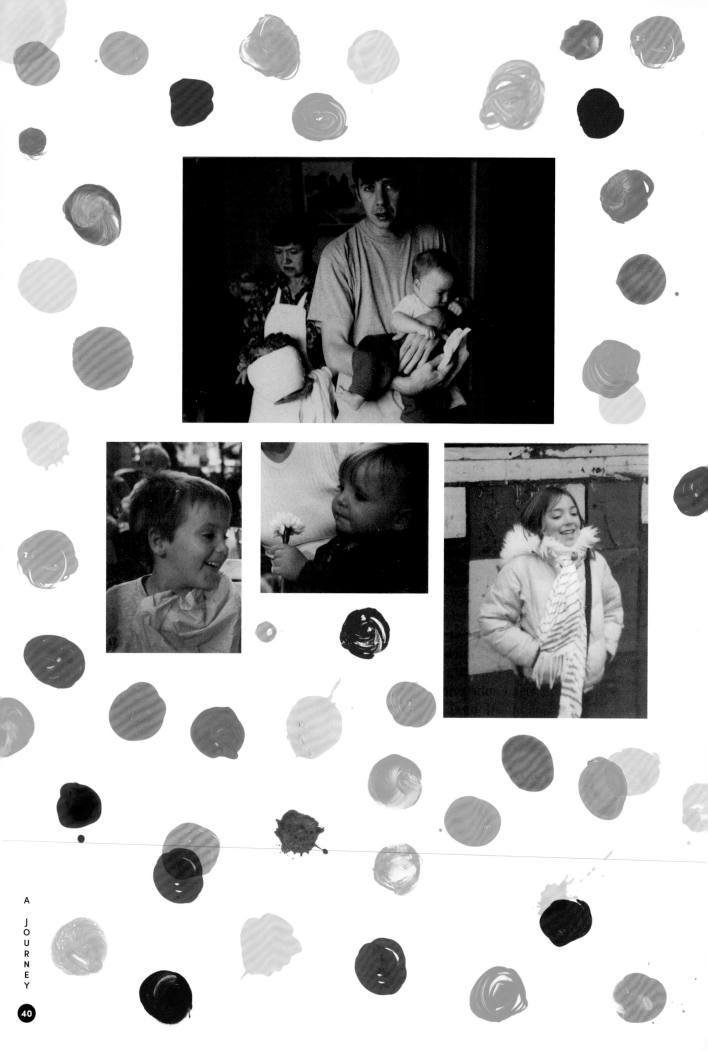

famille tullet

"ange" LUCIE

PAPA HERVÉ

MAMAN

MARIE

GRAND LÉO

CHEVALIER PAUL 2002 *

Illustration

H erué entered the world of illustration with only a few ideas about what he might do rather than a solid and well-stocked portfolio. He knew he'd make quite a bit less than he had in advertising, yet this new activity got off to a good start. The big Parisian department store Le Printemps commissioned a logo for its holiday pop-up shop, the Boutique Noir, and a silkscreen-printed notecard design. The magazine *Madame Figaro* hired him for illustrations.

I told myself that, as an illustrator, I needed to do everything: painting, illustration—I couldn't get stuck in one style.

This time Hervé found himself alone in his work, so he tried setting up a studio with the comics artists Philippe Dupuy (of the duo Dupuy-Berbérian) and Blutch. But soon differences in their approaches to drawing, their relationships to personal work, and their cultures caused them to dissolve the arrangement.

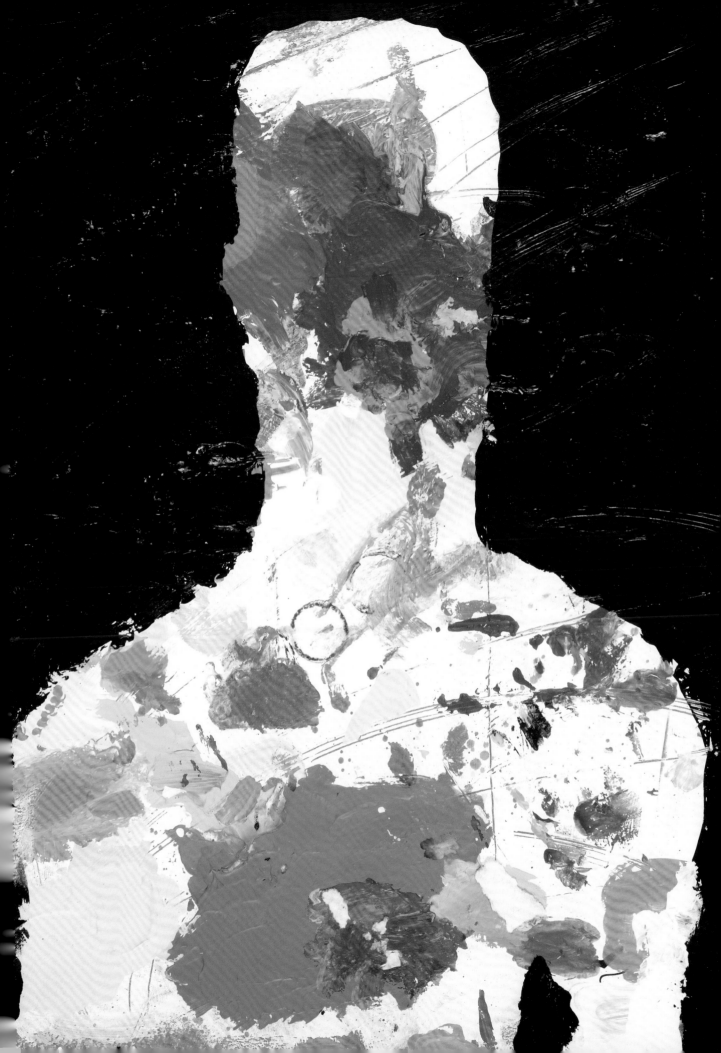

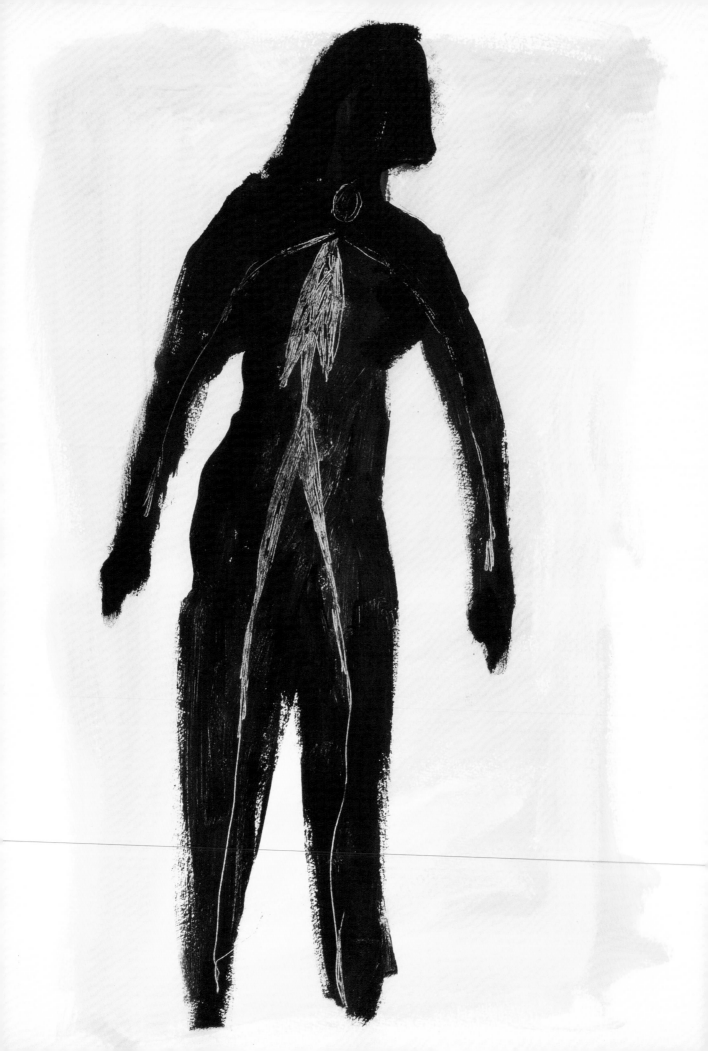

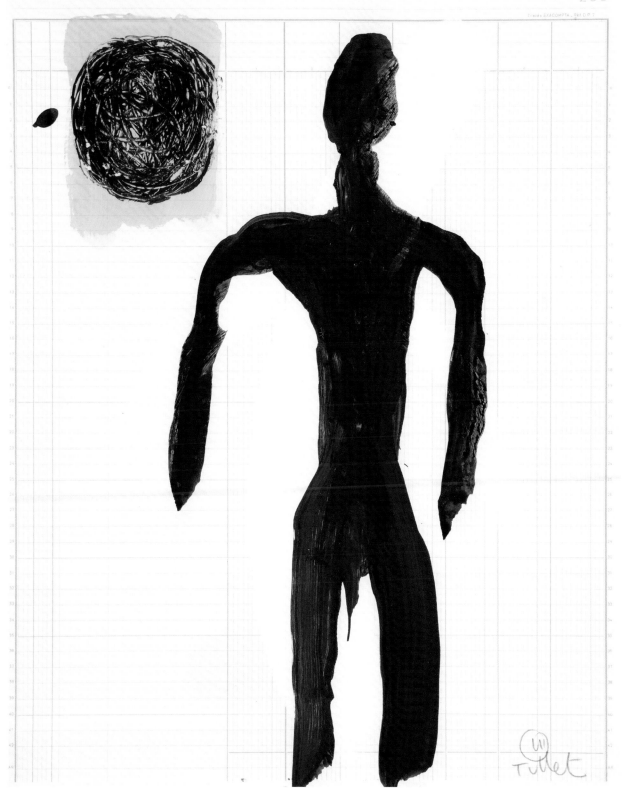

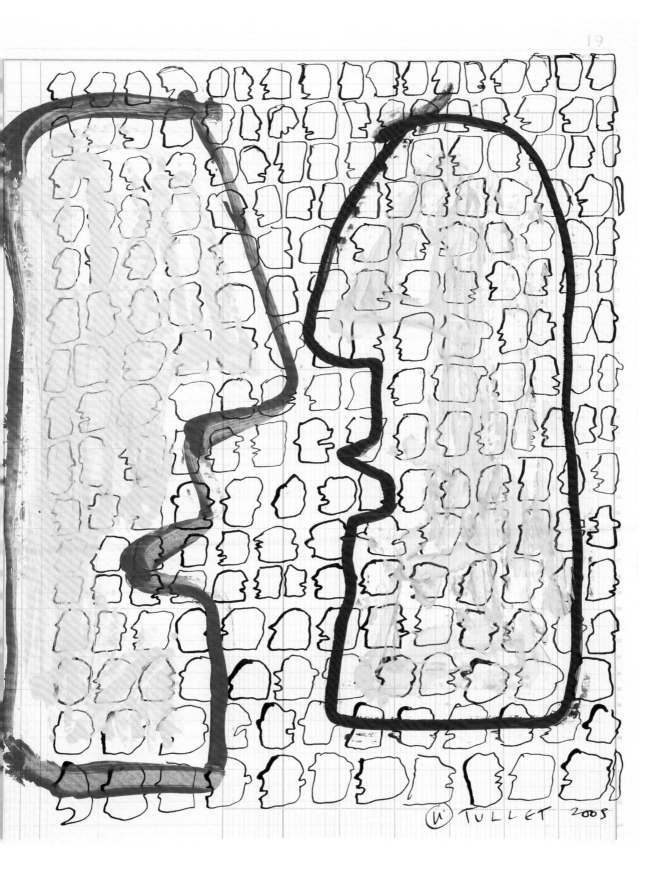

TULLET 2005

A little while later Hervé would find one of those duos that drove his work. He was designing a catalog for the film producer René Cleitman, who was working on *Cyrano de Bergerac* with Gérard Depardieu at the time. Cleitman introduced Hervé to an editor at Hachette, Fani Marceau. It was a fateful meeting: When Hervé proposed a book idea to her, the editor replied, "I don't want a book; I want an author." She also showed him books by the Japanese artist Katsumi Komagata, which had just arrived in France, and which struck the young illustrator deeply.

Excited and encouraged, Hervé played with images, with variations built around oppositions, binaries, duos, or couples. The structure of this work was slow to fall into place and take a form that even approached that of a book.

Even if artists had historically injected children's books with disruptive approaches, illustration remained an applied art that had to fit itself into the marketplace. It was, in fact, rather difficult to get away from the model of "telling a nice story." And Hervé didn't want to tell *anything*, let alone nice stories. But through experimentation and references that he was slowly building for himself as both an illustrator and a father, he started to see more clearly the strong bond between author and reader that pulls the book together. His compass for moving forward became the game of a shared reading experience.

Bit by bit a first book came together; it was extremely badly drawn.

Researching duos and couples led Hervé to a book on romantic couples. The result, *Comment papa a rencontré maman* (How dad met mom), was brought out in 1994 by Hachette, grand old publisher of children's literature (notably books by the Countess of Ségur). Their catalog of publications wasn't exactly considered innovative. Hervé's book was seen as surprising, funny, defined by the advertising spirit of the era, thanks to its use of clichés. Most of all, it distanced itself from traditional concepts of children's books, even if the lines were

often blurred at this time. This was especially true at the very literary publishing house Le Seuil, which had just acquired an art department. The department was developed by the editor Jacques Binsztok and became prized by an entire generation of young illustrators. When Hervé met Binsztok by chance at a literary salon, the latter assured him, "If I had edited just one of this year's books, it would have been yours. Call me." The book in question was Hervé's second, *Comment j'ai sauvé mon papa* (How I saved my dad). Before getting it published by Hachette, he had tried several times to show it to Binsztok, who never even granted him a meeting. Encouraged by Marceau, Hervé extricated himself from his exclusive contract with Hachette and called Binsztok. Enthusiastically, Hervé showed Binsztok the sketches for *Comment j'ai sauvé ma maman* (How I saved my mom).

I showed what I had, such as it was, on a bit of old scratch paper, and Binsztok exclaimed, "Contract!"

Marceau got herself hired alongside Hervé at Le Seuil's art and children's department. She would be the one who accompanied him, reassured him, and in a way protected him at the publisher. Hervé's complicated relationship with the use of color, with drawing, and even the very concept of a children's book required an editor who was patient, attentive, and gentle.

I searched, I was afraid of my ideas . . .

Together, Hervé and Marceau conceived of a "Tullet" box that was placed in the office and into which Hervé could slip all his ideas and explorations. The box was fed constantly. Every so often the two of them would pull out a piece of paper and, once the idea was ripe, it grew into a book. Using this method they developed fifteen-odd titles for Le Seuil.

Hervé, who up until then had found the pressure of the *idea* very anxiety inducing, started to find a method, foremost by using notebooks. The search became like a perpetual mechanism. Planes and trains were opportunities to isolate himself, concentrate, and search doggedly, following a rhythm that he hasn't lost since then.

In 1998 his gentle and fruitful collaboration with Marceau gave birth to one of his most important books, his foundational volume, the mold for all the others: *Night/Day* (*Faut pas confondre*). The play of opposites, already explored, took on a new dimension thanks to a die-cut in the pages. The system of cutouts gave meaning to the book—whose value was quickly recognized. Recognition arrived in the form of one of the industry's most important prizes, the Bologna Ragazzi Award at the International Children's Book Fair in Bologna, Italy. Although the prize doesn't guarantee commercial success, it is of the highest importance in the publishing world, in France as well as internationally. It ensured that the book would be translated and that its author would thereafter be truly respected by children's book professionals around the world. This consecration offered Hervé, for whom this was just his second book with Le Seuil, great happiness and energy, which his publishing house met with full confidence. From then on, things seemed to fall into place.

There remained the question of style, which preoccupied him. He was evolving in children's book publishing, a milieu that seeks out authorial identities, authorial worlds. In every school of illustration—and their number was exploding at this time—students were taught to find "their style." Visual identity guaranteed interest from editors in a marketplace that was beginning to structure itself and globalize in earnest. Ever since a visual signature had been identified as commercially fruitful, these editors had been in search of styles more than authors.

But Hervé had none of the "children's" touch, that famous "style for kids," which left him perplexed. And the question of aesthetics bogged him down in complications rather than allowing him to blossom. The style that defined his first books and which was now attached to him—a thick, sloppy line with a flat application of color—blocked him more than it distinguished him. He would have

to wait a few years before things clicked into place and he managed to free himself from this obsessive question.

It was a major luxury fashion brand, Hermès, that offered him this opportunity, thanks to the strong and precise vision of its artistic director. This individual organized a double commission that leaned on both Hervé's pictorial work and his illustration work, in particular *Night/Day*. The brief was to create illustrations for Hermès's catalog as well as a piece for one of their famous scarves, the Hermès squares.

Graphically speaking, these two aspects of Hervé's work had nothing in common. The eclecticism of the commission, its encompassing of both painting and illustration, could have caught him off guard, so doubtful was he about his editorial work. But instead, the commission produced the opposite effect: It offered him a glimpse of coherence where he had previously seen only division between his different activities.

There aren't many people who put you to work in a space where you didn't believe you could go.

Hervé was suddenly liberated from the obsessive question of style. By working on the Hermès commission, he discovered how to reconcile what he thought was irreconcilable. He felt reunited with himself. The commission became a catalyst of inventions, even though the scarf project was eventually abandoned. Hervé's next book emerged from the effervescence of this realization and from the dazzle of this revelation. The book was *The Five Senses* (*Les cinq sens*), published in 2003 in the format of a thick notebook, jam-packed with colors and discoveries, assuredly eclectic. A first artist's book, in fact.

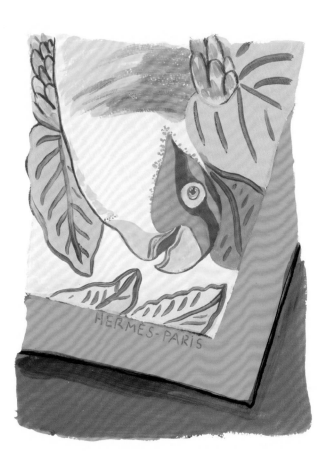

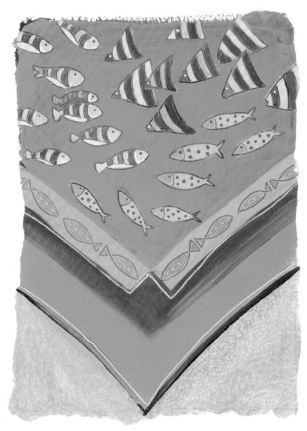

In two years Hervé's work led him from the profusion of *The Five Senses* to the essentialism of an idea that is *I Am Blop!* (*Moi, c'est Blop!*). Blop is a shape, a simple, invented shape that has no name, and that appears in multiple registers, graphic and playful, throughout the book. Once published, the book expanded, and the baton was passed to a multitude of people across the globe who forged the essential dynamic of Hervé's work: the direct and interactive relationship with his readers.

Drawings for Hermès, 2003.

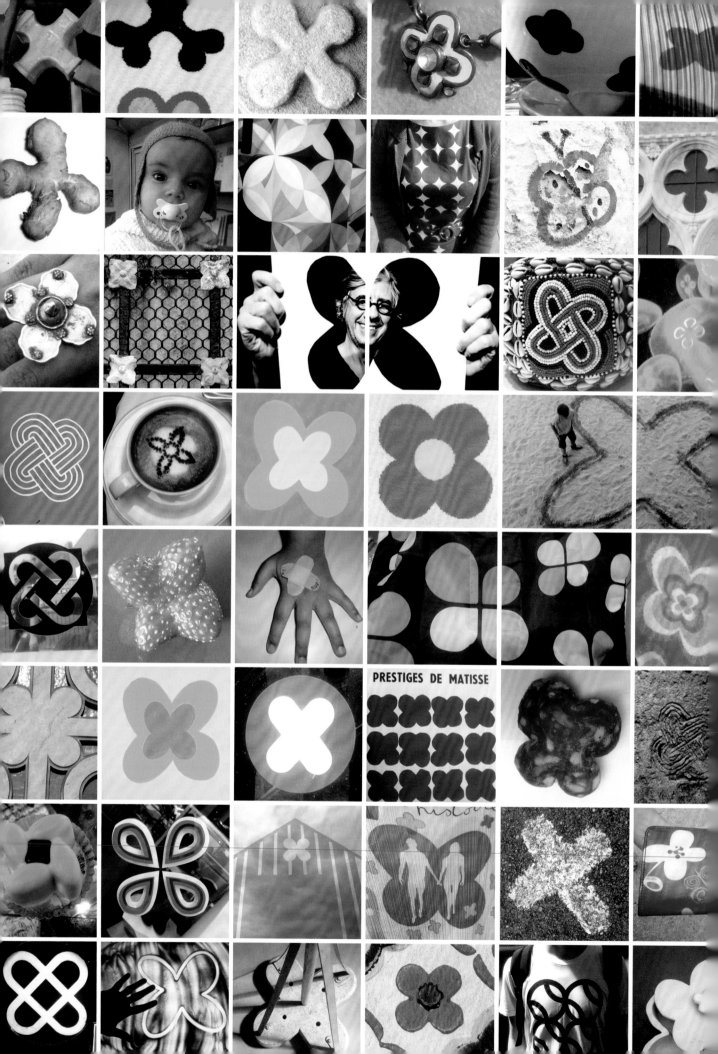

Events

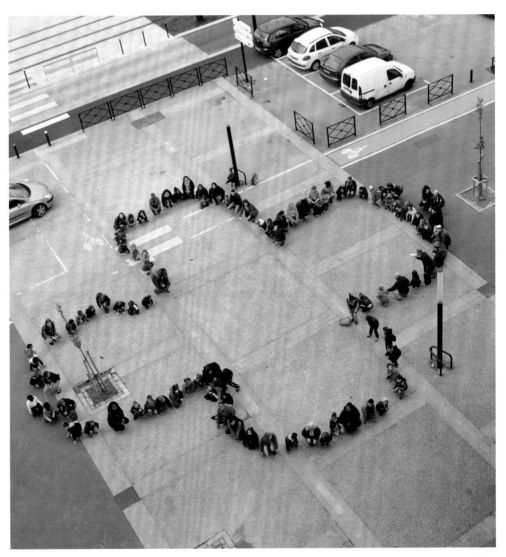

Workshop, Le Havre, France, 2013.

As Hervé took his first steps into the world of publishing and began to define his creativity, he also discovered all the peripheral activities associated with being a book illustrator, in particular the invitations to book fairs and events for children.

One important local book fair was his trial by fire. The experience was equal parts radical and disappointing. The fair portion of the event was an almost industrial reception for several hundred invited authors who, aside from a few celebrities, found themselves sitting for hours behind tables stacked with books, selling and signing only a handful of copies over the course of the day. The presentation portion involved entire classrooms of children, unprepared, inattentive, whispering amongst themselves under the mocking eyes of teachers who remarked to the author, "It's not easy, eh?"

I didn't want to become a speechifier at fairs.

Through other channels Hervé discovered school events, still professional but more individual, initiated by teachers or librarians who noticed his books and wanted to build a curriculum around them. These initiatives widened a horizon that until then had been drawn between two points: the library and the family. Hervé received testimonials and projects. One teacher, inspired by *Night/Day*, took photos all over the school: on top of and below tables, in the hallways, in the bathrooms. Suddenly the scope of the book multiplied thanks to a personal creation. This marked the beginning of readers adopting Hervé's books, a tendency that would only grow. It would eventually make his oeuvre one of the most likely to lead to echoes, replies, mining, or reappropriation of this amplitude, even internationally—all of which prefigured the phenomenon of the Ideal Exhibition.

And so I discovered a whole other story . . .

What set him off was a shock. It happened at La Courneuve, an under-privileged suburb of Paris. Hervé had received a letter of invitation whose interpretations of and reactions to the title of his upcoming book, *Pink Lemon* (*Rose citron*), had particularly touched him. So Hervé went to meet the class. The school was situated not far from where he lived. Nevertheless, he traversed desolate urban landscapes to get there, taking the tramway past the station called Cosmonautes, an emblematic name for this "red" neighborhood, whose population was primarily working class and communist. The school sat at the foot of a block of apartment buildings. No sooner did he walk into the class-room than they welcomed him enthusiastically. The setting, each stu-dent, the teacher—Hervé took it all in on a deep level. Together they experienced intense moments of life and of creativity. A little girl spoke up in class for the first time in front of her drawing, using the mystify-ing made-up word *dégourdement*.

To survive, you need a book. That's exactly it.

The shock came from the contradiction between the miserable environment—and everything that suggested difficult lives—and the very warm, human feeling in this classroom. It also came from the way these children's conditions reminded Hervé of his own childhood and his own sadness. He couldn't help thinking of the war, seeing these students as little soldiers sent to the front line to be mowed down by poverty. He was revolted. He had to act. And his role would be to bring books. Because if one book is fun and stimulating, others can be too. They're a constructive escape that can lead elsewhere. Finally, the shock came from the vast gulf between Hervé's intention and willingness as the presenter, and what the students felt and reflected back with so much enthusiasm. The author, who had come to offer a form of repair to these children, received some in return.

I wished we were all there with these children.

It wouldn't always be easy. Hervé refused to be the one directing the activities. He searched for his positioning, so he tossed the ball back to the students: "What shall we do?" And, of course, he destabilized them. The guest author wanted them to react and get moving. The students had been expecting something from him, and here he was expecting something of them! It didn't always work. Of one terrible class, people had told him cynically, "All you have to do is get them to draw." Three times in a row Hervé visited these children, who didn't react, didn't respond to his invitations. They were completely passive. The fourth time he showed up with a poster he had created, showing a scribble. That was when a child's voice piped up: "That's not a scribble, it's a forest." Hervé reacted immediately; he brought the child up to the blackboard to bounce around this idea with him. And they were off. Everyone participated and had fun, and drawings appeared out of scribbles on every table in the classroom. Heading home on the metro that day, Hervé sketched out his next book, *The Scribble Book* (*À toi de gribouiller*). No more explorations or preliminary research; the book was born in an instant, out of an instant.

It was the first time that an idea for a book emerged from children, like a small miracle.

Images from *The Scribble Book*, 2007.

The Explosion

Opposite: Image from *Press Here*, 2010. Above: Image from *The Big Book of Art*, 2008.

Hervé's editors, however, declined *The Scribble Book*. They had just left Le Seuil (which had been acquired by a larger group) and founded their own house. The name of their company, Les éditions du Panama, was an homage to a poem by Blaise Cendrars, and to founder Jacques Binsztok's dreams of literary travels. This was the first refusal Hervé had suffered, and it came just as *The Five Senses* liberated his work, and as he was throwing himself wholeheartedly into exploring the possibilities of the book. So he imagined a new collection of "game" books based on his fascination with babies, the first readers, the first artists, the first humans.

Babies bring me back to prehistoric times, to the idea of outsider art, primitivism.

These board books are strongly self-evident, offering experiences for little ones. They are variously cut out, stitched, audaciously colored, not afraid of black, of bringing in other materials, or of using the book in new ways.

A difficult period, in which publishing houses were plunged into confusion and suffered replacements, financial failures, and off-the-mark catalogs, conflicted with and hindered a period of intense creation on Hervé's side. Yet he was paradoxically liberated from the questioning that had prevented his fully blossoming.

In 2008, with the end of Panama, which had published games and books on the scale of *The Big Book of Art* (*Le grand livre du hazard*), Phaidon took over the books that otherwise would have gone out of print. Hervé emerged on top after this troubled period, thanks to the loyalty of two professionals.

The first was Sandrine Granon, the designer who, since Hervé's first books at Le Seuil, knew his books and the mechanics of their construction to perfection. She created the link between different publishing houses by safeguarding his aesthetic. Henceforth she would become his one and only artistic director, carrying his memory and know-how, no matter at which publishing house.

Image from *The Big Book of Art*, 2008.

The second person was Isabelle Bézard, editor at Bayard Jeunesse, the large and historic publisher for French youth. Hervé had collaborated with them for the magazine *Tralalire*, in which he had launched his character Turlututu. This double magician engaged young readers by giving them the illusion of taking real action in the book. When, in 2009, Hervé presented *Press Here* (*Un livre*) as his top project, Bézard immediately grasped its scale and promise.

The book was quickly published. Next came the international fair of children's literature in Bologna, Italy. As the Frankfurt fair is in the autumn, Bologna is, in the spring, the place where translations of children's books are negotiated.

Press Here had already found considerable success in France. The hallways of the fair hummed with foreign editors fighting over the rights. No fewer than nine US editors placed bids. The editors of Bayard Jeunesse managed what Hervé experienced as another explosion. By doing so with great rigor, the team granted him the peace of mind necessary to face this upheaval.

It consisted of both immense energy and intense violence.

He would need that peace of mind because, as the months went by, and the translations accumulated, Hervé had to face that he'd given birth to a veritable publishing phenomenon. He received many testimonials and discovered what was happening in bookstores and libraries, how children and adults were reacting when they got a hold of the book. They understood the way it worked as soon as they turned the first page. There was an immediacy, a clarity in these reactions that shook the author to the core. He struggled to understand what was meant by the word "brilliant," which appeared in almost every one of the book's testimonials.

Hervé was already immersed in his next book. After *Press Here* he came up with a new project, titled just as judiciously *Untitled*. It explored the underpinnings of a book's creation. The story recounted how a story takes form. Hervé's fear of running out of ideas was still present, now with an additional pressure point: How to create after success?

The artistic culmination that *Press Here* represented, and its phenomenal editorial and public reception, comprised a major turning point in Hervé's career and life. There would be a before, and an after.

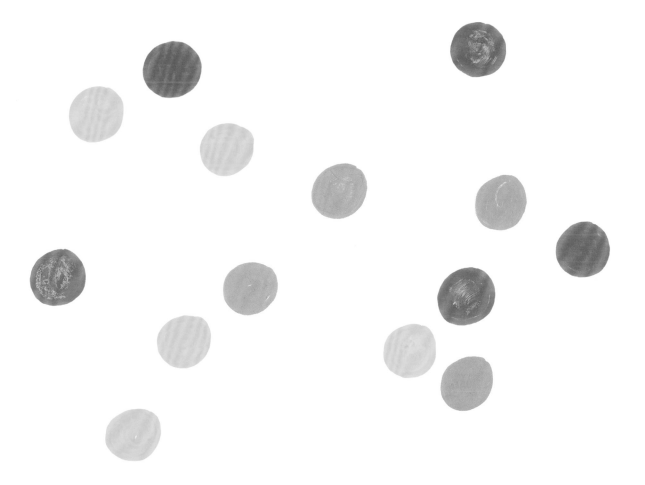

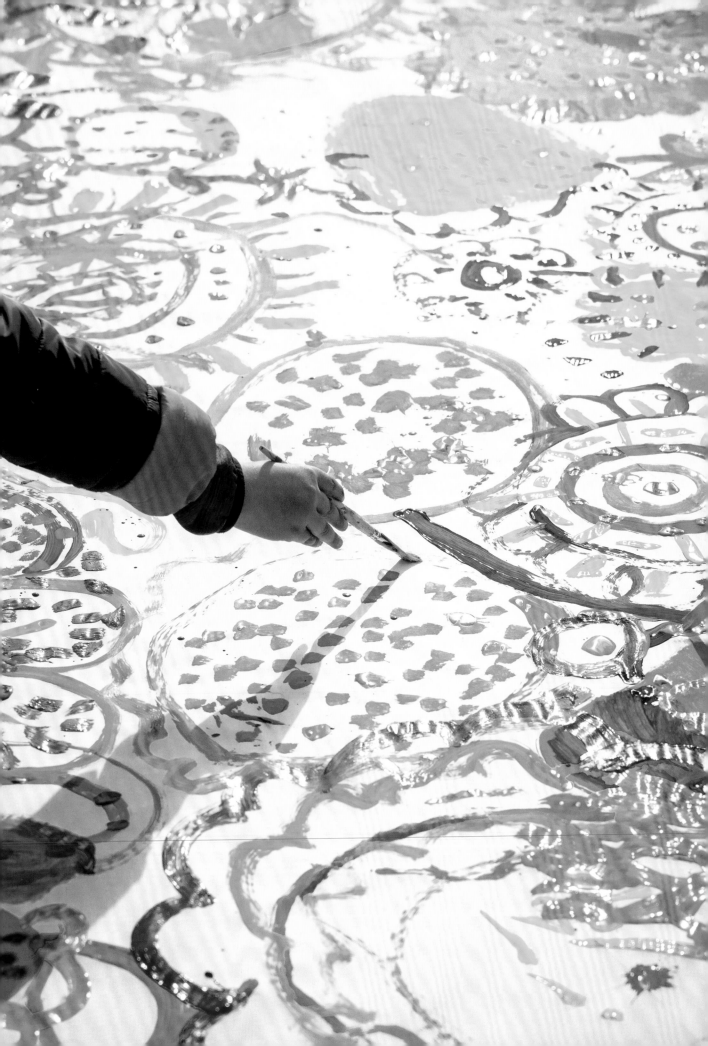

The Workshops

In the wake of this success, inquiries intensified. Little by little, the desire to get all the kids participating at once, to work from improvisation, and to lean on a collective energy tipped the scales from author-illustrator school visits to an artistically innovative event model.

There was nevertheless a decisive moment at a particular place and time: in Los Angeles, where Hervé had been invited for five days by the LILA International School of Los Angeles. The very configuration of the campus—spread out over different spaces, with an enormous courtyard for recess, an amphitheater, and a library—pushed the workshop in a new direction. The spaces were huge, and many students were present. One of the encounters that was supposed to happen outside with the entire student body in fact had to happen indoors, within this atypical architecture. Hervé installed himself at the center of the place and, from a desk, gave instructions to students from different classes, who communicated amongst themselves. The children arrived from the various rooms to receive an assignment, cross paths, and return, forming a ballet of energy. A "drawing factory" was needed to manage this flux of children.

I wanted to do a different workshop every day.

That day the students participated in one of the very first Field of Flowers workshops, which was atypical and memorable. Hervé asked the children to draw dots, circles, dots inside circles, very big circles, then splotches, etc. When the pages were sufficiently full he instructed them to transform these symbols into flowers simply by drawing their stems. A field of flowers revealed itself to the dumbfounded and delighted participants.

On another day a giant traffic jam was organized in the courtyard. All available containers were requisitioned: pails, bins, and pots. The students drew their silhouettes, and roads took form all around on which they wound up drawing cars, and then the entire city. Hervé began using music during the sessions, and from here on out it would accompany all of his workshops.

On yet another occasion, in the amphitheater, he gave a reading on stage, one of his first experiences of reading aloud in public. Five workshops were therefore conducted in succession during that week in the school. These workshops would complete their invention—but never their evolution—upon the publication of the eponymous book by Phaidon.

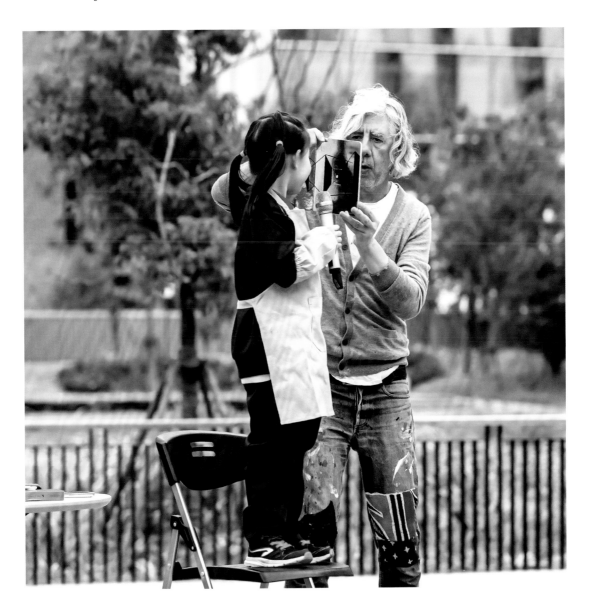

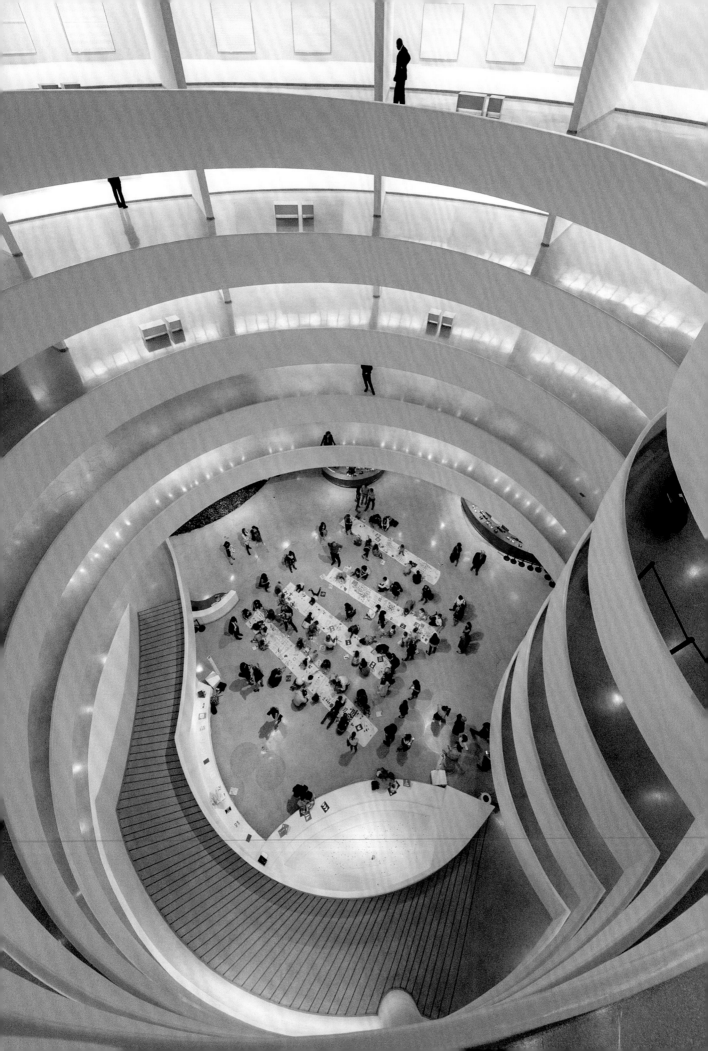

Arrival in New York City

Hervé Tullet
GUGGENHEIM
BOOK READING
AND WORKSHOP
let's play!
● SATURDAY
APRIL 16
1:30 α 3 PM
WWW.GUGGENHEIM.ORG

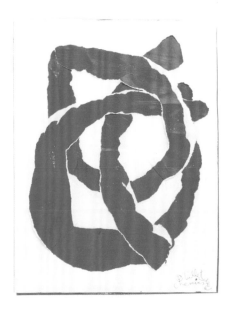

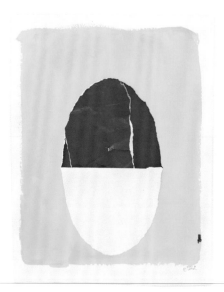

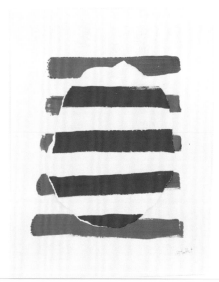

Explorations.

France didn't offer adequate cultural space for this dazzling development. The borders between different cultural domains were too watertight. The very terminology was missing for defining the new, unclassifiable artistic identity that emerged out of the combination of books, games, and workshops. In the summer of 2015 Hervé left for New York with his family, not knowing exactly what he would do there or what he wanted to be. But he was confident, encouraged by the wonderful welcome his books and workshops had received in the United States. And, as everyone knows, encounters happen all by themselves in the big city of New York.

One day, shortly after he had settled in, a common acquaintance was amused to find Hervé and Lucien Zayan (the founder of the cultural and artistic center The Invisible Dog) in the same place. "You two," said the acquaintance, "should talk." Under the guise of introducing himself, Hervé tossed out that he'd had success in the United States but didn't yet know what he would do with it. His audacity made him sympathetic, or else this success story resonated strongly with the founder of a center that drew its name from a commercial hit (the products that it had previously made). Hervé and Zayan took off immediately to shop for jam together. Later an actual exhibition idea emerged from this meeting. Hervé wanted to do an exhibition cocreated by children, with a workshop-style opening and closing. But Zayan didn't go for this idea, preferring to steer clear of the younger audience.

And there, suddenly, I had the epiphany: I would make the pieces myself. Pieces made by me, but that could have been made without me.

This was Hervé's first winter in New York. He didn't yet know that the city is paralyzed by bad weather during this season. For those months the city offered him the perfect cocoon to work on the pieces for the exhibition. Big pieces—rolls of paper—in which color, graphic motifs, and (for the first time at this scale) torn paper take center stage.

The opening was a success, drawing almost a thousand people. The final day of the show a kid arrived with all his pocket money, $100, to buy a piece. This exceptional experience was nevertheless somewhat marred by a private visit from the director of a big New York museum. Hervé and Zayan welcomed him personally. He took a quick spin around the exhibition before saying to the artist, with a knowing look, "Fontana, huh?" Hervé's desire to justify himself, to explain his approach (which was not at all influenced by Lucio Fontana, the artist known for his lacerated canvases of the 1960s), quickly gave way to disappointment. He realized that, once more, the logic of class and categorization was working against him.

A second, fateful meeting followed, offering Hervé a perfectly timed chance to think about his artistic identity. This encounter was with Virgil de Voldère, a former gallerist and the founder of the bilingual preschool La Petite École (LPENY). At first Hervé was hesitant to meet with him because he didn't want to go back to doing school visits. But a dinner brought them together and the inevitability couldn't be ignored: They had a lot to say to each other.

Virgil, my mentor, my angel, helped me understand the relationship that I could have with art.

De Voldère helped Hervé untangle all the questions he could think of: What is an artist without a gallery? Isolated? Outside the circuits of art? Bit by bit, Hervé oriented himself. He found his own logic, adopted qualifiers such as "artist without art," "conceptual approach," "pedagogy of letting go," or "art for all." The gallerist-turned-teacher accompanied Hervé as he updated both his philosophy and his method. He finally dared affirm what was him and what wasn't. De Voldère was also a consummate professional who resolved questions about designing spaces for exhibitions with schoolchildren, the placement of white, the management of lighting. . . . Together they worked on the processes of making visible and making possible that prefigured the Curriculum project.

In the fall of 2017 a third encounter finished making sense of Hervé's American experience. This one was quick, like lightning, with Maria Russo, the children's book editor of the *New York Times Book Review*. The encounter lasted only as long as a Facebook live event. The sequence was filmed from overhead, framing Hervé's hands, and a light atmosphere of tension suffused the studio, as with all live broadcasts. Hervé was there with his blank pages and his discarded drafts, as well as his trusty Posca markers. The communication between him (who expressed himself only with his hands) and her (who was only a voice) wasn't easeful. And yet a kind of equilibrium emerged between what Hervé showed and the commentary, as if Russo were dubbing or translating the drawings. The sequence was truly a leap into the unknown, direct and stimulating, with a singular creative approach.

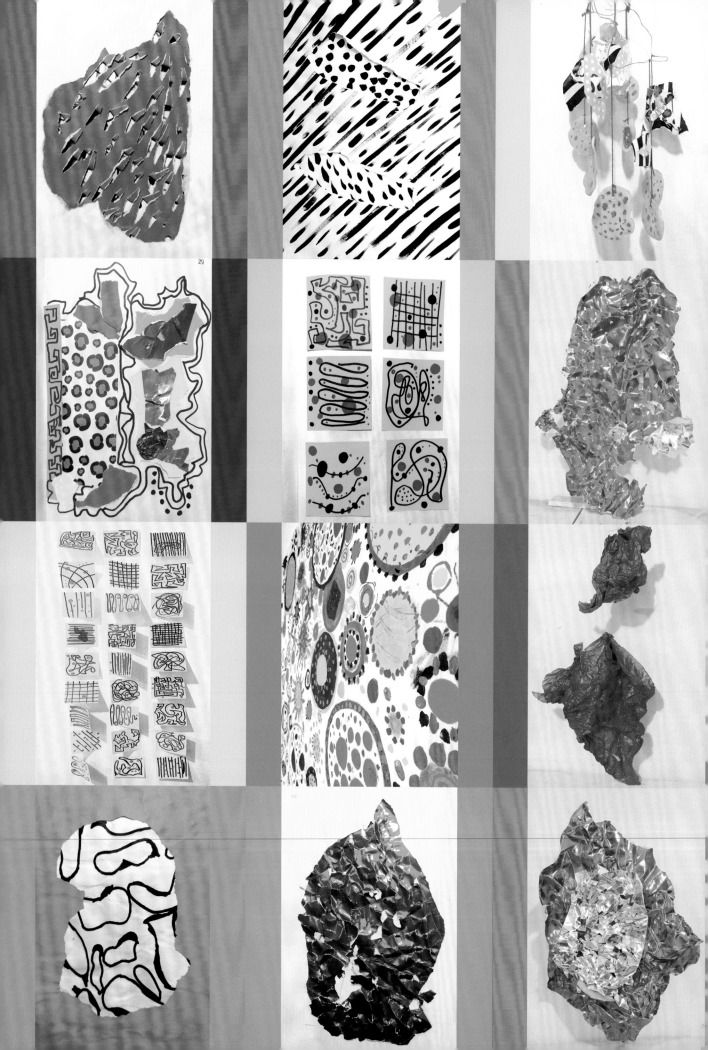

The Ideal Exhibition

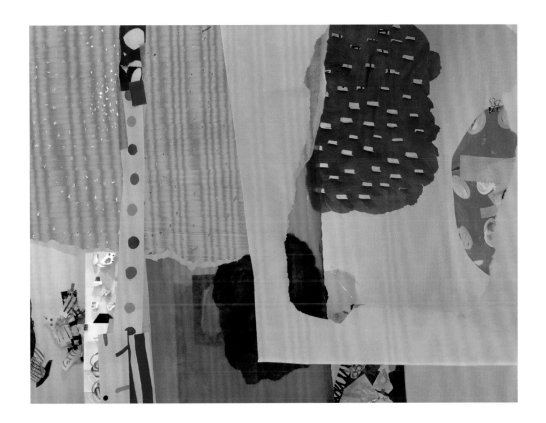

During this time Hervé was traveling a lot. He accepted invitations from all over, both in the United States and around the world, on every continent, to do public readings and giant workshops. At the Tate Modern in London, the Museum of Contemporary Art Tokyo, a primary school in Malawi, the Israel Museum in Jerusalem . . . and in South Korea. That experience stood out. First, in the way Hervé arrived in the country. Upon landing and trying, as he always did, to get close to the local culture, notably through literature, he was deeply moved by the country's connection to war. This resonated strongly with his own history.

Hervé was first invited to South Korea in 2009 by Guy Hong of the Artcenter IDA. Long before the Frenchman had set foot there, the center had already understood everything about his books and planned a high-quality program. Hervé was presented as the star artist of a big exhibition on contemporary children's illustration, with impressive spatial installations and an ambitious roster of events. This first foray would lead to several exchanges and, almost ten years later, in 2018, an ample retrospective devoted to Hervé's work at the Seoul Arts Center. It was accompanied by a thick catalog that Hervé's son, Léo, coordinated. From then on he took charge of organizing events and publications for his father's work. The pairing of show and catalog constituted one of the first times Hervé was recognized, holistically and coherently, as an artist and an author of children's books.

One year later the 1101 Museum, inspired by Hervé's work and philosophy, opened its doors in Seoul with a progressive space dedicated to the Ideal Exhibition. This was possible because the Bel Foundation, having seen the Facebook live event with the *New York Times*, had given Hervé the funds for his next big project, the culmination of his workshops and his reflections on all the work he'd done for the last few years.

Oh! A Retrospective, Seoul Arts Center, South Korea, 2018.

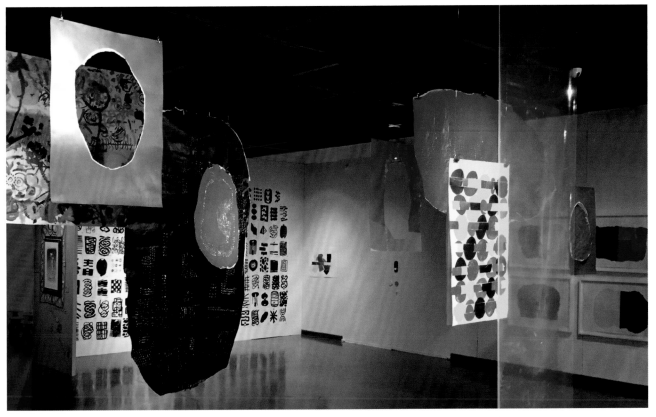

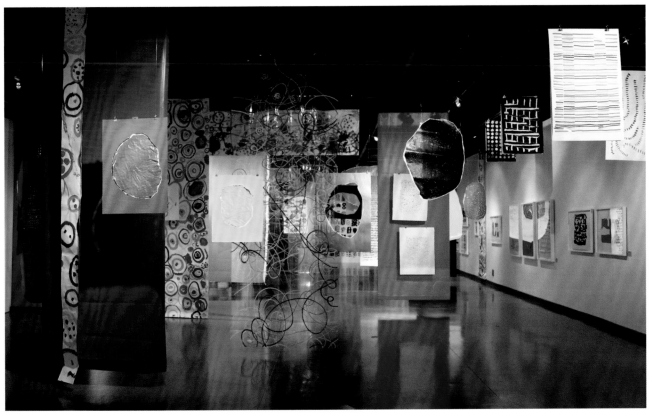

*It's an exhibition of mine that can be done without me;
a real exhibition led by my instructions . . .*

The idea was to build off Hervé's books (having shown that they call
for nothing but investment in reading actively and putting concepts
into practice) and give others the keys to create an exhibition. It
should be possible to create the show under any conditions, from
a matchbox to a museum, by one participant or hundreds, with or
without materials, to create works of art and to arrange an exhibi-
tion. Creating and showing: creating with joy, without any prerequi-
sites, supported by methods, and then showing by sharing in your
own surroundings while connected to others' experiences around
the world.

A video aid, shot in Montreal by Tobo, constitutes the user manual
and the accompaniment of the Ideal Exhibition. Setting one up is
completely free—liberated from any commercial preoccupation—
based on a pure logic of transmission desired by the artist. The
videos were shot improvisationally, by a team that knew how to
provide a frame without cramping Hervé's need to abandon control.
From the very first sequence Hervé's unexpected gesture of wiping
his paint-covered hands on his T-shirt sets the tone for this visual
aid, as polished as it is spontaneous. Hervé launched the first Ideal
Exhibition in Montreal, at the Librairie Monet. And he happily
concluded that the process worked perfectly.

*People invited me, proposed projects to me; every time
I sent them over to the video aids of the Ideal Exhibition.*

Over the course of several weeks the Ideal Exhibition spread expo-
nentially into all sorts of spaces: homes, schools, libraries, social
centers, associations, contemporary art museums. . . . Some people
shared their testimonials without necessarily having registered on
the website or having accessed the videos, but merely based on their
knowledge of Hervé's workshops.

Each experience was different. Using the same method, each person could express their singularity, lend a personal touch, and make the Ideal Exhibition into a moment of privileged exchange. When the events were shared online, all the photos and the stories or commentaries demonstrated a phenomenon that was almost organic in both its presentation and its depth of lived experience.

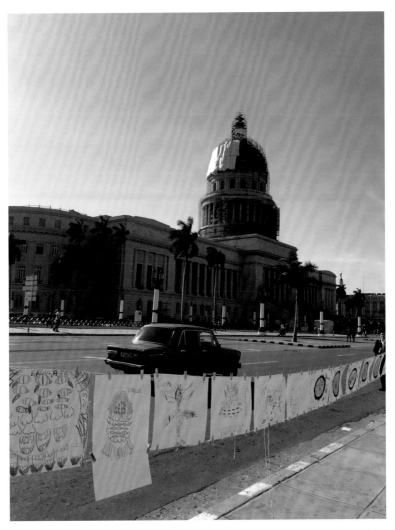

The Ideal Exhibition, Havana, Cuba

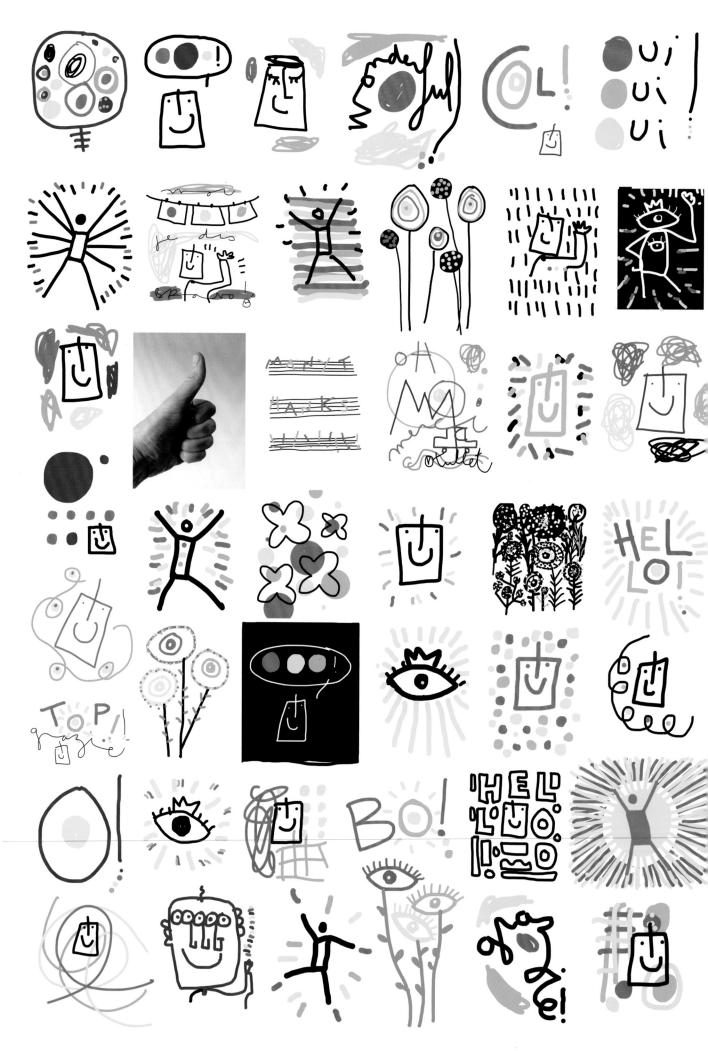

Hervé Tullet 2.0

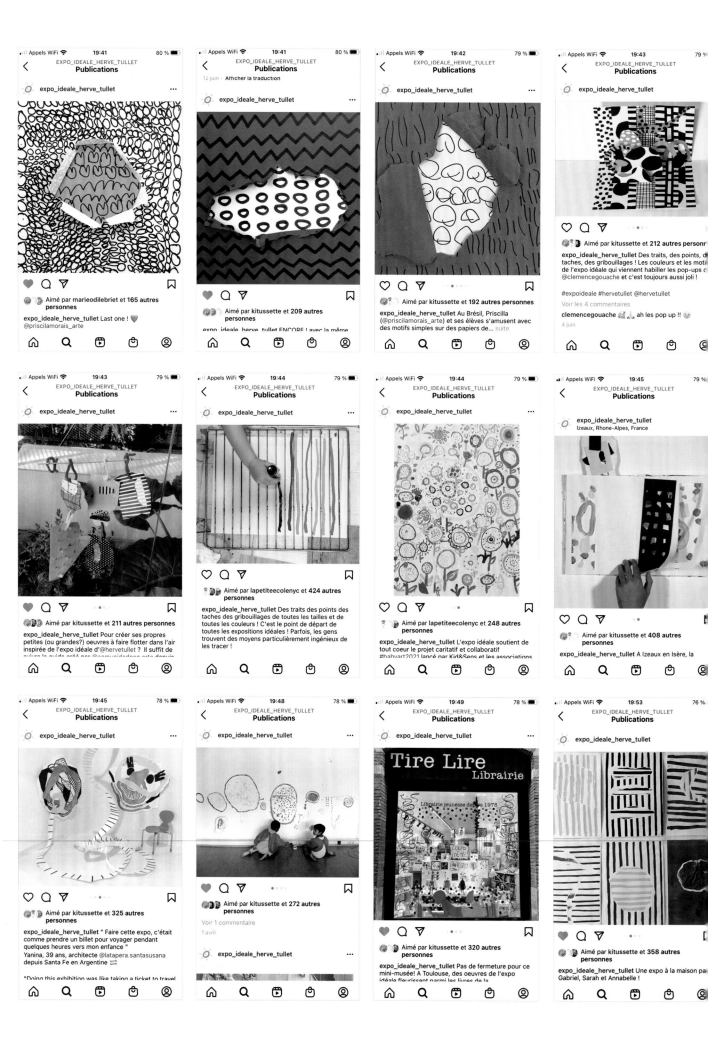

expo_ideale_herve_tullet

Aimé par marieodilebriet et 165 autres personnes
expo_ideale_herve_tullet Last one ! 🤍
@priscilamorais_arte

expo_ideale_herve_tullet

Aimé par kitussette et 209 autres personnes
expo_ideale_herve_tullet ENCORE ! avec la même

expo_ideale_herve_tullet

Aimé par kitussette et 192 autres personnes
expo_ideale_herve_tullet Au Brésil, Priscilla (@priscilamorais_arte) et ses élèves s'amusent avec des motifs simples sur des papiers de... suite

expo_ideale_herve_tullet

Aimé par kitussette et 212 autres personnes
expo_ideale_herve_tullet Des traits, des points, des taches, des gribouillages ! Les couleurs et les motifs de l'expo idéale qui viennent habiller les pop-ups de @clemencegouache et c'est toujours aussi joli !

#expoideale #hervetullet @hervetullet
Voir les 4 commentaires
clemencegouache 🎨🙌 ah les pop up !! 😍
4 juin

expo_ideale_herve_tullet

Aimé par kitussette et 211 autres personnes
expo_ideale_herve_tullet Pour créer ses propres petites (ou grandes?) oeuvres à faire flotter dans l'air inspirée de l'expo idéale d'@hervetullet ? Il suffit de suivre le guide créé par @comunidadaqq_arte depuis

expo_ideale_herve_tullet

Aimé par lapetiteecolenyc et 424 autres personnes
expo_ideale_herve_tullet Des traits des points des taches des gribouillages de toutes les tailles et de toutes les couleurs ! C'est le point de départ de toutes les expositions idéales ! Parfois, les gens trouvent des moyens particulièrement ingénieux de les tracer !

expo_ideale_herve_tullet

Aimé par lapetiteecolenyc et 248 autres personnes
expo_ideale_herve_tullet L'expo idéale soutient de tout coeur le projet caritatif et collaboratif #babyart2021 lancé par Kid&Sens et les associations

expo_ideale_herve_tullet
Izeaux, Rhone-Alpes, France

Aimé par kitussette et 408 autres personnes
expo_ideale_herve_tullet A Izeaux en Isère, la

expo_ideale_herve_tullet

Aimé par kitussette et 325 autres personnes
expo_ideale_herve_tullet " Faire cette expo, c'était comme prendre un billet pour voyager pendant quelques heures vers mon enfance "
Yanina, 39 ans, architecte @latapera.santasusana depuis Santa Fe en Argentine 🇦🇷

"Doing this exhibition was like taking a ticket to travel

expo_ideale_herve_tullet

Aimé par kitussette et 272 autres personnes
Voir 1 commentaire
1 avril

expo_ideale_herve_tullet

expo_ideale_herve_tullet

Tire Lire
Librairie
Librairie jeunesse depuis 1978

Aimé par kitussette et 320 autres personnes
expo_ideale_herve_tullet Pas de fermeture pour ce mini-musée! A Toulouse, des oeuvres de l'expo idéale fleurissent parmi les livres de la

expo_ideale_herve_tullet

Aimé par kitussette et 358 autres personnes
expo_ideale_herve_tullet Une expo à la maison pour Gabriel, Sarah et Annabelle !

Every day from then on, on social networks, Instagram, and Facebook, messages arrived, videos were posted, and images of the Ideal Exhibition continued to be shared. All over the world children, adults, parents, teachers, librarians, organizers—all sorts of people, both well-known and anonymous—joined the group dynamic.

At the same time, at de Voldère's urging, Hervé collaborated closely with a multidisciplinary educational team to develop the Curriculum. It was a tool of scale. The project aimed to broadcast, for an educational setting, Hervé's principles of creation in twenty-four lessons. The guide was Jacques Rancière's reflection on transmission through the adoption and mobilization of knowledge, and in particular Rancière's flipping of the vertical relationship between teacher and student and his definition of the "ignorant teacher." The Curriculum, intended from its conception to be put into action from New York to Seoul, aims to have the teachers let go. They are expected to bring all the necessary means and support for students to conduct their own creative experiences.

To consecrate the success of the Ideal Exhibition, a boxed set was published at the end of 2020. It consisted of an initial, selected catalog of the creations alongside a kit of papers and a guide to creating a personal exhibition. At the same time, ambitious, broad-reaching programs, encompassing all the dimensions of Hervé's work, were planned as far away as Asia. The visibility was total; transmission was the rule that bound this all-out broadcast as the twenty-first century got underway.

Recently, a young man explained to me the guideline of this movement: open source.

The little paper boat launched into the gutter has been pressed, agglomerated, and consolidated into a ball that transformed its original material—fragile and perishable—into a durable composite material, reinforced by all the varied and unique experiences all over the globe . . . A round ball like the hole that, in 1998, set off the principle of *Night/Day*, like the dot at the core of *Press Here*. Now it brings together a new community, international, supported by digital technology and the mobility of the web as well as by the energy that liberates creation. As it rolls along, this ball brings as many people as possible (and of every age, which is rare) into a coherent system where artistic and educational spirit incarnate themselves henceforth in the Idea.

This idea is first and foremost of a truly emancipated childhood, imagined as the future of humanity. The idea is not nostalgia, nor does it treat childhood as a source of inspiration, as it often has been in the history of art. Childhood is the location of creation in its natural state, in its gesture, its thoughts, its values. An actual universal childhood, experienced for itself, that transforms the dynamic of the adult inherently holding power into that energy, that propulsive force of creation, to which Hervé intends to devote himself from now on.

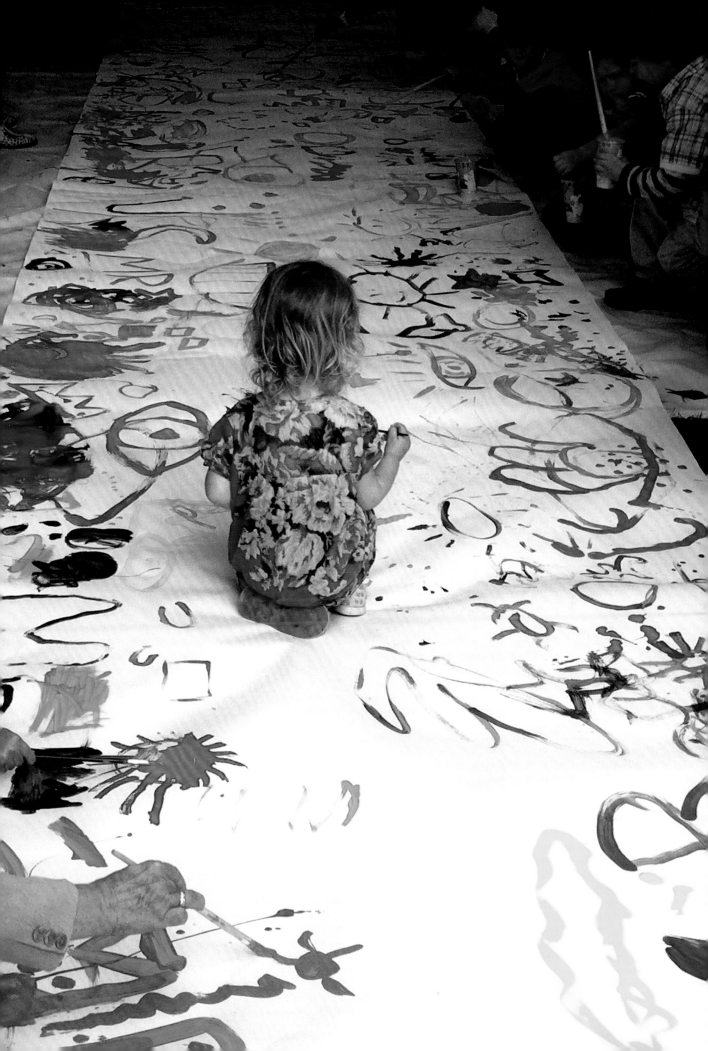

Sparks

I had an idea
It arrived without warning, honestly I wasn't expecting it
Standing where I was standing, and doing what I was doing
It was so beautiful, so strong, dense; I wrote it all down
It exploded from every crevice, like a geyser, an incredible
Richness, a whole world, new, accessible, fresh
I felt good, strong, confident
Then the next day, it had disappeared, like sand running
through
Fingers; the notes, however, are still there, and numerous,
but they no longer
Speak to me, everything seems empty, everything is gone,
I see a void
A nothing
Luckily, there are the notes, and the memory, something
There to be found
Oh well, I must accept things as they are: I have a title, and
also an idea
Maybe, and a marvelous memory of this explosion
So I wait, and I'm sure that it will come, one day, without
Warning

Delving into how Hervé Tullet develops his projects isn't a matter of due diligence, nor of the usual curiosity about what happens behind the scenes. The approach, the gesture, and the process itself are inseparable from the product. They give it its meaning.

The Method

The Idea

It's at the origin of all Hervé's creations. From the very start—his school years, his beginnings in advertising, and especially his early publishing—the idea has been the motor of his work, his cornerstone and his philosopher's stone. In return, it gives meaning to his oeuvre, which could be interpreted as a search for the idea in its purest form, or in its perpetual resurgence. Every book is the realization of an idea. Making a book means giving shape to an idea—completing it in some way—before making room for the next one.

When I started making my first books, I was interested less by drawing, and more by the idea of the book.
In fact, I was obsessed with the essence of an idea, since that is what communicates most strongly; every book must resolve a question; every book is supported by an idea.
When I find myself working on a project, I must get past the idea.
Or get closer to it.

An idea is fragile, really very fragile.
When I present a book idea to my editors, I'm not selling a finished idea; it will be refined later.
Only after making pages and pages will I be able to find the meaning.
The idea is in flux,
It's up to me to make it happen: I'm free and I'm responsible. The editors give me the chance to live the idea, day to day, they don't forbid me, don't ask me to be more explicit, to predict, don't even ask how many pages or how it will unfurl. They only ask me to follow it to the limits of my intuition. It's an organic thing which, thanks to practice and motor memory, becomes almost unconscious.

The Conception

The idea is there, evident, sometimes only in visual form. It imposes itself. Now the book must be prepared: its rhythm, its sequence. Its narration. Hervé won't try to fool you with fake elegies about the work. With his natural sincerity, he'll even speak of his strained relationship with it.

I accumulate sensations and words, without paying especial attention.
Bit by bit, things become clearer until they become all-consuming;
the work happens inside, in waves, it becomes clearer.
Then at some point, a feeling of grace emerges, a levitation, a trance.
It works, or it doesn't.
If it doesn't work, I start over
And I forget
Until things settle back into place,
And that's where the work happens.

The work is to return to the intuition of the first gesture.
I think, I imagine, that I want people to sense the moment of least distance between me and the reader,
I want to transmit all sorts of things from the moment of creation, and I do this more and more intentionally, consciously: rediscovering the instant of creation in order to offer instants of reading.

The Notebooks

Iconic objects of creativity, used by beginners and great artists alike, notebooks are essential to Hervé's work. He has many of them, particularly black ones with Bible paper, sold at the shop Papier + in Paris's Marais neighborhood. Certain notebooks have a particular importance in the genesis of one project because they represent a decisive stage of it. In the transitional phase between the subterranean advance, which draws diverse ideas together into a single idea for a book or project, and the realization there is a very important step: creating the notebook.

It takes a good notebook to set up a good idea. The qualities you're looking for can even include the shape of the notebook, as in the case of the black bias-cut notebook I used for I Am Blop!
It's an impulse; it works or it doesn't;
Sometimes you know in the space of an hour.
The notebook has the ability to reveal something about the idea,
Because there are no good ideas in a bad notebook, it has to contain traces of the primitive idea.
The notebook is a foundational act of creation,
Something must happen there which will leave a path to inspire the book, something which can catch my eye, which belongs to the unexpected.

I put my ideas into these black notebooks.
Today, an iPhone can perform that function, too.
These ideas are little things you can carry with you, you can find them just about everywhere; it's there, an impulse, a notebook.
To get somewhere, I might waste a notebook.
I have to choose one that seems to correspond with the feeling of what I don't know.
What I'm looking for when I record an idea in a notebook is an unfurling.
I'm searching for what the heart of the idea is,
whether it fits in 70 spreads, and if it does, whether there's enough material;
So, that's the act.

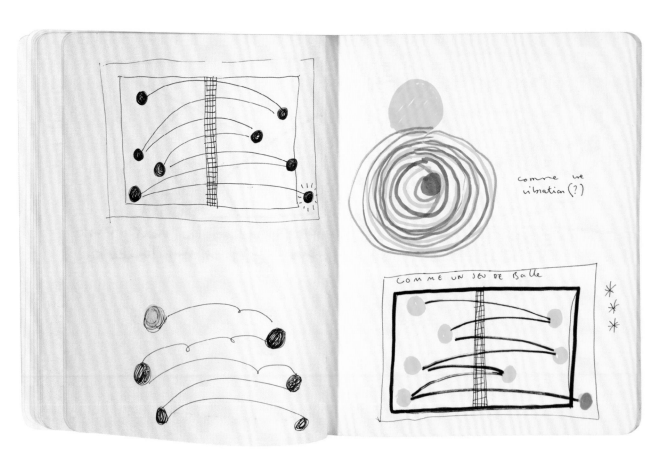

comme une
vibration (?)

COMME UN JEU DE BALLE

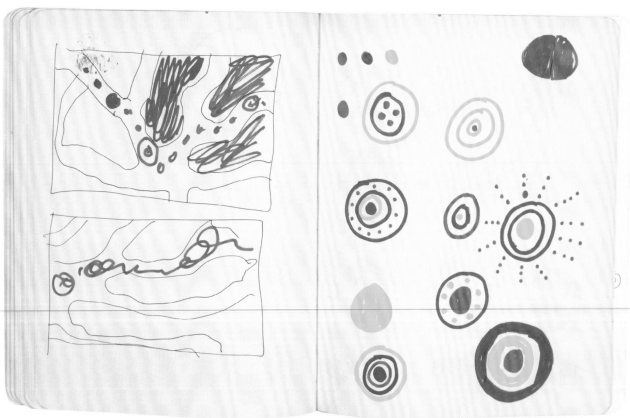

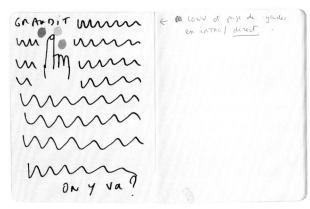

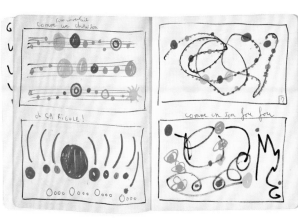

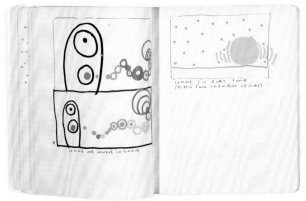

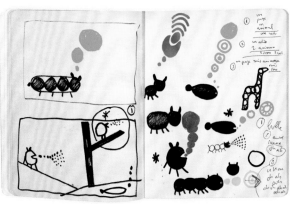

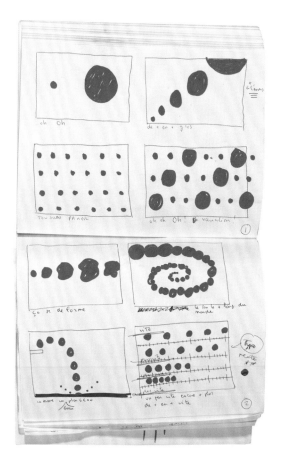

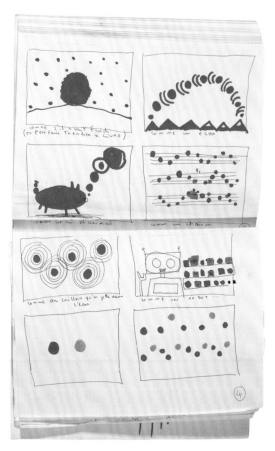

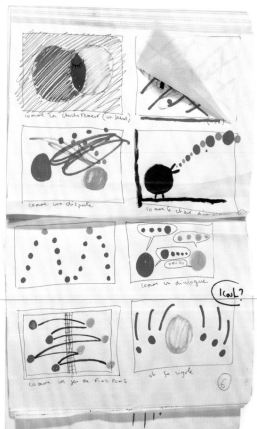

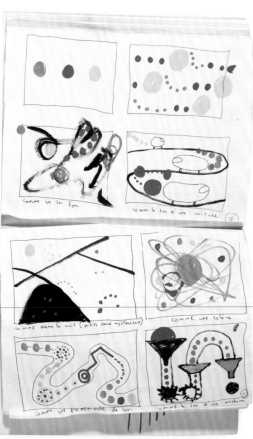

The Fulfillment

There is a sort of dazzle in transmuting ideas into notebooks and then into books. If this fulfilment reveals a kind of purification, it emerges both from the clarity of the concept and from a process of successive reductions. In this brief, efficient, almost impulsive process of iteration, a form of impatience can be hiding.

Once the sequence is written down in the notebook, I can add elements,
make connections, find tiny sparks,
Ideas that didn't come, or that I forgot, that haven't yet been gathered,
Words, objects, notes that will be pulled together.
This moment, if it happens, and if I'm pleased with myself, then becomes
a project, and there is only one person who can see it: the editor.
At that moment, I experience the idea being shared for the first time,
And I'm there naked,
But in a flash, I sense that the idea is getting through,
That the editor can see it.

Even while completing a book—that is to say, executing the final art—Hervé doesn't leave that state of urgency. His conditioning must not only draw out of the page the freshness of the gesture, of the handmade, but also integrate finality. There is no contradiction between the energy of impulse and the necessity of completion. Especially since, during this phase, the final form of the book remains open in terms of the number of pages and the sequence of the pages. In fact, the images from the notebook can remain helpful, be reused or perhaps refined. And Hervé isn't alone. His editor, Isabelle Bézard, can make suggestions, lift up or uncover an essential element of the book's structure. The art director, Sandrine Granon, also steps in; she is an indispensable partner in the process who can keep working on the images in post-production and handle the framing and the layout. She even sometimes combines images. Or asks the creator for new ones. As with everything Hervé does, energy and improvisation are given free rein within a well-defined space.

It's still the moment for spontaneity or impulse.
Before I start, I don't know how I'll tackle it,
Through the center, or from the beginning or the end.
I'm going to be inside a moment that reveals itself in the tense fluctuation
of a closed setting,
With music, time, space, and materials.
The conception of the images summons a new group of feelings and
impressions that the notebook specifies.
In fact, I can return to the notebook, as to an image to reproduce.
The image from the notebook becomes a reference that leads to the same
spontaneity—unless I simply ask the artistic director to integrate the images
from the notebook. I bring her more pages, more drawings than necessary,
and often several versions of the same design.

I know it's done when I get fed up with it.
To get there, I go through a system of filters, a succession of reductions,
a funnel, a dynamic driven by the paradoxical desire to get rid of things,
to get back to a neutral zone, the zone of uncertainty: to return to the state
of not having an idea, to return, in sum, to the quagmire.

Throughout this stage, the notion of the handmade, of accidents,
of fingerprints is essential;
I need to make the spontaneity and fragility tangible, to make the drawing
not impressive but accessible.
More and more, as time goes by, I'm searching for a call and response,
an exchange with the reader.
For example, I draw a splotch, which is then printed in the book—so it takes
on a value, notably because it was chosen, it represents something
of course, but it also remains a splotch.
By adopting this splotch and reproducing it, the reader makes others
that become just as important as those in the book,
They become beautiful and yet,
They aren't just splotches.
That's why I try not to set any boundaries, or as few as possible,
between my creation and the reader's adoption of it.

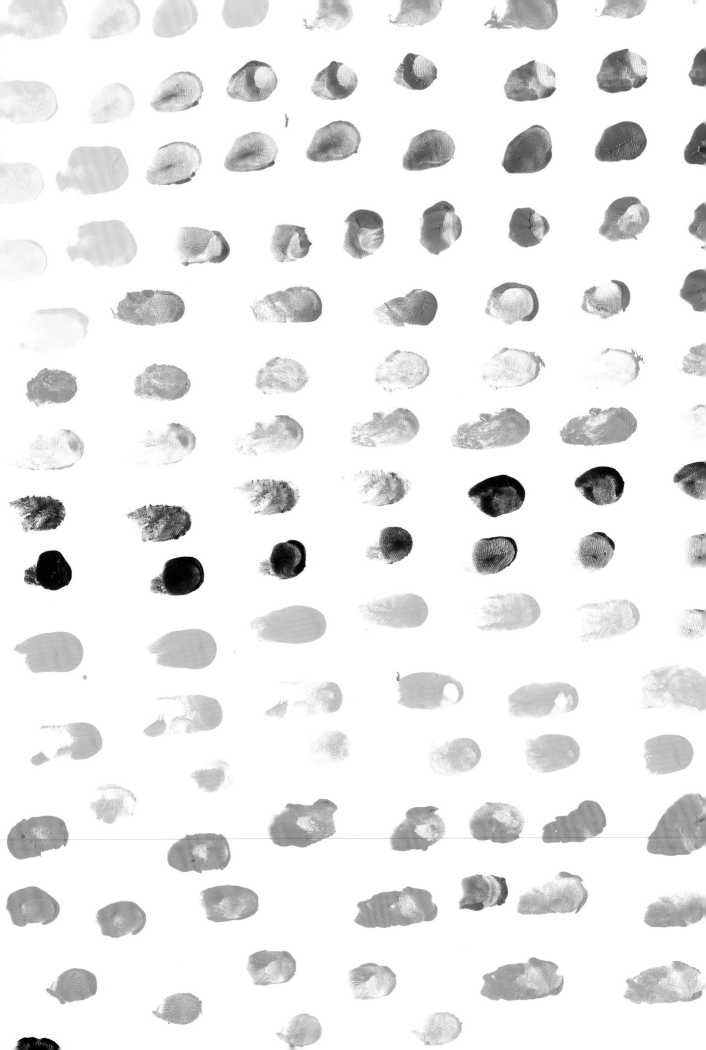

The Books

ET BLOP!

Comment papa
a rencontré maman

(How dad met mom)
Hachette Jeunesse, 1994

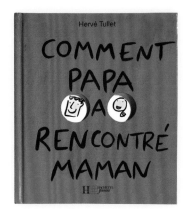

This was Hervé's first book for kids. At the time it was published, the market for children's literature was undergoing a profound change. New techniques were being deployed; new qualifications were emerging. Hervé was a freelance illustrator who painted on the side. There was nothing urgently pushing him toward this work, but it allowed him to add another string to his bow and to get his foot in the door of an appealing sector. His experience as a father, looking for innovative ways to support reading with his kids, led him to this project, which humorously dramatizes a meet-cute through little sketched couplets.

When I was imagining my first book for children, I thought I understood the mechanics of this type of book. A parent reads to the child: The parent has fun, the kid has fun watching their parent have fun. At least that's what I had experienced with my children and with certain books that I could find at the time.

I wanted to make a book that was funny for both adults and children,
but that would remain at a child's level.
That doesn't mean getting down on all fours,
It means speaking normally, and above all not hesitating to speak directly to children.
Through this experience, I invented several things.

The book garnered interest from readers eager for offerings that broke with a certain tradition of the bedtime story. Booksellers and librarians perceived its uniqueness, with its very loose, unpolished drawing style, driven above all by the idea, and running on clichés, like media content.

I worked based on what I had learned in advertising, on a metronomic
rhythm, "tick tick boom," particularly in all the research I did to produce
videos. At the time, new content was starting to be shown on TV: short bits,
funny and incisive, very energetic gags. This required a real intensity,
an almost automatic search for ideas—all this was my culture.
We would juxtapose a problem and a revelation; it was binary, efficient.
My first book for kids was in a certain sense the book of an ad man.
A little trendy, a little zeitgeisty, funny, with a subject that raised themes
not yet approached in children's literature.
From a certain point of view, it's a book about love and violence—
Maybe my first provocation?

> In fact, the story itself is not the main event, or at least it isn't meant
> to be taken at face value. Rather, it is the play of associations among
> ideas and the humorous portrayals that make up the book's primary
> appeal. There is also its use of a cutout, until then only used by
> artists like Tana Hoban or Katsumi Komagata (whose books Hervé
> discovered thanks to his first editor at Hachette, Fani Marceau).

What came to me first wasn't the story, but the associations;
Little by little I accumulated playful links or transitions: from the guy to the
black eye.
Like in a publicity stunt, the strength of the image gives all the explanation
necessary.
I worked on basic typewriter paper, very thin and delicate,
The drawings were absolutely not up to snuff; the hands, for example, were
reversed,
I felt my weaknesses in this domain.

Once the book was published, it didn't sell. But the question of sales was
very abstract for me.

⑯

⑰ •

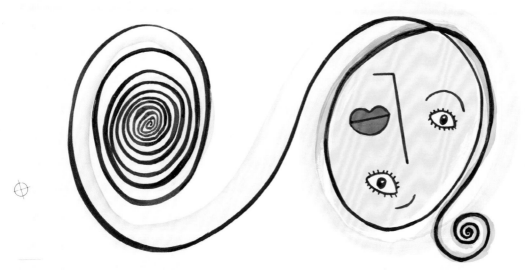

⑱ •

⑲

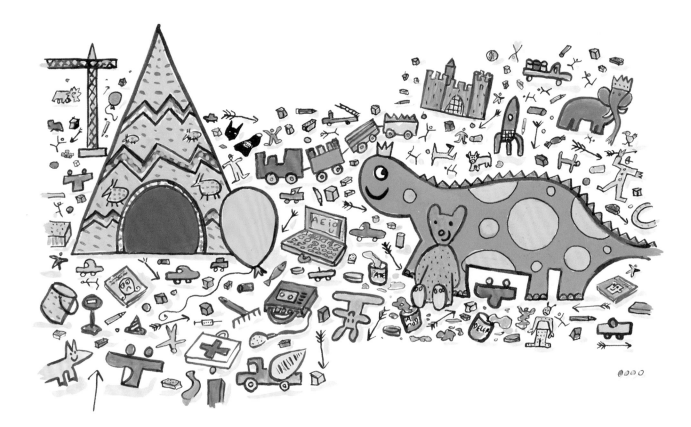

For the second book, I didn't have an idea. So I did what everybody does:
a sequel, then another. It was logical.
But the second book was drawn better.
The third even better.
There was a progression in the style.
Most importantly, every book followed in the same vein; which must mean
that there was a vein. And a subject.
I wasn't on the wrong track, so I ploughed ahead.

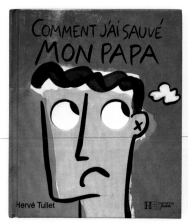

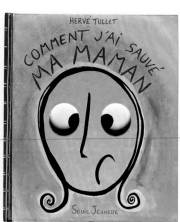

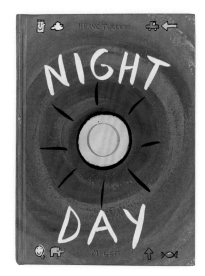

Night/Day

Seuil Jeunesse, 1998 /
Little, Brown & Company, 1999

The dynamic of dialectic oppositions, already very present in Hervé's first book, was refined during his first few years in children's illustration. Both his notebooks and the box of ideas that sat on his current editor's desk overflowed with these binaries. The result was a volume about opposites, a theme that had not yet been explored in concept books but that would be widely taken up afterward, until it became a children's genre in and of itself. That's how Hervé's book came to be honored with a Ragazzi Award at the Bologna International Book Fair, in the nonfiction category, with an emphasis on "a feeling of complete innovation." Even today the contemporary quality of the book speaks clearly, through the profusion of concepts included, the movement from page to page, and the use of the cutout. For its author-illustrator, this book was foundational.

They say you're always making the same book.
Night/Day is my base structure:
The fundamentals of opposites: small, big, right, left, up, down, surprise, reversal, contrast, play, humor.
An idea; a progression.

I had regularly noted down oppositions in my notebooks, but I didn't yet have in mind the principle of the hole, even though I had used it in my three previous books.
Suddenly the idea of the hole became the link, the transition between concepts!
And bam, right away I put on some music! Specifically, a compilation of Japanese Gagaku music from Ocora Radio France. This music has a depth to it; the sound is dense; you can immerse yourself in it, like you can in contemporary music.

As the CD played I threw everything onto pages of A3 paper with India ink, in black and white—what I was searching for, what I was imagining, it was a powerful idea; the clarity of the idea.

I assembled everything, the sketches, the raw work, and I headed to the publishing house.
Then a problem arose: The editor wanted to do the book in black and white!
Immersed in a certain culture and set of references, they had this vision for the book,
But at the time it seemed impossible to me,
Because black and white was too radical, too demanding, too "design," too dependent on drawing; I thought I wouldn't be able to manage it.
And Fani Marceau, who had been recruited alongside me, came to my rescue,
And I made the book in my way
And in color!

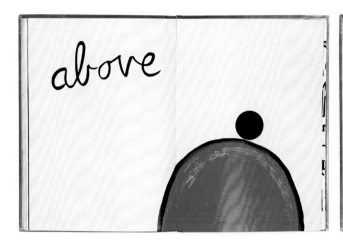

above

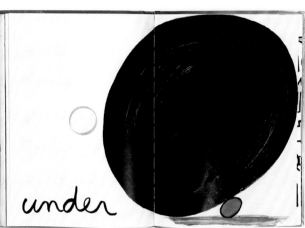

under

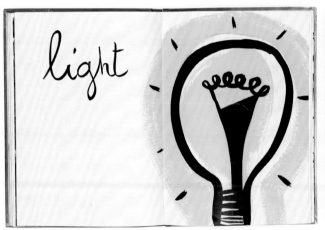

light

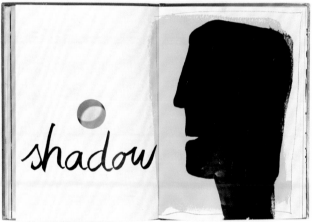

shadow

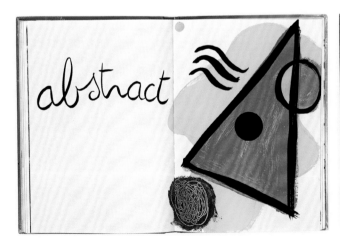

abstract

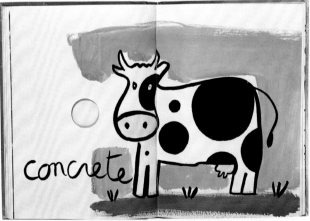

concrete

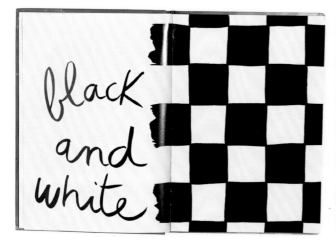

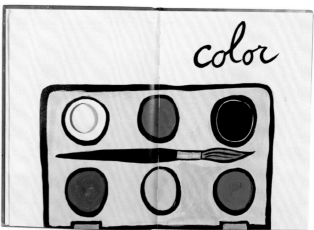

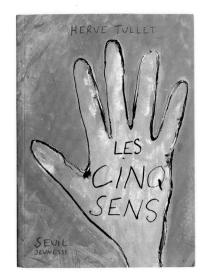

The Five Senses

Seuil Jeunesse, 2003 / Tate, 2005

The Five Senses seems to be an artist's book, despite its format being simple, similar to a notebook in its dimensions and bulk (which don't identify it as an illustrated book either). Yet, already, on the cover there's a very discreet relief effect, which suggests painting or ink. Inside it's an explosion: The book is saturated with colors, textures. Each new spread is unexpected, and the surprises pile atop one another with cutouts, imprints, braille, mirrored pages, crinkly plastic . . . It both evokes sensations and creates them.

It emerged one weekend that I spent on my own in Paris,
I started working in a studio
And I didn't stop.
I didn't have a notebook, but I was off to the races: My notebook was created in real time on pages,
I did 1, 3, 10: expressing the sensation of cold, it's good, done.
This or that feeling? Done, what's next. . . .
I produced without thinking,
I liberated my senses because I liberated my style,
I felt something foundational and expressed it straightaway, as it came,
And that liberated my gesture.

Then I organized the papers in folders, one for each of the five senses:
That's when I realized it was work, because the folders were more or less full,
And I had to make lists, balance things out.
Next I showed up at the publishing house to show where I was at.
The drawings were spread out on tables in a meeting room.
Fani Marceau said, "Oh boy, this is going to be expensive."

The editor in charge of the children's division, Brigitte Morel, replied, "Well, if it's expensive, then it's got to show: What are we going to add?" "Adding" stymied me because I didn't want the book to be a gadget. That was precisely the book I didn't want to make, one of those trendy sensory books for very young kids. They're weak books tackling strong subjects. So we decided together to add, parsimoniously and coherently, an emboss here, a transparent paper there, a cutout over there....

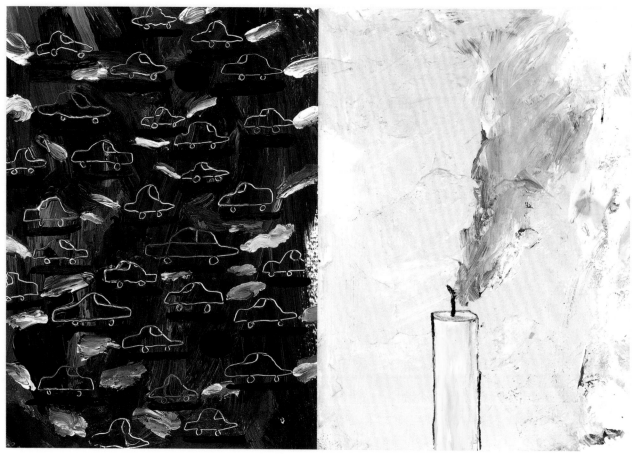

A	B	C	D	E	F
G	H	I	J	K	L
M	N	O	P	Q	R
S	T	U	V	W	X
Y	Z				

Turlututu: C'est magique !

(Turlututu: It's magic!)
Seuil Jeunesse, 2003

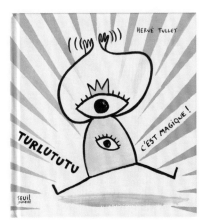

This book was the first step toward the narrative system that would be revealed in full with *Press Here* seven years later: playing with the persuasive force of the narrator to incite the reader to interact with the book in all sorts of ways. Here, a character/narrator, Turlututu, is established. Drawn in an archetypal manner, with a (crowned) head and a heart shaped like an eye, he addresses the reader directly, questions them, and gets them to act.

He's named Tutu (Tullet),
Turlututu is me:
He moves like I do when I'm running an event and I bring a child up on stage (I overact, I'm a performer),
But he's me in two dimensions, rudimentary.
He has two eyes because he looks a lot.

At the start, I was intuitively attached to this character, enough to refrain from making him more sophisticated.
Intuitively, this suited me, and I later understood why: He's a stick figure, that first character that children draw.
As a character, he emerged very quickly.
I remember someone at the publishing house saying, "Careful, he's a character, you need to work on him."
But I had no desire to work on him; he's flat, without volume or expression, he's always drawn the same way, his arms have a limited number of movements,
I was happy with this unexplored character.
I could see that it was a style that adults wouldn't like.
But, in fact, that leaves room for the idea.

While many books for children show magical characters such as fairies or witches, Hervé strove to offer children a strong element of truth in the magic and render it effective within the book. A simple turn of the page produces anticipated actions, which the narrator declares to be magical. It's similar to the way that illusionist shows worked in the nineteenth century. In the third book in the Turlututu series, *C'est toute une histoire!* (It's quite a story!), the person reading aloud (therefore the adult) is put in an awkward position vis-à-vis their listeners, since the narration has them describe images with words that don't match.

The most wonderful page in Turlututu: C'est Magique!, *the one that for me reveals the most, is when he disappears, and the reader finds themselves with a blank page.*
I think it's precisely there that the principle of Press Here *appeared for the first time.*
In Turlututu: C'est toute une histoire *there's also a fundamental reversal. Since the image is shown but the accompanying word is wrong, suddenly the child is the one who knows how to read, not the adult. The drawing of the sun is captioned with "a radiator," the car with "a horse." . . .*
When you read this on stage with children and their teacher, a rift opens up: The adult doesn't know how to read!
This provokes a great moment of confusion in the reader, and that moment is important because it completely reverses the rapport between teacher and student, or even between adult and child.

For me, the Turlututu books were really an experiment.
But at a certain point, it became a little tiring.
Looking for ideas was fun, but doing the drawings, the background, repeating characters,
Turned out to be more boring and that's how I decided to stop.
Turlututu is nevertheless a good companion who follows me still.
And I'm always astonished by the vivacity of this character.

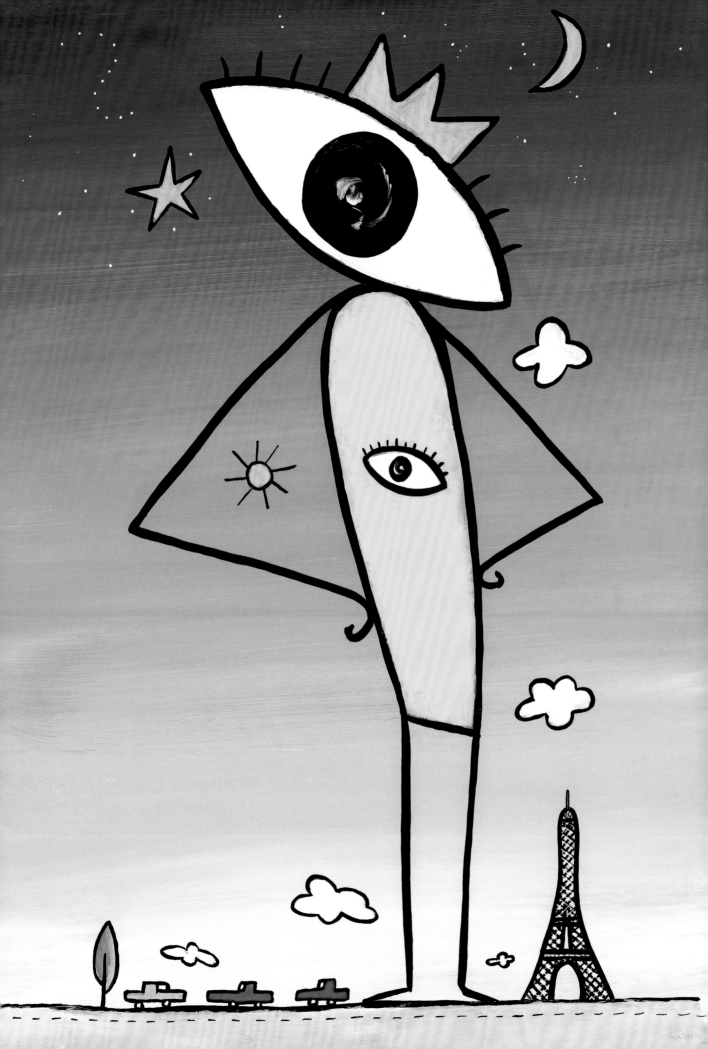

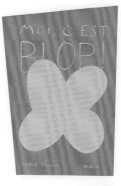
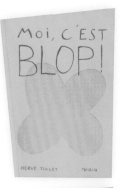

I Am Blop !

Les éditions du Panama, 2005 /
Phaidon, 2013

With its trapezoidal shape and its four chromatic cover variants, this book is profoundly original. Starting with a hollowed-out form on the first page, the book establishes a declension with variations—black, white, big, little—then very quickly adds some surprises such as the mirror facing "Blop discovers." From page to page the reader witnesses ideas put into action, more and more rich, audacious, and surprising, as if they were witnessing the unfurling of a creative thought in real time. The book evokes Andy Warhol, because in this wonderful idea factory, the reader finds the same use of repetition, transformation, and combinations of forms and colors, of which the icon Blop is emblematic.

When I tackled Blop, I wasn't motivated, because it was a heavy project:
At the beginning, I had in mind a repeating splotch, and it bores me to draw the same shape over one hundred pages.
I sensed that it was an idea, but I couldn't tackle it.
Blop has a link with outsider art, or Arte Povera, in its simplicity, or in the systematization of its repetition.
I had an obsession with shape and I wanted to manage to reveal meaning with nothing, to rediscover the feeling I had when reading Little Blue and Little Yellow *by Leo Lionni: creating an entire universe and emotions with simple bits of color paper.*

A notebook in the shape of a parallelepiped gave me the internal rhythms, but it took time before I wanted to show it to the editor,
And yet, she immediately expressed enthusiasm: It clicked in the way it only does when you have a special rapport with an editor.
It clicked enough that I could face completing ninety pages!

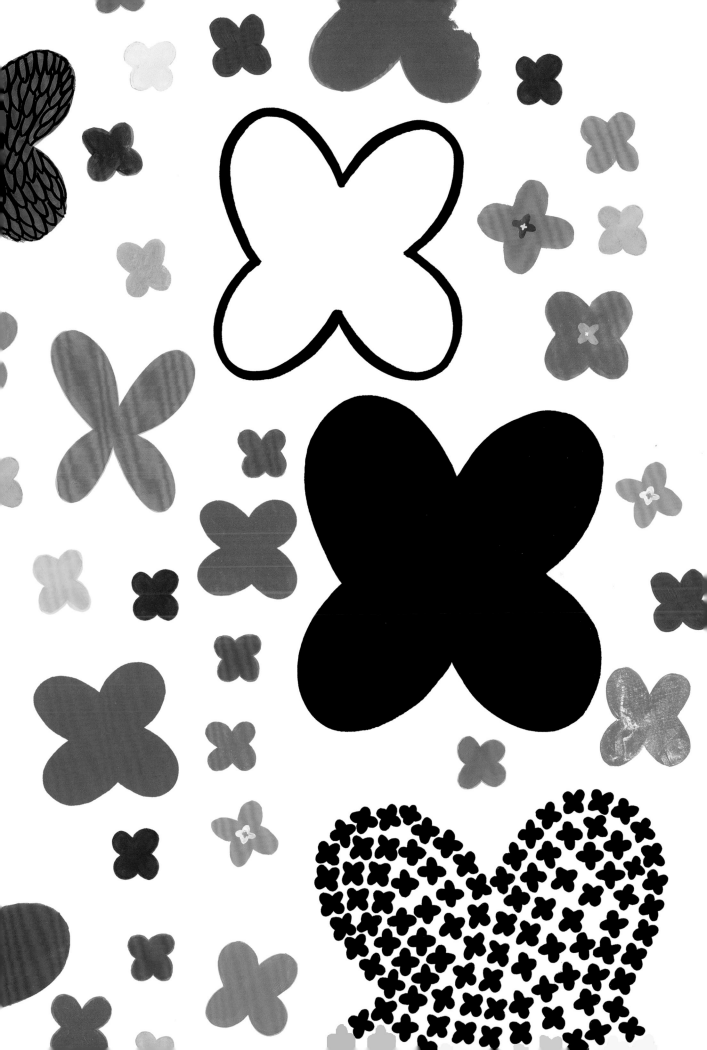

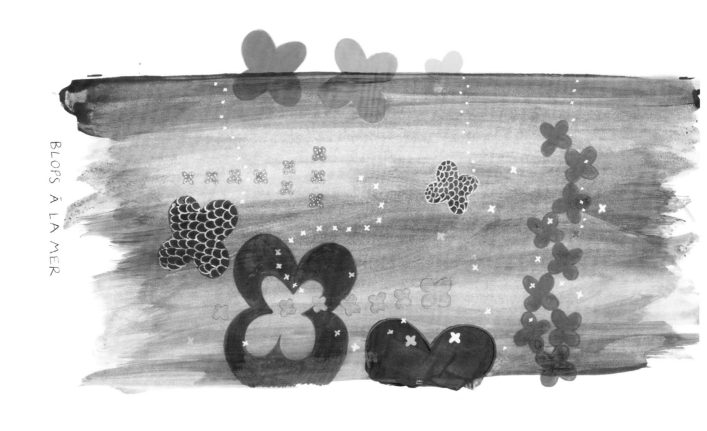

BLOPS À LA MER

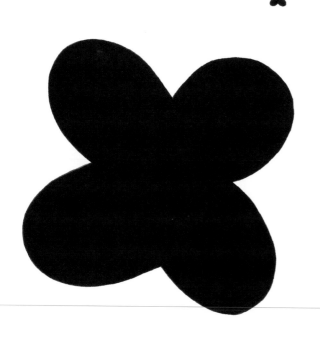

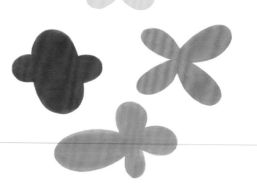

MAIS OÙ EST BLOP ?

U UN TRÈS GRAND BLOP ET ET
 UN TRÈS GRAND BLOP

 UN TOUT PETIT BLOP
 UN TOUT PETIT BLOP MAIS OÙ EST BLOP ?
 MAIS OÙ EST BLOP ?

Hervé invented a shape that has the simplicity of geometry but that appears in nature as a clover, a cross, a butterfly, and an infinite number of incarnations. This would be proven by the hundreds of contributions that arrived in response to Hervé's blog post calling people to send in "their" Blop. It was the first act in the viral interaction between readers and author via the internet.

I took myself seriously when I made the shape Blop.
It was very much a designer's gesture, with extensive and in-depth research, on tracing paper: a real logo creation.
And the surprise, when the book came out, was that that shape existed already: I realized that Blop exists everywhere.
Yet this shape didn't have a name.
Then I wanted things to spread through communities and groups, and it worked: The readers searched for the shape in the real world, in everyday life, on the street.
It became viral because it was obsessive.
The primitive form of Blop is a cross: There was a missionary quality to its diffusion that I've found again today with the propagation of the Ideal Exhibition.
The book was in a way completed by the readers, magnified one hundred times,
Yet I had imagined none of this when I was making it.

The other big revelation with I Am Blop! *was that it was a book of sounds. That was unanticipated, too.*
But it nevertheless became of primary importance during public readings that I did for this book, and it added a whole other dimension,
Which later led to Say Zoop! *(OH! Un livre qui fait des sons); a digested Blop.*

The book's other powerful idea was to make the Blops move within the space of the book, for the storyboard sequence. For the first time I had the intention of animating a figure, like a precursor of choreography.

Game Series

(Série des jeux)
Les éditions du Panama, from 2006 onward
Phaidon, from 2011 onward

These are sixteen-page board books, all in the same format, titled "Game." They signaled a new stage in Hervé's work by positioning themselves at the extreme limits of what a book is in order to concentrate on a playful and creative interaction with a very young reader.

The starting point was the word "game" that popped into my head; "game" becomes the idea.
I had a yellow piece of paper (which I've kept) on which I wrote "game." Then I added "of shadows," "of light," "of words," etc.
I didn't yet have all the ideas on the theme of games, but those first two or three were motors, they guided me and sufficed to reassure me about the list I was making.
For "game of light," I remembered the experiments I did as a student, with my friend Jean-Loup, using a colander and an electric lamp.
A sound and a light with a colander: It's magnificent, you're surrounded by luminous projections.
During this time, wordless books were being sold. I thought only with my eyes, the books were mute. I had the feeling that in the dark, with shadows, you have better things to do than read a text. But the editor wanted to add a text, so I let her.
But if I were to republish The Game of Light, *it would be wordless: to leave the possibility of inventing the text yourself.*

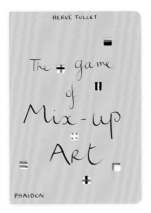

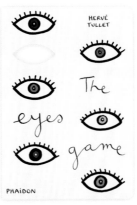

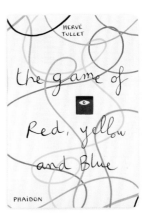

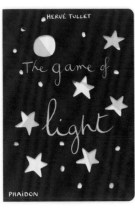

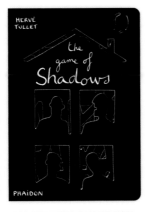

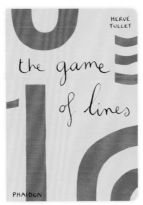

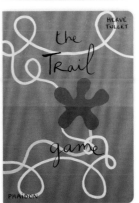

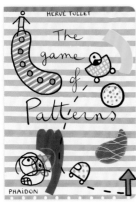

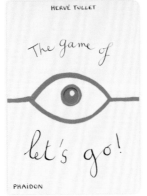

These titles were published in a group, and each installment brought new inventions, for example with the cutouts, which could be circles to stick your finger through, thereby turning them into characters. The cutouts could also show more elaborate shapes that supported projections, or then again they could be notches into which other materials could be inserted, as called for by the book.

The Five Senses, *with its holes, its papers—all that sparked something, I felt that it was a bottomless wellspring.*
The board book structure was my starting point. It's the format meant for really young children.
And I accept that completely.
But books for babies are books in passing, books to be thrown away, bought quickly at the supermarket, books that disappear, without importance. The editor told me, "We don't put meaningful content in board books."
Once the game books were published, though, they were beautiful, joyful; they were asking to be put in boxed sets.
In this case, they were board books that last,
And I was absolutely aware of making a good board book.
You can use so many things, so many materials to find the idea of a book.
And at the time I didn't realize that I was making my Prebooks: That occurred to me later, when I discovered Bruno Munari. . . .

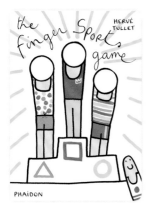

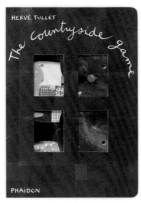

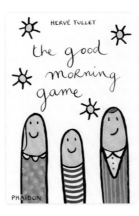

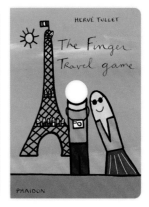

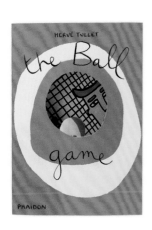

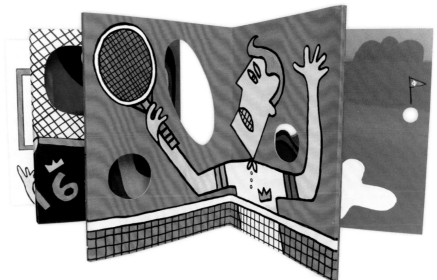

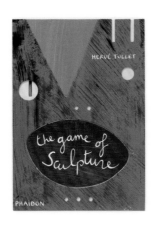

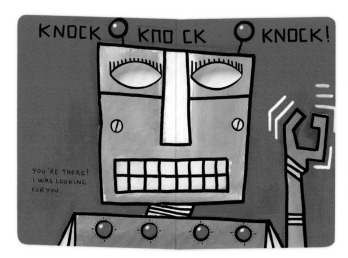

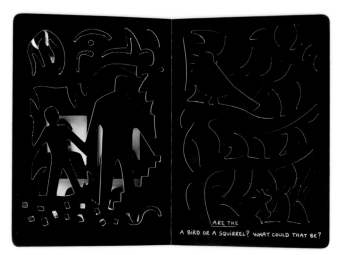

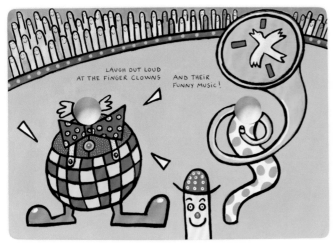

LAUGH OUT LOUD
AT THE FINGER CLOWNS
AND THEIR
FUNNY MUSIC!

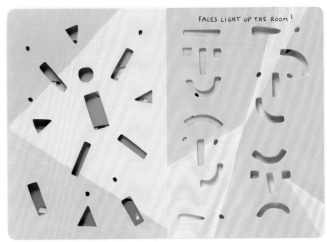

FACES LIGHT UP THE ROOM!

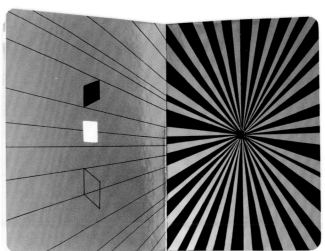

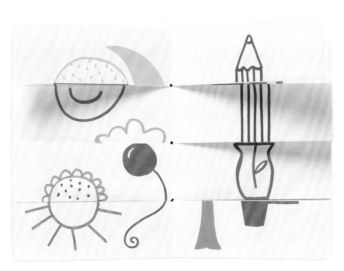

The Big Book of Art

Les éditions du Panama, 2008 /
Phaidon, 2013

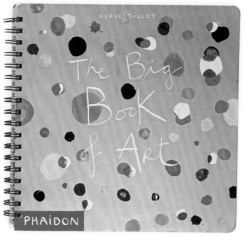

This time, all verbal narration is thrown aside and the book makes itself understood in a completely intuitive and personal manner. It's the first art book for babies, but it's also Hervé's first total art book. An institutional support system for creation (from the Val-de-Marne department, in a suburb southwest of Paris), won during a call for entries, permitted Hervé and his editor to envisage an exceptional undertaking on an ambitious project. Like so many avant-garde creations, its format was square, and the book comprised eighty-six pages—unimaginable for babies! The pages are plasticized, filled with motifs and colors, and spiral-bound, allowing creative manipulations that are channeled and kept harmonious by a segmented structure.

The book asserted all my graphic vocabulary of the time.
Over the course of the various sections, you could move from the splotch to the shape, from the shape to the color, then from the letter to the sign.
It was a controlled articulation.
Finally, with this book in hand, you could hold your first dictionary,
A first dictionary for babies.
When you're little, you start by making scribbles, then splotches,
Then you're going to create, you need colors, letters—which remain abstract—then one day, there will be signs and guided associations.
This is a book for babies, but once you know everything that's inside,
you become a child, ready to learn how to read.
It's therefore a progression, a path, an initiatory story in a way,
And a game.

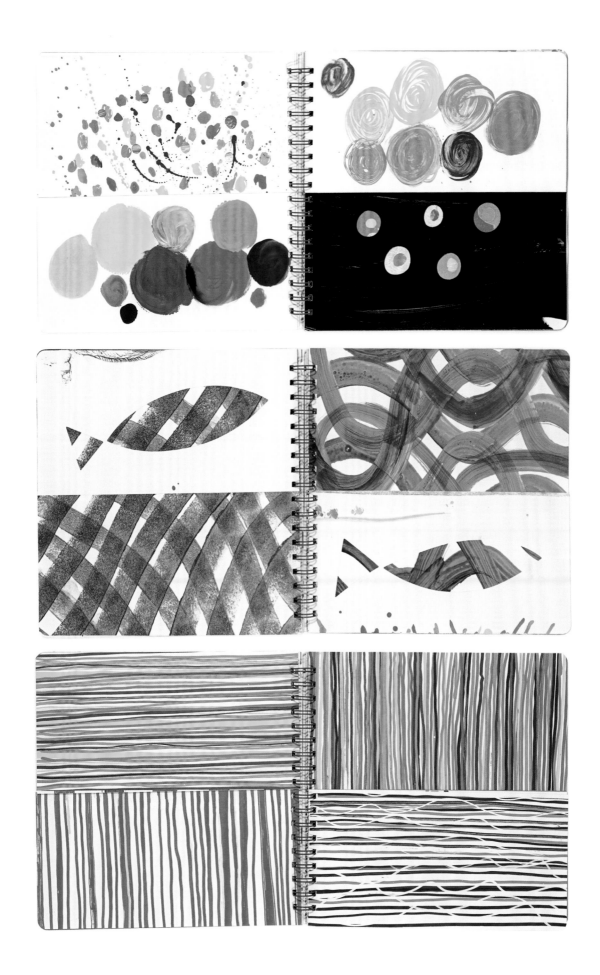

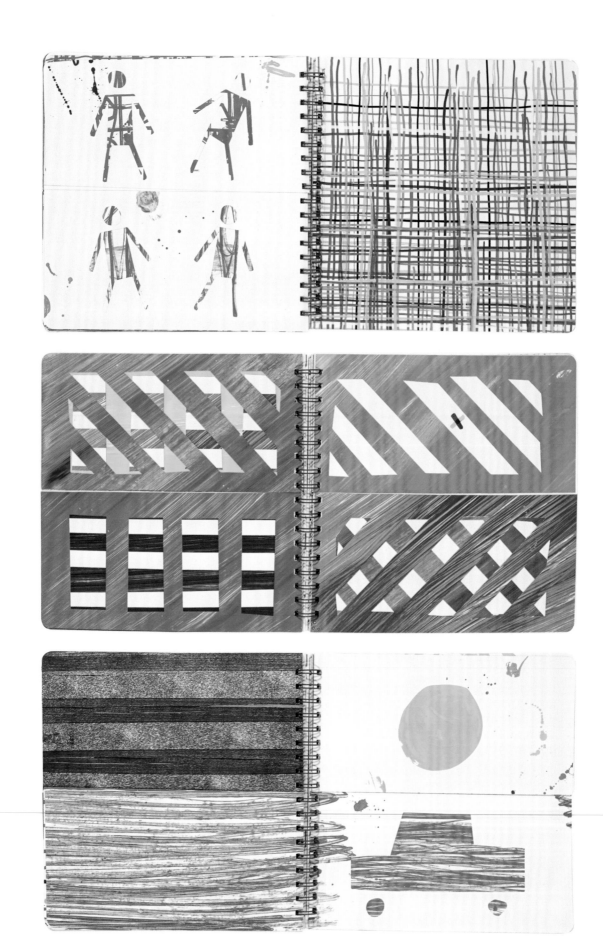

Press Here

Bayard Jeunesse, 2010 /
Chronicle Books, 2011

PRESS

HERE

Hervé Tullet

It had taken Hervé fewer than twenty years, progressing without failure, to arrive at the maximum purity of the idea, at its very essence. The narrative interactive principle was perfectly in place, and he touched the nerve center of childhood: the absolute belief in a magical world. As touchscreen tablets began to appear, Hervé leaned on the reflexes that young readers had learned from using multimedia devices, asking them to interact with a dot in the book, which produces an immediate effect once the page is turned. The book anticipates the reader's reaction by determining it. In so doing, it can give the illusion that it's obeying the reader's commands and draw out of them a series of actions and gestures never before seen in the world of books.

The inspiration for the book was so powerful that it no longer needed to use Blop, so I could move from Blop to a dot. Which is even more obvious and radical.
A graphic obviousness,
The purest form of drawing for an idea.
And so I searched.
I made my first attempts at dots on a musical score: Things were in motion!
Very few notes—and therefore dots—were needed for it to work.
I made a notebook, in one go, but it lacked the multiplication of dots.

I had long reproached myself for not taking pleasure in making my books.
I was always trying to escape drawing,
But with Press Here, I had fun, even if I drew it in two days.
There was, even so, an aesthetic, or maybe a fostering, and even a design.
I used hollowed-out rulers to make the dots, but I also wanted to escape perfection.

I made my first drawings on a matte paper, with Posca markers:
It was flat, cold, smooth, and it looked too much like a digital image.
I then did a trial on Chromolux paper: the Posca dried in a certain way,
I placed a finger on top of the dot: It left a print, a vibration.
That was it, I had it! I carried on, I didn't make ten drawings in one go:
I made one, bam, another, bam, another . . .
And this aligned with the format of one of the notebooks: Fifteen dots
fit on one spread. All this fell out naturally and reassured me about my
relationship with chance and destiny: There was a mathematical clarity,
a power which you cannot escape, like a fraction.
The drawing became less important,
And the book was practically done.
The first dot was a yellow dot, like a sun.

There have been plenty of books that I honestly thought were the best
in the world.
Here, I cherished the hope of having arrived at a perfection of the idea.
But I had no inkling of the consequences.
I had in mind to make the Little Blue and Little Yellow *of the twenty-first*
century, but not at all to match its success.
In fact, one can't imagine making a bestseller.

WELL DONE! AND NOW THE ONE ON THE RIGHT...
GENTLY.

FABULOUS! FIVE QUICK TAPS ON THE YELLOW...

AND FIVE TAPS ON THE RED...

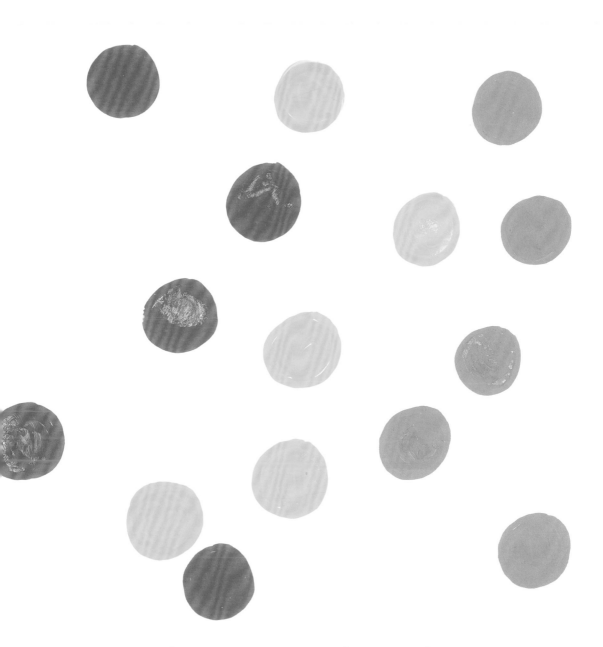

NOT BAD. BUT MAYBE A LITTLE BIT HARDER.

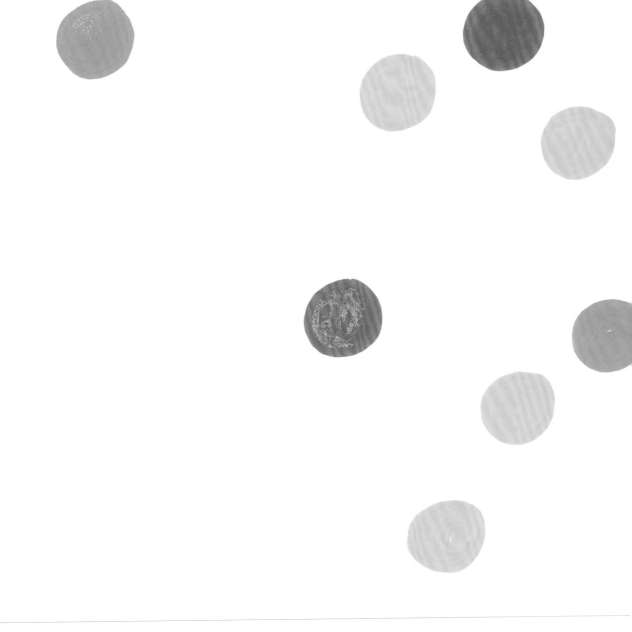

THERE. WELL DONE.
NOW TILT THE PAGE TO THE LEFT...
JUST TO SEE WHAT HAPPENS.

MIX iT UP!

Hervé Tullet

Mix It Up!

Bayard Jeunesse, 2014 /
Chronicle Books, 2014

With the same format, the same motif of a dot in its first few pages, and the same way of directly addressing the reader, this volume could be considered a sequel to *Press Here*. It is not at all that, however, since it addresses a completely different idea that lends the principle new life. This idea is that the book offers a particular magic that affects the mixing of colors. The reader will literally dip into the colors and stroke them to create mixtures and learn their effects. The traces left by their finger, by the pages sticking together, by splatters, by stains—all are perceptible and elicit the exciting feeling of reality, thanks to the photoengraving work that makes the material tangible.

Between Press Here *and* Mix It Up! *there was* Sans titre *(Help! We Need a Title!) the final book in which I drew the art, although I did it with my left hand, so the drawings were not really drawn.*
Then I arrived at Mix It Up! *with great difficulty because I wasn't sure of having completely understood what I'd done with* Press Here, *understood what magic I had put into a book even as I tried to escape it.*
Also, an idea was burrowing into my brain. When I had met Christopher Franceschelli, the American editor of Press Here, *he had said to me, "After this, you should do a book about color."*
I was really bothered by his wanting to give me ideas. For a long time, I sat with this idea in my mind, like an intruder;
I wanted to figure out for myself where I would go next.
At the same time, I searched long and hard, and found things that brought me back to drawing, which I didn't want.
I felt that I was working hard, putting in time.
I couldn't come up with a second magic book.

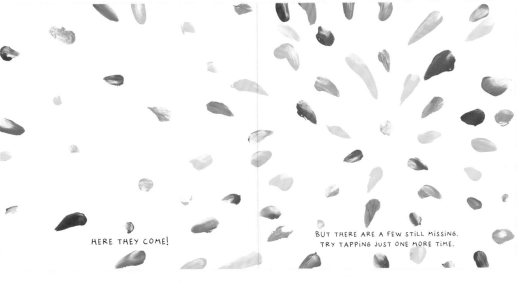

HERE THEY COME!

BUT THERE ARE A FEW STILL MISSING.
TRY TAPPING JUST ONE MORE TIME.

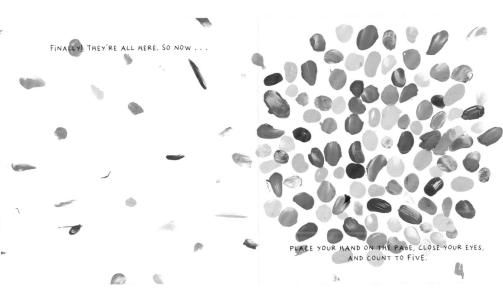

FINALLY! THEY'RE ALL HERE. SO NOW . . .

PLACE YOUR HAND ON THE PAGE, CLOSE YOUR EYES,
AND COUNT TO FIVE.

YES! YOU'VE GOT THE MAGIC TOUCH!

LET'S MIX IT UP!

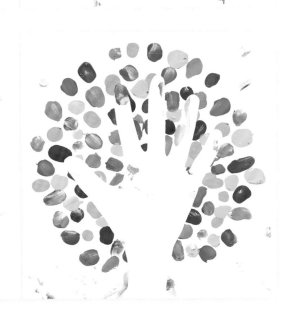

I understood later that Press Here *is not a magic book, but a participatory book.*
And that my previous books were that, too, but it took me a while to arrive at this realization,
To understand that Press Here *wasn't a completion, but rather the first step along this path.*
With Mix It Up! *I got stuck on the question: how to create movement and magic by turning the pages and having a magical revelation.*
At some point I had a revelation: The imprint of my finger leaves something like a dot, a spot, on a color.
Today, when I see the reactions of children after they pull their hand away from the page—they always scrutinize it with astonishment—my intuition is confirmed: I didn't know it would work out this way.

Creating a book entirely by hand, without any tools, using only dots that are fingerprints and lines that are the drips from splotches, is really more radical than Press Here.
The power of this book, to me, is that people know about mixing colors: The gesture is a little surprise. You might have outgrown the stage of discovery, but when you add in the gesture, when the color comes alive, you can rediscover the surprise and it works for everybody.
I emphasize a lot that I made this book by hand,
But I had to present a decent book to the reader: so I lingered on the sides, I added fingerprints here and there to signify the gesture, which is in fact on the title page: It echoes the framework of Press Here *but this time, it's made with fingerprints.*

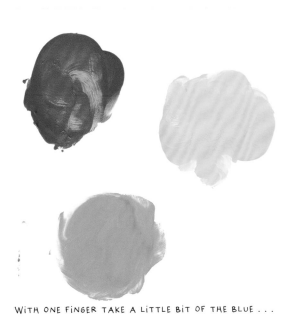

WITH ONE FINGER TAKE A LITTLE BIT OF THE BLUE . . .

AND JUST TOUCH THE YELLOW. RUB IT . . . GENTLY . . .

SEE?

CLOSE THE BOOK AND PUSH DOWN REALLY HARD . . .

SO THE COLORS SQUISH TOGETHER. . . .

YOU THOUGHT SO?

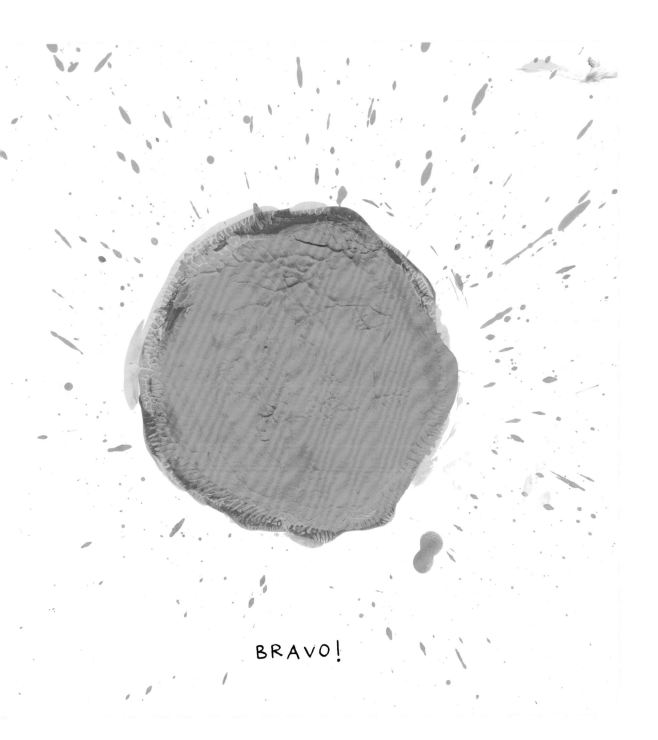

BRAVO!

FROM THE CREATOR OF THE BESTSELLING
PRESS HERE

I Have an Idea!

Hervé Tullet

I Have an Idea!

Bayard Jeunesse, 2018 /
Chronicle Books, 2019

With its vertical format and its cloth cover, this volume of Hervé's is perhaps the one that gets closest to the conventional image of a book, as if the form were meant to cede all airtime to the content. The book opens with three small splotches in primary colors, a little splattered, a little smudged by fingerprints—a discreet homage to *Press Here*. Throughout the book the colors remain pure, never mixed, because this work is a manifesto about ideas, an expressive description of their emergence, the way they appear, and how to cultivate them. It is the quintessence of Hervé's creative work and, for many readers today, the quintessence of creation itself.

I had searched a lot, I had rolled out many articulations,
I was writing my story in a loop: the story of searching, finding, getting bored, looking everywhere. . . .
I had filled numerous notebooks without having the revelation,
Impossible to nail down these words.
I didn't know where those notebooks were, actually.
It took a lot of time, years in fact.
When I went to New York with one of the notebooks, I put it in a box and forgot all about it.
One day, tidying up my studio, I pulled that notebook out of its box,
And I thought it was good,
So I used it as a starting point: I drew it out.
After that, I worked with Isabelle and even with Sandrine to make many adjustments,
Since paradoxically, this wasn't a book with an idea.
The idea was so obvious you couldn't say anything about it,
But here we had a text about the idea, which asked: "What is an idea?"

I

ALWAYS

Love

THAT MOMENT

WHEN . . .

SUDDENLY

you FEEL

I experienced it as if it were my last book, the capstone of all the others,
The most important book,
The one that explained everything.
Practically a message: "I'm going to tell you what I'm working on."
A little bit of a testament,
It's one of my favorite books.
When a young person asks me what they should read, I respond,
Letters to a Young Poet by Rainer Maria Rilke.
I Have an Idea! is my Letters to a Young Poet.

The text resembles those outsider writings,
When I read it, it's poetry.
In public, I don't read it with my performance voice; I use my own voice,
There is always an emotion at play.
I don't know it by heart,
I have the impression of speaking,
Whereas with my other books, I'm performing.

At the time when I was working on it, I thought it was my last book;
I had the word "ultimate" in mind.
I actually believed it, and I said it often—to the great dismay of my editors.
It wasn't a ruse, more a way to stimulate myself, to make myself
uncomfortable, but I really believed it.
In fact, you should always be making your last book: in order
to give it your all.

OH!..

I
Have
an
idea!

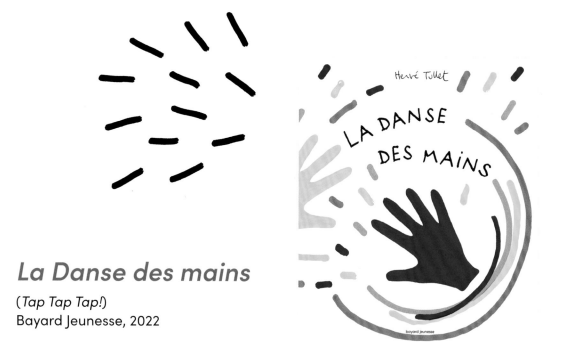

Hervé Tullet

La Danse des mains

(*Tap Tap Tap!*)
Bayard Jeunesse, 2022

In 2017, with *Say Zoop!*, Hervé called forth his reader's voice. Touching a blue circle set off the sound "oh," a red circle led to "ah," and both the instructions and the images that followed invited sonic creations. Five years later, *La Danse des mains* marks a new stage in the dynamic of books that engage the reader's body. As in *Mix It Up!* (2014), placing a hand on the book kicks off the action, which is then guided from page to page with verbal instructions and sculptural figures. At the heart of the book, the reader is asked to detach their hand from the page and move it about in the air, above the physical book. The text takes the form of succinct, poetic directions, and the images take the form of abstraction in which colors and movements are set free. Thus these two books call on all their reader's capacities: the voice and the gesture.

In Say Zoop!, I established the connection with voice, like a musical score. In La Danse des mains, it's the connection to the space around the book, which is explored through gesture. It's as if I were continuing to realize the potential of Press Here, which already had a tangible connection to the act of turning the page. Each book can be understood like a new gestural score. In each, the reader is physically engaged.

With La Danse des mains, the idea is really to get outside of the book. That's why its printed in large dimensions. Vis-à-vis painting and gesture, it was necessary to move to another scale of book. Here, the two hands that usually hold the book have abandoned their posts; the reader is forced to set down the book, get up, and move.

In a way, this book is an invitation to watch your hand painting, either in the air or in the extension of the book, later, with paintbrushes. The sculptural score invites writing through gesture, a choreography. I myself created the

second half of the book to the music of James Brown, in a dynamic similar to that of my *Field of Flowers* workshop. In the sequence of pages, I had to push to the limit, a gesture that perhaps evokes big lyrical abstraction, à la Robert Motherwell.

From here on, I understand my work on paper, in books, to be like that of a sculptor. Object, superimposition of pages, of papers, space around the book, and experience: I am indeed focusing on the three-dimensionality of the book.

Images from *Say Zoop!*, 2017.

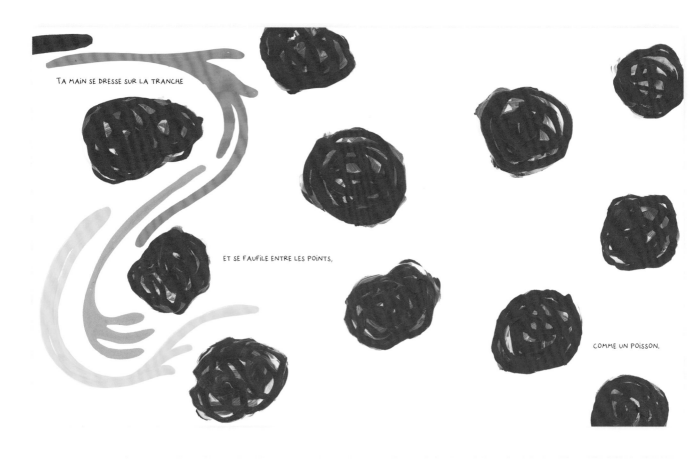

TA MAIN SE DRESSE SUR LA TRANCHE

ET SE FAUFILE ENTRE LES POINTS,

COMME UN POISSON.

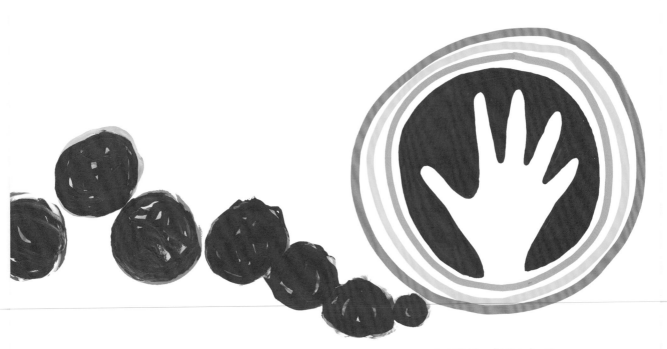

IL ROULE, IL ROULE...

ET ARRIVE JUSQU'ICI POUR S'OUVRIR.
OUF! TA MAIN PEUT SE REPOSER.

Above and following pages: Images from *La Danse des mains*, 2022.

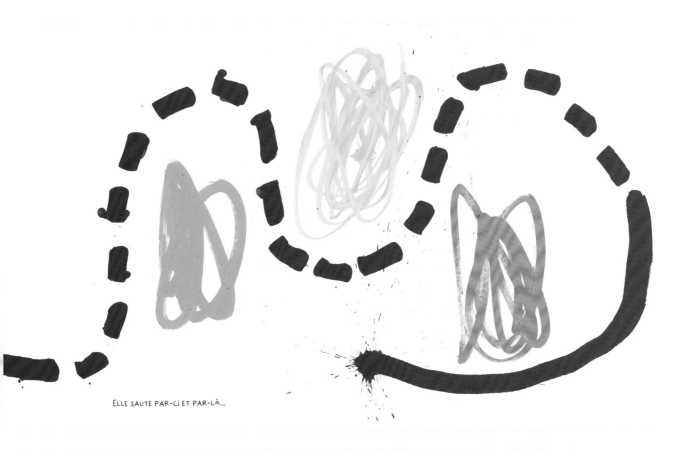

ELLE SAUTE PAR-CI ET PAR-LÀ...

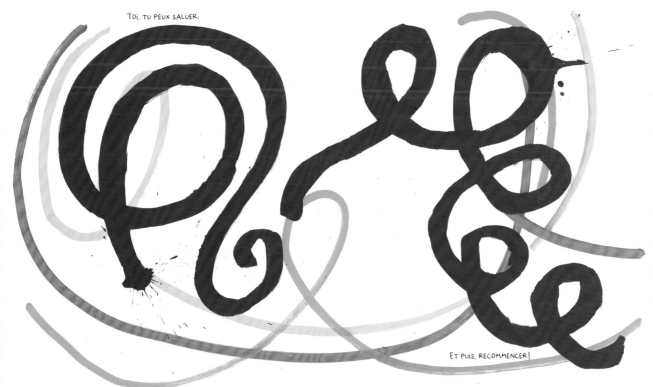

TOI, TU PEUX SALUER.

ET PUIS, RECOMMENCER!

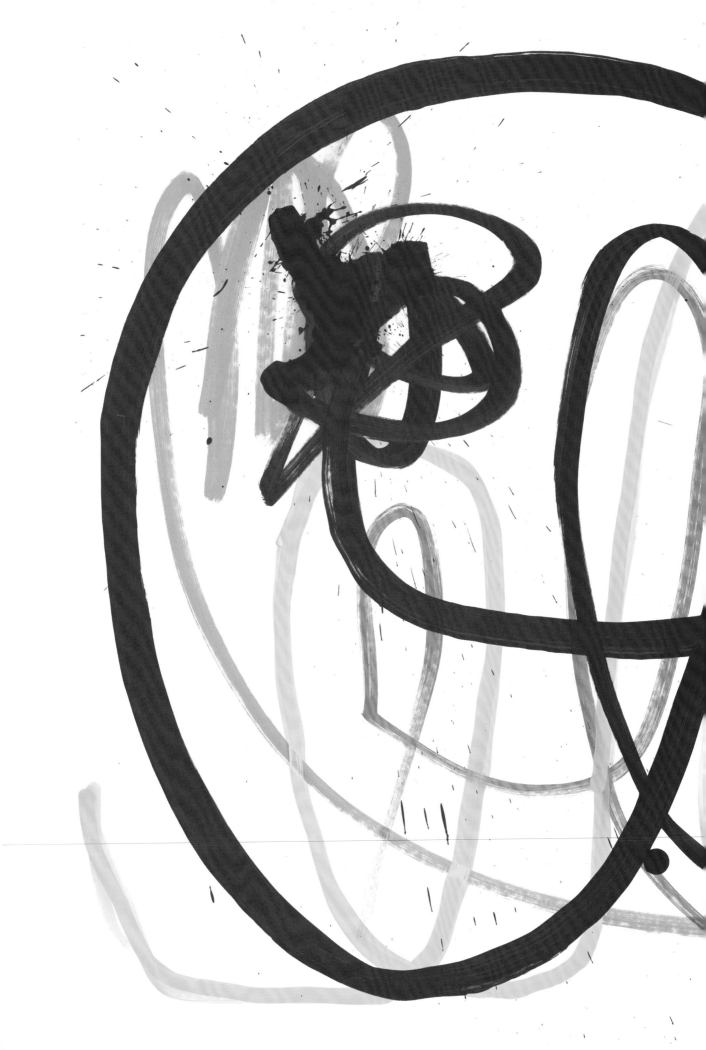

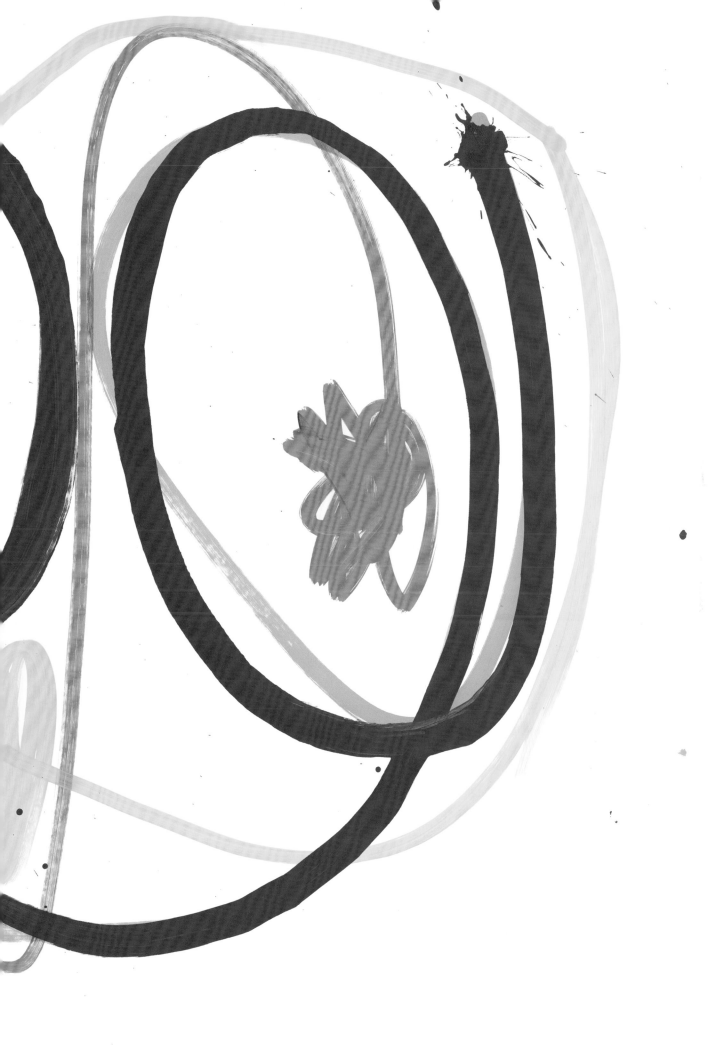

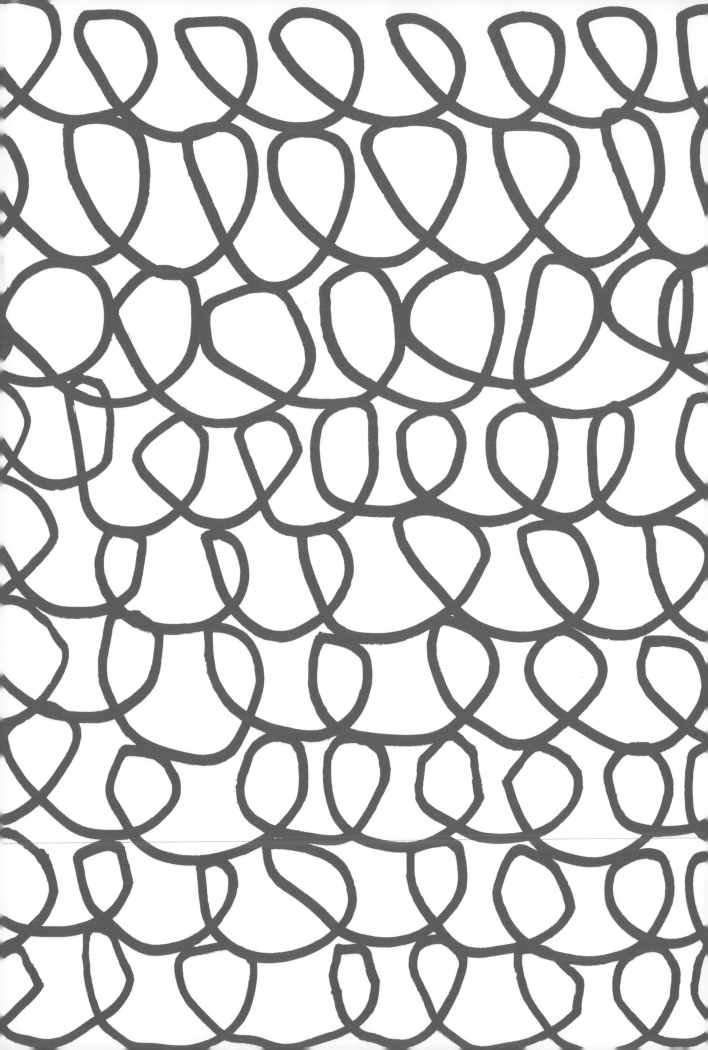

Principles

The work is the gesture

The value of the gesture is more powerful
than the result,
You can keep a drawing,
The gesture is a moment
That's what I'm trying to say in my drawings
They sum up what has happened and
therefore have the value of a memory
The aesthetic is offered up
to be appreciated by each
Since it has no standard value
No typical workshop or model
If you follow the instructions to the letter,
you create the same thing
But the gesture has created movement,
Coincidences, groups of children,
A baby who's sat down; none of which
was foreseen

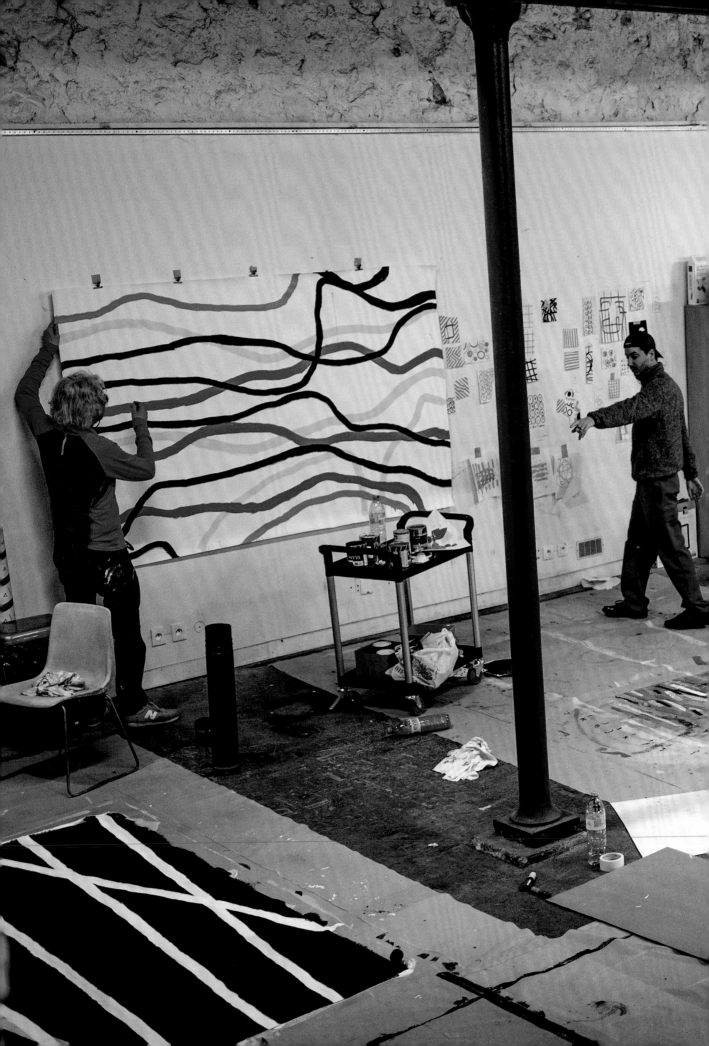

studios

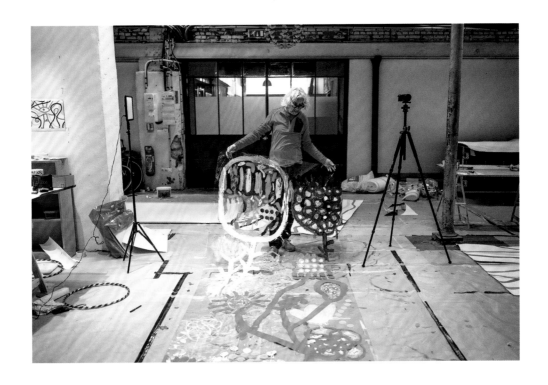

In both his practice and his theory of the studio, Hervé pays little attention to the imagery of the artist at the heart of "his space," bathed in beautiful light, surrounded by elegantly stained walls and shelves filled with pots or tubes of photogenic colors. Because when research and work favorably follow the path of the idea, the studio is incarnated in all sorts of places, from the breakfast table to the tray table of a long-haul flight. But in the life of the creator there are also personal studios filled with his choice of materials, or ephemeral studios imagined as some kind of hive.

The studio is first of all my mind and my black notebooks, no matter what the project is.

I have no regular studio practice, no creative protocol; nothing is fixed. I'm more attached to a sort of permanent minor chaos, always at hand, so that I don't feel trapped in a studio by its size, its availability, by the use of materials or an invasive practice. I like to be light; I don't like to be dependent. For me, therefore, the studio is more ephemeral, but what isn't ephemeral is the book. That reassures me.

Most of my exhibitions are put on without me, or with me but I show up with my hands in my pockets, so to speak, to join a collective with whom I'll construct something. The location of the exhibition is already full of materials and I go to give instructions.

Nevertheless, I produce a lot. After I spent almost five years in New York, the number of pieces that I had to bring back to France astonished me. "At the end of the day, you really like working," my son Léo said to me. Let's say, rather, that I like to get work off my plate.

As far as materials go, I'm very pragmatic. But every so often I can still look to acquire quality paper or colors. Notably when I'm creating for my own pleasure. For my latest personal drawings I bought beautiful paint, the best, Golden, and I used it to create a series with chromatic harmonies, especially between yellows and blacks, with a real sense of searching and a real pleasure.

All that being said, I sometimes do work in a dedicated space. In which case, I have to compromise, even at home. When I arrived in New York I

had to create pieces that were sometimes five meters long in a tiny room, without a sink. Because of the lack of space I had to plan my absences so as to let the paper dry at the right times before being able to fold it away and continue.

But today at last, in the Paris suburbs, in Ivry, I have a real studio: very large, useful, with everything one could need. . . . It arose out of necessity for an exhibition at the Albright-Knox Art Gallery in Buffalo. This came about a bit by chance; thanks to their request, I found myself in a real, practical studio, almost normal. And it's been a real experience for me. The ambition was to be within a collaborative creative experience, to re-create a sort of workshop. Like a location of total creation, a place where I invited various people to stop by, run into each other, and create. A bit like Warhol's factory. Holding on to people's creations, working together, with a margin of surprise, improvisation, discovery: That is, at the end of the day, what I most want to work toward right now.

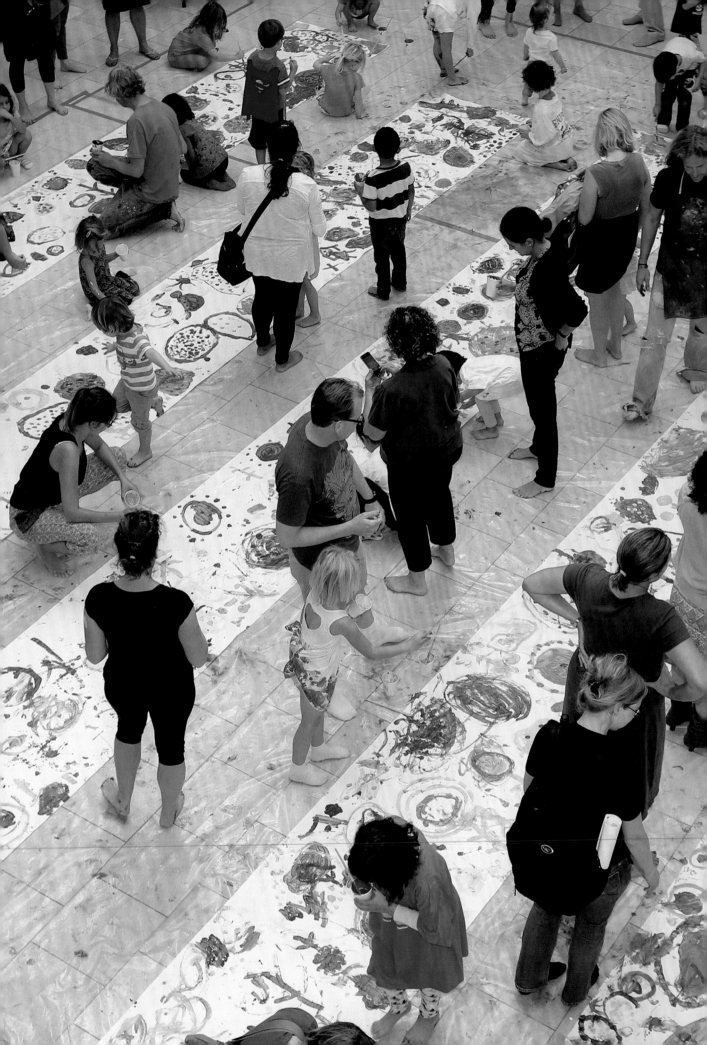

Space

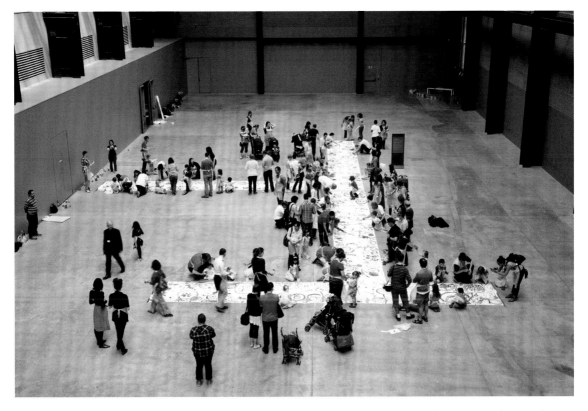

Workshop à la Modern Tate, Londres, Angleterre.

A vast space, well laid out, with every material necessary: good paper, music, people, babies, children, and adults who move without bothering each other, wander amongst papers spread out on the floor, and make plenty of drawings—this is the ideal situation for a workshop. For Hervé, the space is the main thing that permits the setting in motion, and therefore the instability or discomfort, necessary to liberate creative energies.

At the beginning of workshops people are really settled, particularly because they're waiting for things to get going. They tend to stay in front of their personal square yard of floor. So it's not easy to get them moving; it's about making them take up space. Even with what they're going to produce. For example, when I ask them to make a dot, then a bigger dot, I then have to insist, "a MUCH bigger dot" before they dare take over the sheet of paper. . . . The space of the dot is a double space: its own size, and the area it has to conquer. It is then necessary that each person agree not to stay in front of "their" dot, agree to let go of "their" drawing, and subscribe to the collective dimension of the workshop.

Only the babies have the right to stay put and mess around. They become green, red, yellow, everyone is happy, the baby becomes a spot of color, a big splotch. They are the ones who make the most beautiful corollas. And at the end, I allow myself the treat of drawing the stem that creates a flower.

But one must also adapt to a space, without giving up the ambition of getting people moving, of catalyzing a dynamic of creativity. Sometimes people simply can't move. That's the case at the hospital. So the children stay lying down and draw on the room's little tray tables. Sometimes there are too many people in a really small room. At yet other times, all we have available are pencils and nothing else. But no matter what, we make do with what we have, so that something happens.

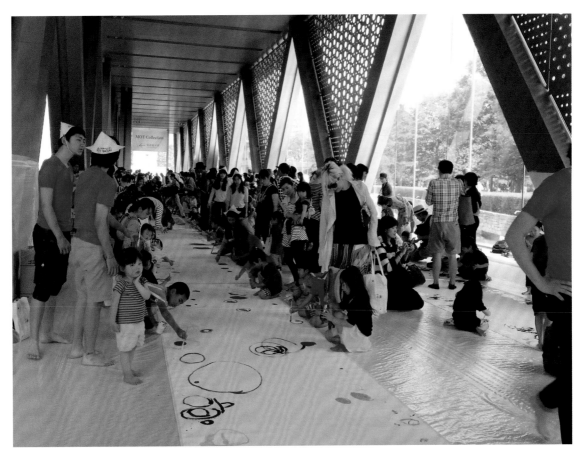

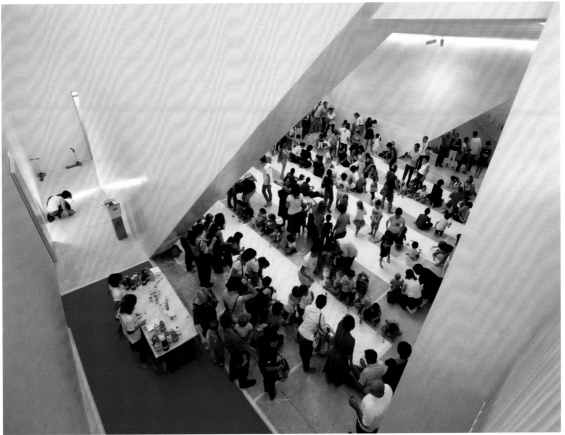

Above: Workshop in Tokyo, Japan. Below: Workshop at the Palazzo Grassi, Italy.

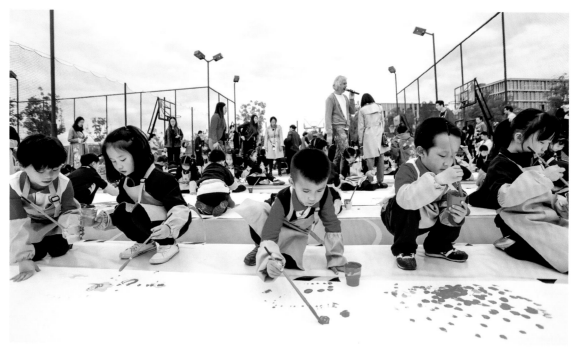

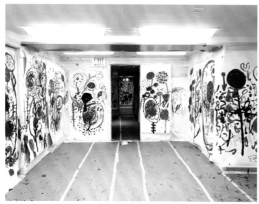

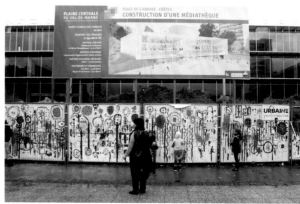

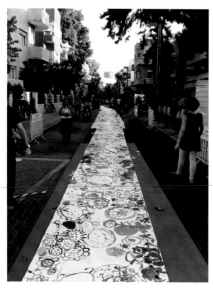

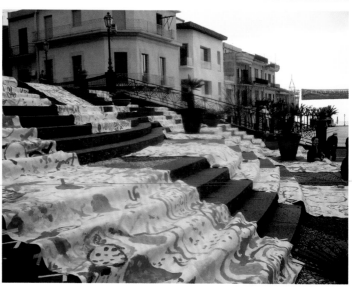

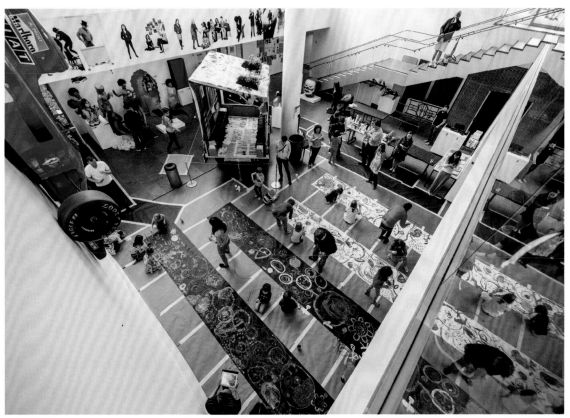

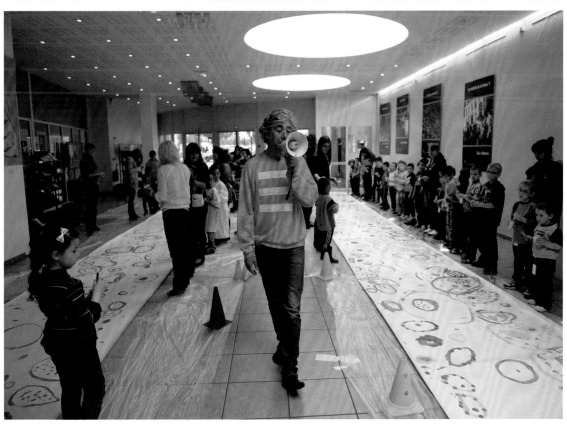

Improvisation

Image from *The Five Senses*, 2003.

Improvisation has something to do with the constant quest to get past oneself. But also with acceptance. When, in certain locations, the situations are complicated, after a moment of dismay you must resolve yourself to live this moment as it presents itself and demonstrate the spirit of play and reactivity. This results in singular experiences, such as being perceived as someone else, suddenly changing roles during an encounter, or even following a mistake to its limit. Or then again, carrying on with your presentation in front of a timid and perplexed audience. The reason: The author walked into the wrong room, and these students don't know him at all.

One day, on the radio, I heard the jazz musician Martial Solal give the following definition of improvisation, which I have since adopted: "With improvisation, you always have the impression that you're going to fall, but you never do." I've had many occasions to verify this, but one of them was more decisive than others. I was giving a lecture in front of a room full of people. At one moment: a total blank. I no longer knew what to say. I stayed mute for several long minutes. It was a terrifying silence; I felt horribly ill at ease. And then I found my voice again, and the thread of the lecture. At the end, people came up to me to say with a knowing air, "Bravo for the mute trick." People thought it was all planned in order to draw out questions or reactions. That time, I fell. And yet, people not only lifted me back up, but also congratulated me. Today I can no longer fall.

Another musical anecdote that interests me is the one about the 1964 Miles Davis and Herbie Hancock concert. Hancock played the wrong note, a really dissonant one. But Davis bounced off that note, as if it weren't a mistake, and drew it out, played with it, brought the whole group along with him. He reacted in the instant, in a fraction of a second. That reaction time is a magical time in music, and I often attempt to get back to it through drawing. For Miles Davis there were no false notes, only opportunities.

In the Ideal Exhibition, by suggesting gestures rather than models, we prepare for a margin of interpretation or error vis-à-vis what I propose. The interpretation renders the product beautiful. In Sri Lanka, for example, there were magnificent collections of colored paper hung up, which I had never thought of. It came out of nowhere and yet it was immediately

absorbed into the process. And for me, there's the possibility of reusing this contribution as a jumping-off point.

What a joy to see, by chance, a stain land on a drawing; I wouldn't dream of touching it, but rather leave it as it is, in the truth of the instant. Compromising with that stain is a pleasure, using a vivid, impatient gesture, to the point of grabbing the wrong brush or the wrong color. What a joy, too, to draw with my eyes closed, preventing myself from seeing what I'm doing. But in general, I don't really look, I work to the rhythm of Miles's music. I'll have time later, when it's dry, to discover, look, select, or, if necessary, start all over again.

To be unaware is more powerful than to be aware.

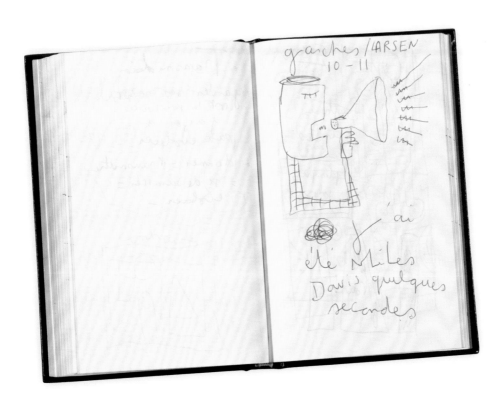

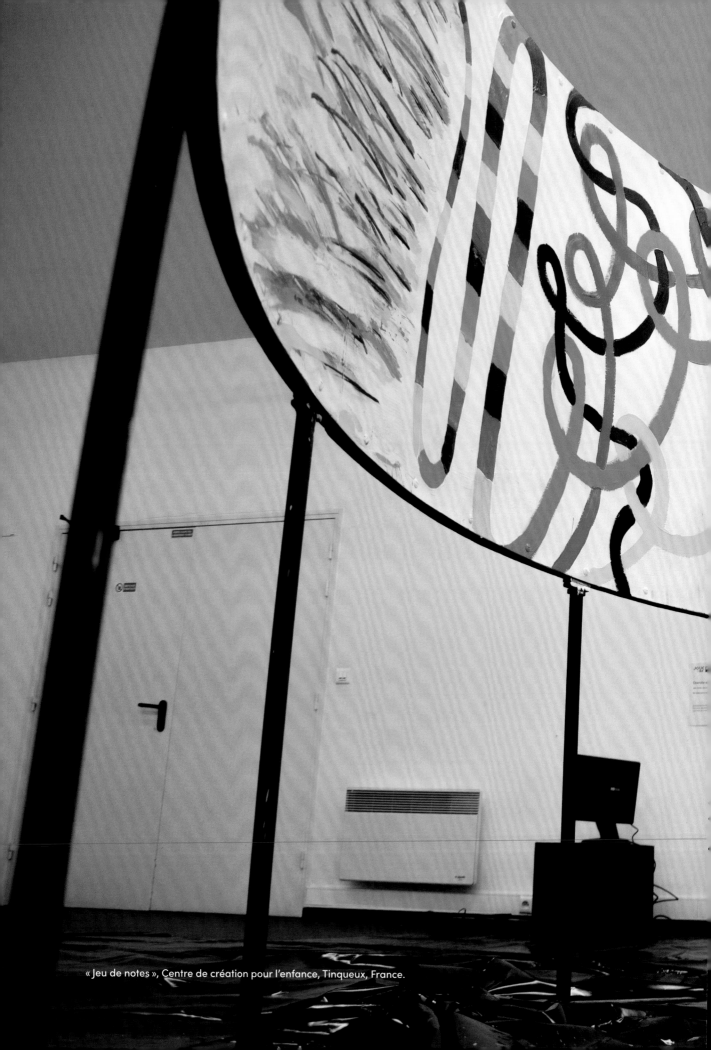

« Jeu de notes », Centre de création pour l'enfance, Tinqueux, France.

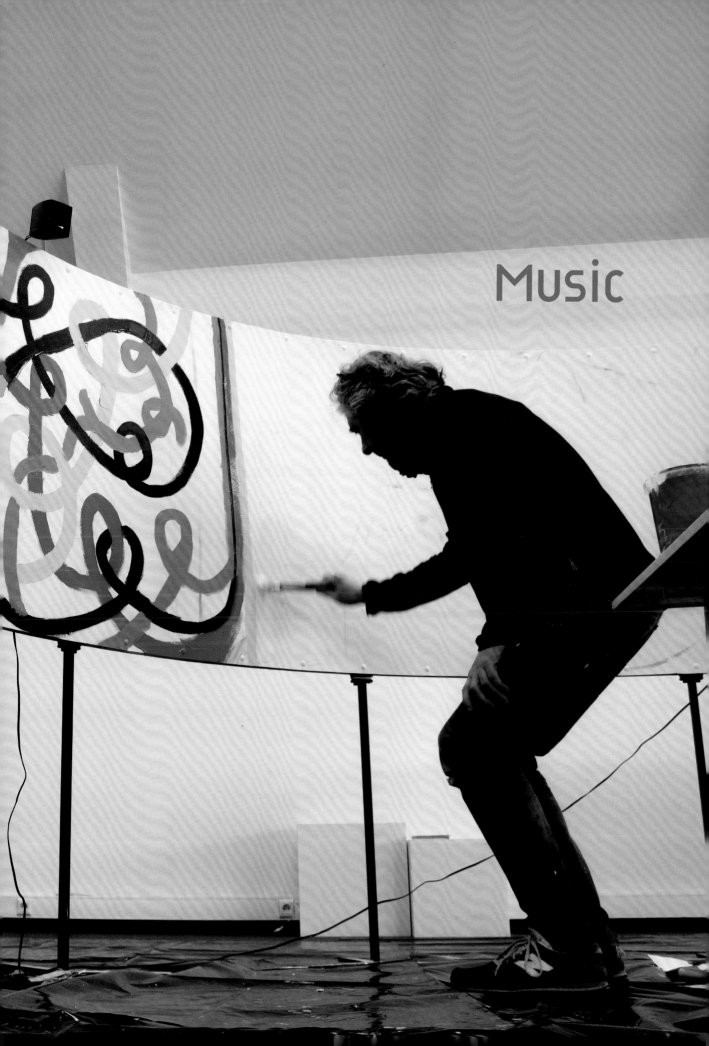

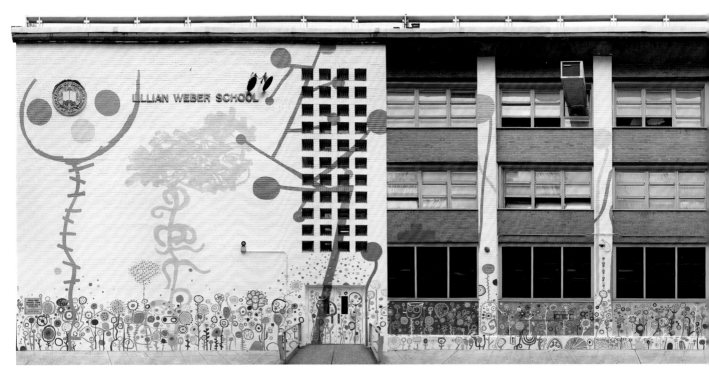

In a workshop there's space and there's the instant, to which the music contributes a lot. In one very particular phase of the goings-on, at a tipping point, the end of the first part is announced and the music begins, at very high volume. Paradoxically, at this moment, just as the participants have been united in a collective reaction to the same instructions, they return to their individual selves and each invests themselves personally.

In workshops the music is loud, lively, rhythmic; it pulls you along. It's not at all childish; it's not there to reassure. Playing the Beastie Boys is very well thought-out; and I always play the same music. I find myself as a sort of conductor, or a composer, and the music sublimates the experience. It's really at the heart of the process. Paradoxically, you forget, and the feelings come to the fore, you're touched, it colors the ambience and gives emotion. And when the music doesn't work, it's horrible; nothing has any meaning anymore.

I also put on background music when I work, not necessarily to give rhythm, but to escape into another world. I'm inside a movement, inside a choreography, a sort of forgetting; I go to pick up a drawing, set it down again, make another one, become obsessed by a gesture. It lasts an hour, an hour and a half, and then I stop when I get sick of it.

In every case, music is a form of transmediation, a sonic space, three-dimensional and energetic; a rhythm.

The way I listen to music reflects a real journey, which makes sense of my own history with music. I began as a child with what existed around me, Claude François or Johnny Hallyday, and then I made my way from there.

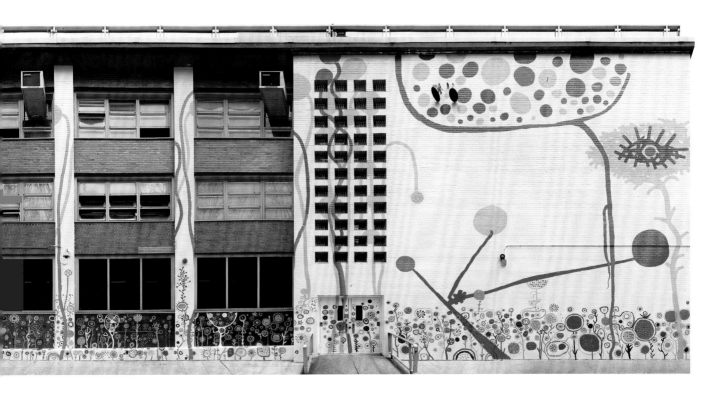

I discovered rock, the Rolling Stones, Deep Purple, Led Zeppelin. . . . On the other hand, I didn't understand the rock of the 1980s. One day, all my CDs were stolen. Instead of trying to buy the same ones again, I attempted to build myself a music library, particularly of classical music: Debussy, Brahms, Bach . . . then Baroque, Purcell, and soon I was listening to Klaus Nomi. I made my own connections, by moving from Handel to Mozart. I then avoided all the big nineteenth-century symphonies and operas and went straight to French music of the twentieth century. And finally contemporary music: Igor Stravinsky, Benjamin Britten, György Ligeti, then Luciano Berio, Morton Feldman. And, at last, Miles Davis, as a kind of synthesis.

Through Miles Davis I could listen to everything again, every genre; he is really irreplaceable, because he himself incarnates a path. One day, in New York, at a workshop in which we were creating a large mural, one of the participants was a musician who had known Davis. Pointing to the mural, I asked him, "Is this what music is?" "Yes, that's exactly what music is," he replied with a big smile.

I play piano very badly, but I play. I taught myself. The notes shift, a surprise jumps out. It nourishes me. During readings, my books have become like a score for my voice, which becomes more music than words. The sounds associate themselves with images, they're in the book no matter in what language.

Permanent mural at PS 84, a public school on the Upper West Side, New York, 2018.

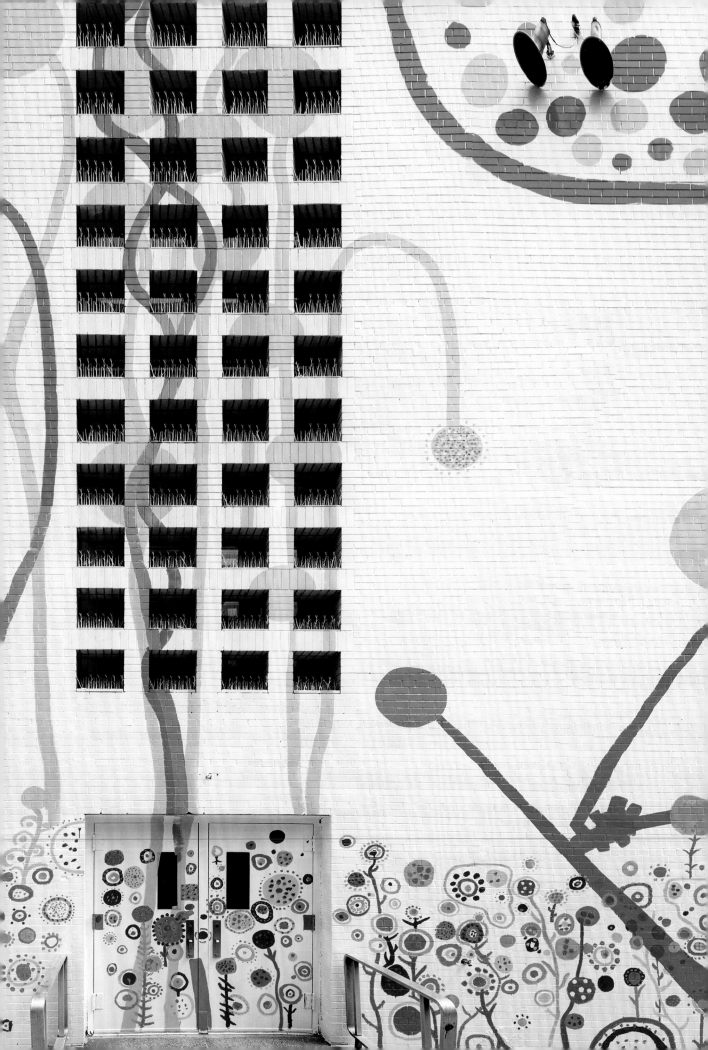

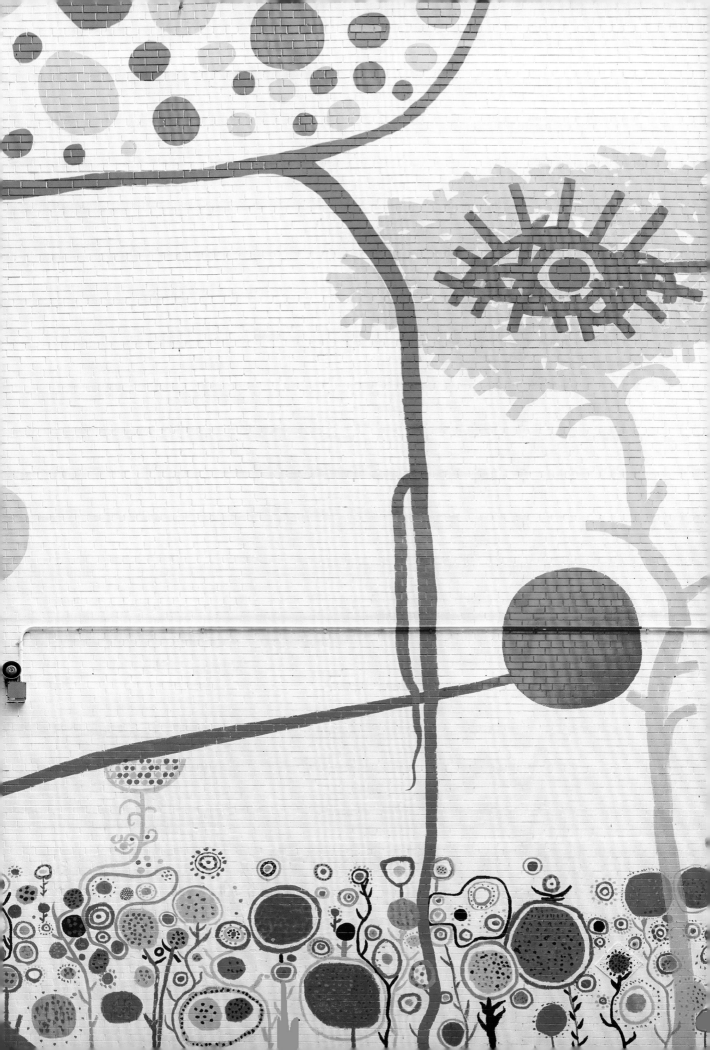

The Playlist

During Hervé's workshops the musical accompaniment is of great importance. It gives rhythm, meaning, and impulsion to each sequence. He established a playlist several years ago. Although not every track is played every time, they're always played in the same order.

1. "Groove Holmes," Beastie Boys
2. "Sabrosa," Beastie Boys
3. "Sina (Soumbouya)," Salif Keita
4. "Now That I Know," Devendra Banhart
5. "Love & Communication," Cat Power
6. "Water No Get Enemy," Fela Kuti
7. "Water No Get Enemy," Intro, D'Angelo, Femi Kuti, Macy Gray, and the Soultronics (featuring Nile Rodgers and Roy Hargrove)
8. "Dreaming," Jon Hassel
9. "Mã," Tom Zé
10. "Rated X," Miles Davis

Each track was chosen specifically; this playlist was developed with precision. It has accompanied all my workshops since I made it, except if there are musicians present, of course. In general, I rely on this list, I don't go beyond it, and I don't look for something else. In fact, I don't want to take risks. I'm happy to rediscover these tracks every time.

I conceived of this playlist as a progression. We open with something extremely dance-y, with the first two tracks by the Beastie Boys. It's powerful and strong. A groove. We're not at all in the realm of music for children, but rather in a kind of energy. These two tracks are really made for getting things moving.

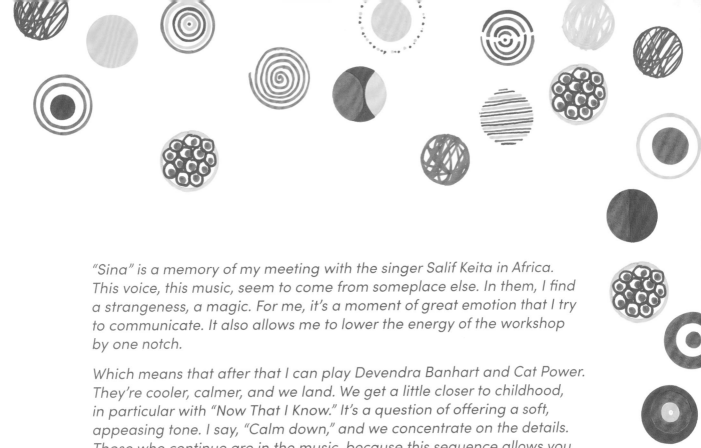

"Sina" is a memory of my meeting with the singer Salif Keita in Africa. This voice, this music, seem to come from someplace else. In them, I find a strangeness, a magic. For me, it's a moment of great emotion that I try to communicate. It also allows me to lower the energy of the workshop by one notch.

Which means that after that I can play Devendra Banhart and Cat Power. They're cooler, calmer, and we land. We get a little closer to childhood, in particular with "Now That I Know." It's a question of offering a soft, appeasing tone. I say, "Calm down," and we concentrate on the details. Those who continue are in the music, because this sequence allows you to be on a wavelength with the music. Exactly like me when I'm working in my studio.

"Water Not Get Enemy" is really the emblem of my workshops. It's a melopoeia, vibrant and joyful. Which carries on for a while because we go straight into the second version. It spins, it's dance-y, it's loud. I like these two interpretations of the same piece, made by different interpreters, the second being an homage album to Fela Kuti . . . who wasn't just anybody!

"Dreaming" is an opening piece that I use when people are settling in, as background music. I can also use it at the end of the workshop. When used at the beginning, it gives an ambience of mystery. At the end, it's an appeasement. It accompanies that little sadness of the afterward, when everything falls apart, everything is undone. Like the feeling after a fireworks show, when everyone's leaving.

"Mã," by Tom Zé, I use for the Drawing Factory workshop. Once, at the Museum of Contemporary Art of Los Angeles, we did the inaugural workshop of the exhibition. People were outside, and I was hesitant to ask them to come into the museum. With this piece of music a sort of procession formed, and people headed indoors, joyfully, tranquilly, with this collective swaying movement.

I never play "Rated X," but it's MY encounter with Miles Davis. It sums up everything: the blues, Africa. It's a Miles Davis track that situates itself where you don't expect it. It emits an animal energy, discordant, violent. It's the only track on the playlist that I put there just for me.

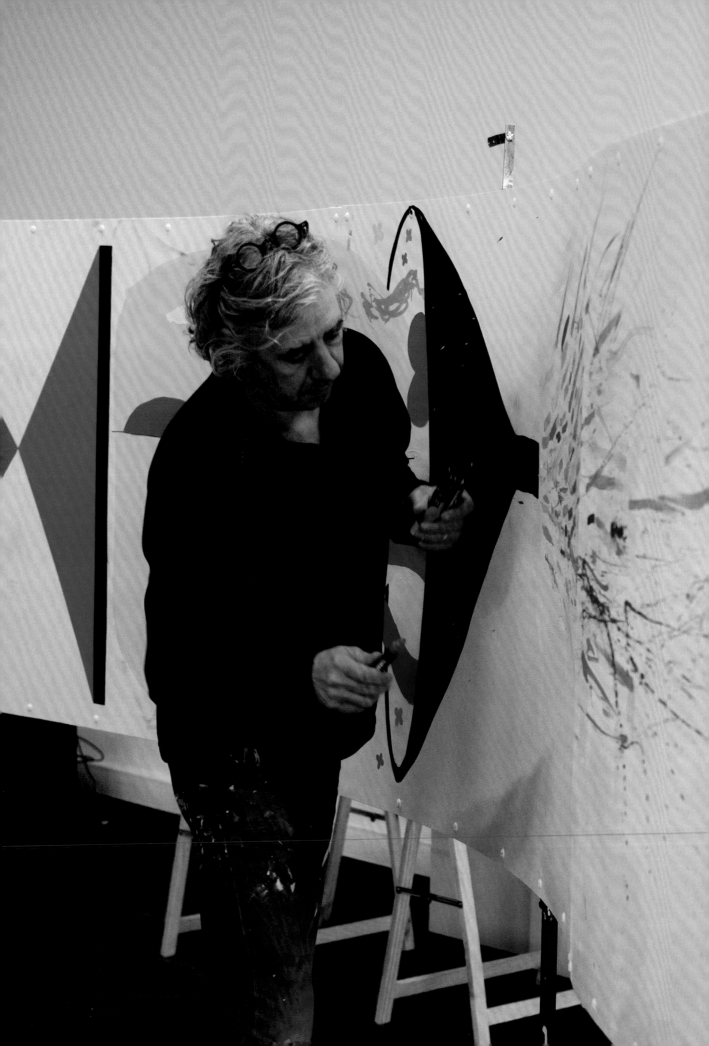

Sound

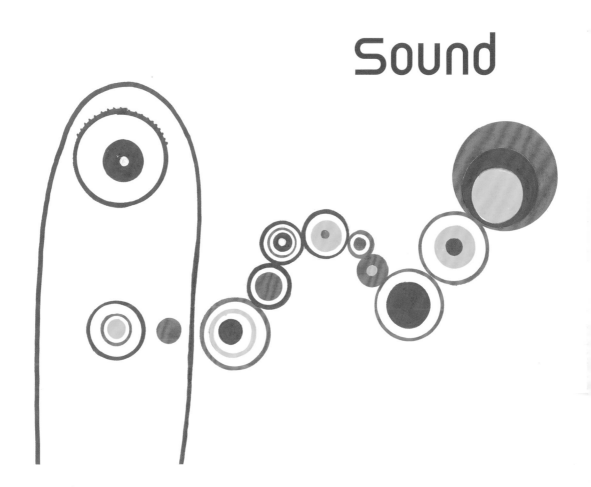

"Jeu de notes," Centre de création pour l'enfance, Tinqueux, France.

Up until *I Am Blop!*, Hervé's books didn't have any real sonic dimension. *Say Zoop!* consecrated this usage by leading the reader through page after page of a sonic creation that was, by necessity, singular and ephemeral. It was the workshops, above all, that had revealed this new dimension to the total object that is the book—in particular the first phase of the workshops, during the participatory reading with the group.

One day I was doing an event at a center, and when I arrived, people held out my first books, saying they adored them. But I didn't like them at all anymore! At the time I considered them the work of a young author, not very well put together. Nevertheless, I took one of them, Petit ou grand? (Little or Big?), with its graded cut pages. I opened it to the first page, the one with the fish. And I said, "hum," and immediately heard an echo of "hum." I continued, "yum," and received a reply of "yum" in unison. That was what gave me the idea of beginning all my events with readings. That day the participants gave me the game of the book.

Over time, those books have become the ones I systematically read aloud in order to initiate the exchange around sound, expressions, and modulations of voice. This produces a really powerful, free, and varied exchange: I can, for example, create kinds of loops with my voice. Something always happens. Without it ever being written down, there is a logic that I've adopted and that flows through each of my books. After a moment I select someone from the audience to come up next to me. It's a way of passing the baton to someone from the group, and therefore to the entire group. The idea is to encourage them to do a reading without reading the text, to express emotions using only onomatopoeias, such as a "grrr" spoken with strength that conveys rage.

These sounds have nothing to do with the native language of the participants. I adapt myself a little based on which country I'm in; I look for onomatopoeias that resemble the tonality of the language. In Japan I could very well repeat "Tokyo Tokyo Tokyo" while modulating my voice, but it wouldn't be anything like Japanese. In fact, I hold myself to avoiding words with meaning.

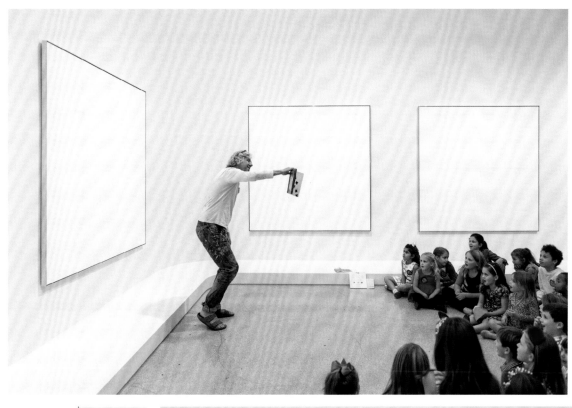

Workshop and reading at the Solomon R. Guggenheim Museum, New York City.

Somehow, I'm completely habituated to thinking that sounds make a dialogue. This becomes a universal language as soon as I've introduced it, and exactly the same thing happens with books. The support offered by the image is so powerful that the text becomes less important. I begin to read with nothing more than gestures, hand positions, like a magician. These readings liberate the participants, who never show any fatigue: It could go on for hours. . . .

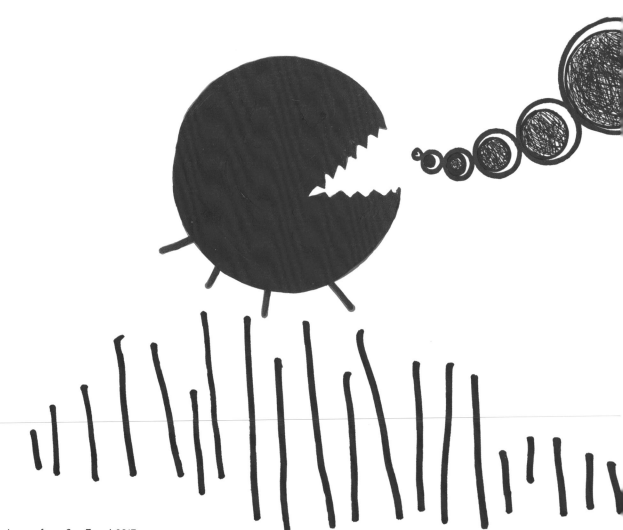

Image from *Say Zoop!*, 2017.

With Say Zoop! *I wholeheartedly adopted this way of engaging with the reader. I wanted the book to exist through sound. So its pages became a sort of musical score for oral expression. And as often happens, the readers took the book on as their own.*

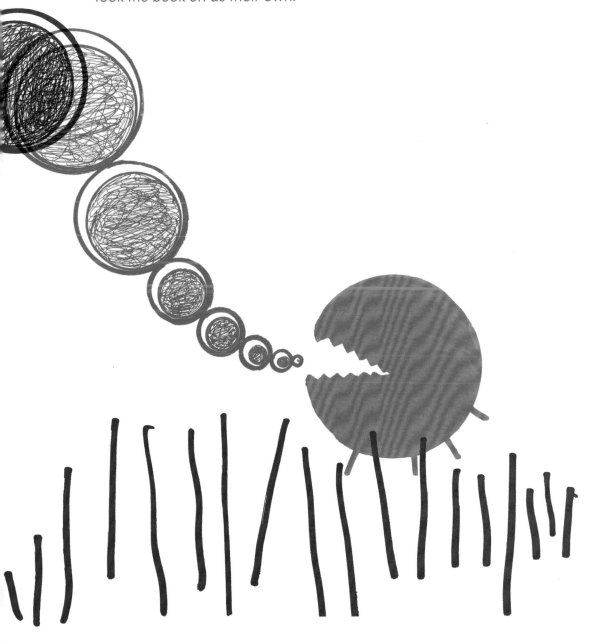

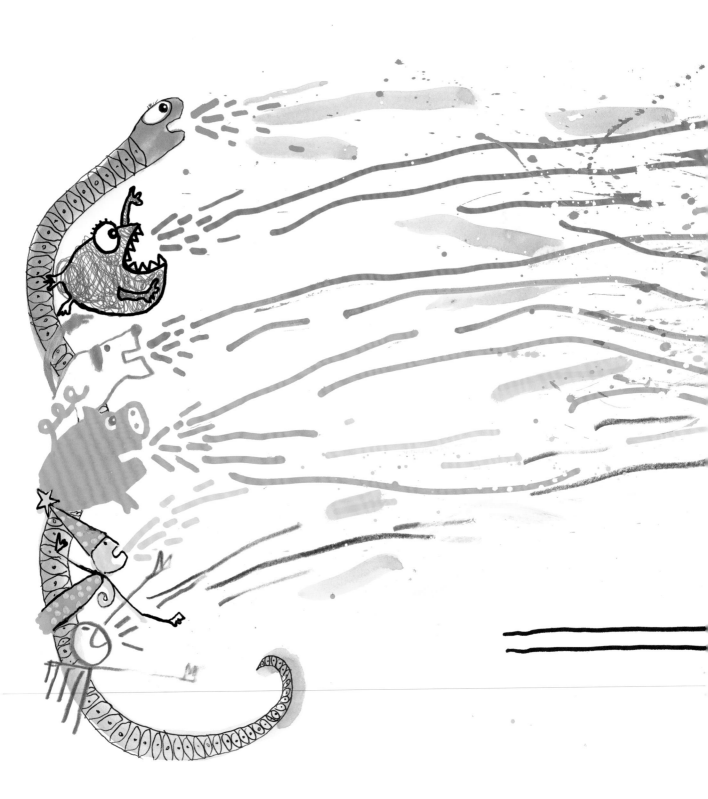

Theater

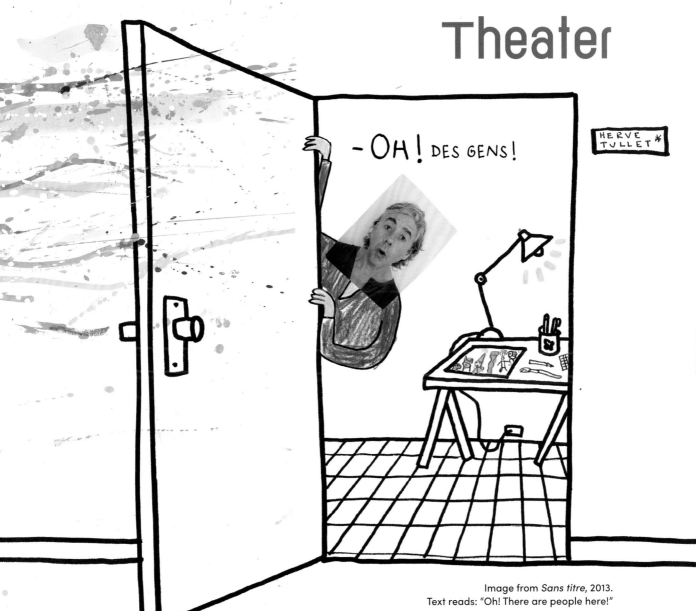

Image from *Sans titre*, 2013.
Text reads: "Oh! There are people here!"

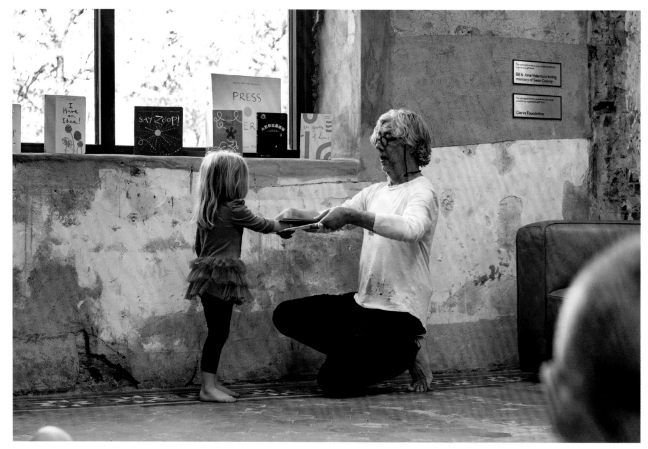

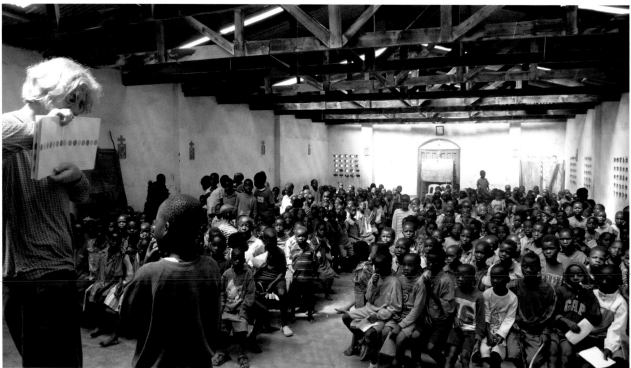

Above: Reading at the Pittsburgh Children's Museum. Below: Reading in Malawi.

In his readings, his workshops, and his videos, Hervé is playing a role. Half authority, half clown, he impresses and amuses his astonished audience. From his very first classroom events, during the 1990s, he had the intention of freeing the book from its materiality, its finiteness, its primary function, and breathing into it new perspectives on reading and creation.

The first time I went to England to present my books, I participated in an event with the author-illustrator Michael Rosen in a big theater. He was facing a thousand kids and was putting on a real show for them. He got people up on stage. Seeing such a young audience really affected me. So after that, during all my events, whether in a theater or a classroom, I got in the habit of calling a young participant up to stand next to me. The actor Philippe Caubère also really impressed me with his show Le roman d'un acteur (The novel of an actor). *He was alone on stage and played all the parts. We, the spectators, could see everything—the characters, the set— even though they were incarnated by a single actor.*

My show, which is a reading, a workshop, or the introductory video for the Ideal Exhibition, corresponds to a theatrical Me. I've become a character. Turlututu was the first incarnation. Sometimes I storm out of the room, offended; I slam the door. The audience is shocked, and then I come back. But they accept it because it's all a game. It passes, just like at the theater.

In a project that I'm currently developing with a certain town's multimedia libraries, the idea is that I will be installed in some location, as an artist mounting an exhibition. As my mood dictates, I'll receive groups, reinvent myself based on the time of day, everything improvised. The public won't come for a reading, they'll enter an exhibition space in which they'll find the artist who welcomes them and, of course, enjoins them to participate.

Nowadays, with social media, I make a lot of videos, and it comes very naturally to me. No sooner am I in front of the camera than I become my character. It's like a switch has been flipped. The first time it happened was during one of my first events in a troubled neighborhood. I had slept badly, it was early, and in the metro on the way there, I was nodding off. Then, as soon as I arrived, the machine of extroversion turned on.

I'm in my own show: I amuse myself, I surprise myself, and that's what facilitates communication. So I embody an adult in a totally unusual situation. Less composed than usual, without a strategy, existing in the moment as it is lived or acted. In reality it's a risk, because I could do something stupid, say a swear word, or skid out of control! But this risk is worth it because it shows that we're together in the instant. And speech becomes more free.

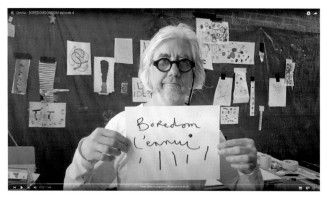
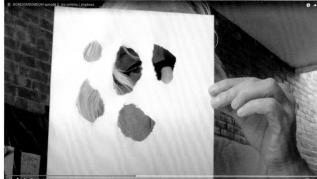

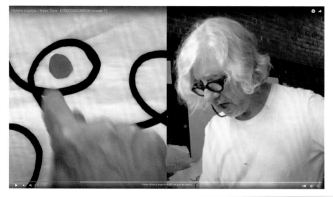

Stills from Bore dom dom video series.

Stills from an Instagram story about *La Danse des mains*.

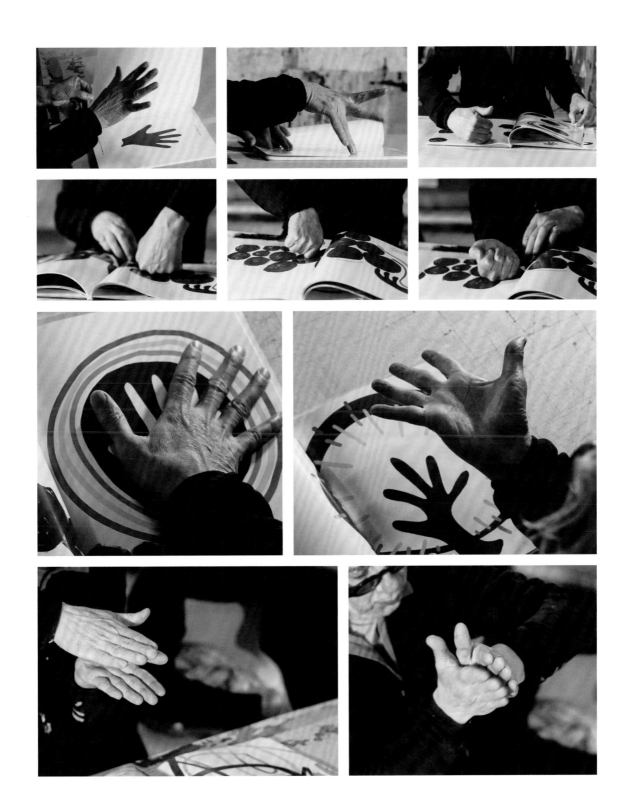

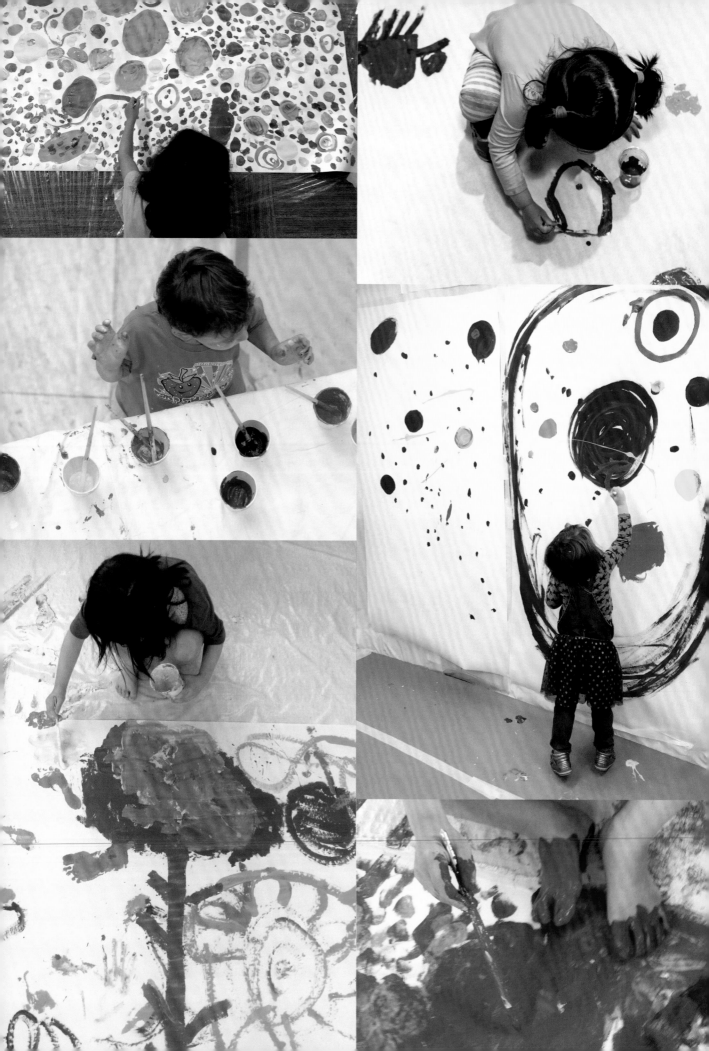

Knowing
When to Stop,
or Reaching the End

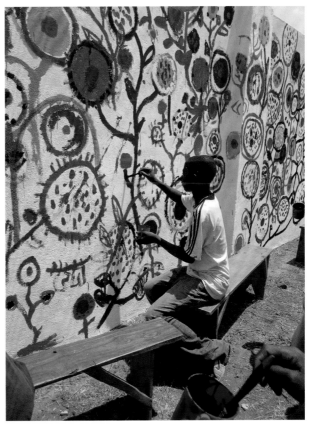

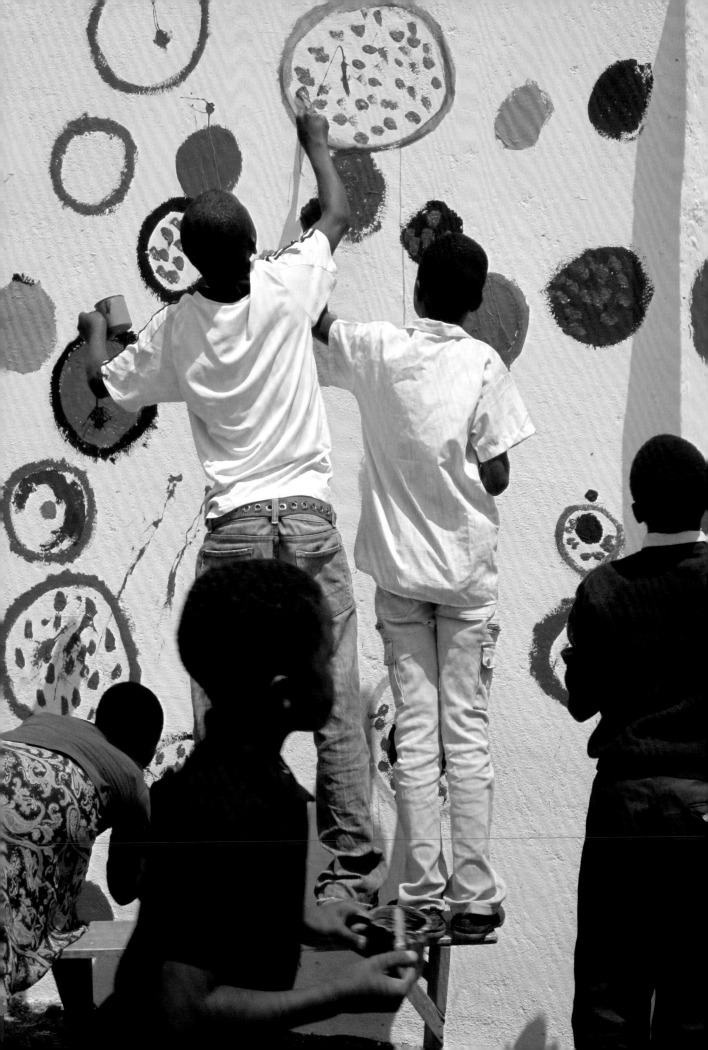

The duration of a workshop is, of course, never defined in advance. Its rhythm establishes itself via the real-time experience, the location, the materials, the participants, and even the way it unfurls. While the sequences are defined and Hervé has set goals, the session remains perilous to manage until the end.... And, in fact, ending a collective experience or a personal project follows fairly similar logics.

My gestures, my instructions must lead to something. Now, I don't particularly like a scribble as an ending. The "sound" workshops take the form of scribbling sessions, but that's a limitation. I've always got to find the rebound, the transformation: For example, we can tear up the papers to make something else. We're not doing something for the sake of it; there is actually a goal. It's not so easy to find this balance. Notably because, during the workshops, I have this slightly hippie, relaxed attitude; I invite liberty. And yet I must keep control. This is accomplished with small touches.

At the end, the participants may not know anymore where to express themselves, and they might try by any means to keep going. The excitement then collides with the lack of space or of support. If I let them go, everything would end in a mess. The collective drawing comes together in the moment, which is why I have to stop them: "OK, all right, we're going to leave it there." I can also show that I'm shocked, or outright mad. The end of the workshop is approaching, I have to stay vigilant. Sometimes certain individuals wreck everything or follow the example of someone who starts painting on walls that weren't meant to be painted on.

I've never wanted to explicitly announce the end of a workshop. There's no signal, no timing, nothing to say that it's ending. I chose to let things run out, without closure or ceremony. The end is an improvisation.

Once, during a big workshop in a park, the pots of paint and the papers, laid out on big blue canvas sheets, had been left out long after the end of the workshop. All afternoon people kept adding to them, going back to draw really beautiful things with kids.

Mural at the Jacaranda School, Malawi.

Drawing, for me, is an attempt to reach the end: to get to a moment when you've done enough to have something that works. I do this with a certain level of comfort because behind me, I know Sandrine, the artistic director, and Isabelle, the editor, will look over what I give them. In fact, I generally present multiple things, many more than are needed, and the idea is then to make a selection. It's a habit I got from advertising, where you make several proposals to the client to show that you've worked a lot!

Every time, I follow the thing to its end, I don't make only one drawing, I live an experience, long or short. In this sense I run toward using up the energy of the moment. I'm very concentrated, and when I get to the end of making a book, I sense it. When I illustrated a text, something rare for me—it was The Aspiring Poet's Journal (L'agenda du [Presque] poète) by Bernard Friot—I worked continuously: a text, a drawing, I turned the page, new text, new drawing. The magic of the dialogue between text and image was happening live. There was a progression that I understood and that meant I was advancing at every step. In this way, I made 365 drawings. And with every page the pleasure was renewed.

The Baby

Playground at the 1101 Museum, Seoul Arts Center, South Korea.

The understanding of the baby has profoundly evolved over the past forty years: Specialists have demonstrated that newborns are sensitive, and that they are intelligent. Bit by bit, always with a delay, our entire society has taken stock of the newborn's exceptional capabilities. Hervé, for his part, has long put the baby at the heart of his practice and his thought.

I have an imaginary baby who validates everything I do.

Babies have to do with origins. Because with the baby, as with the prehistoric human, we're talking about a primal human who is nevertheless pretty sophisticated. In pure form, in simplicity. This links to my connection with outsider art.

I know that in every child, there is a baby. I've been able to observe the astonishing connections among different stages of life. Children morph back into babies when they come into contact with them. And the same goes for adults when faced with a baby. You have only to see the disarmed smiles, utterly without defenses, that they instinctively offer up to it. And the face of the baby lights up in return because a stranger smiled at it, in the street or on the subway. You can sense a very strong connection. This can also lead to solidarity among children: When you're five years old you're absolutely on the same wavelength as a three-year-old, because the memory of the three-year-old you were comes back to you spontaneously.

Above: Hervé Tullet's Blocks, Areaware, 2019.

Opposite: The Perry School, New York City.

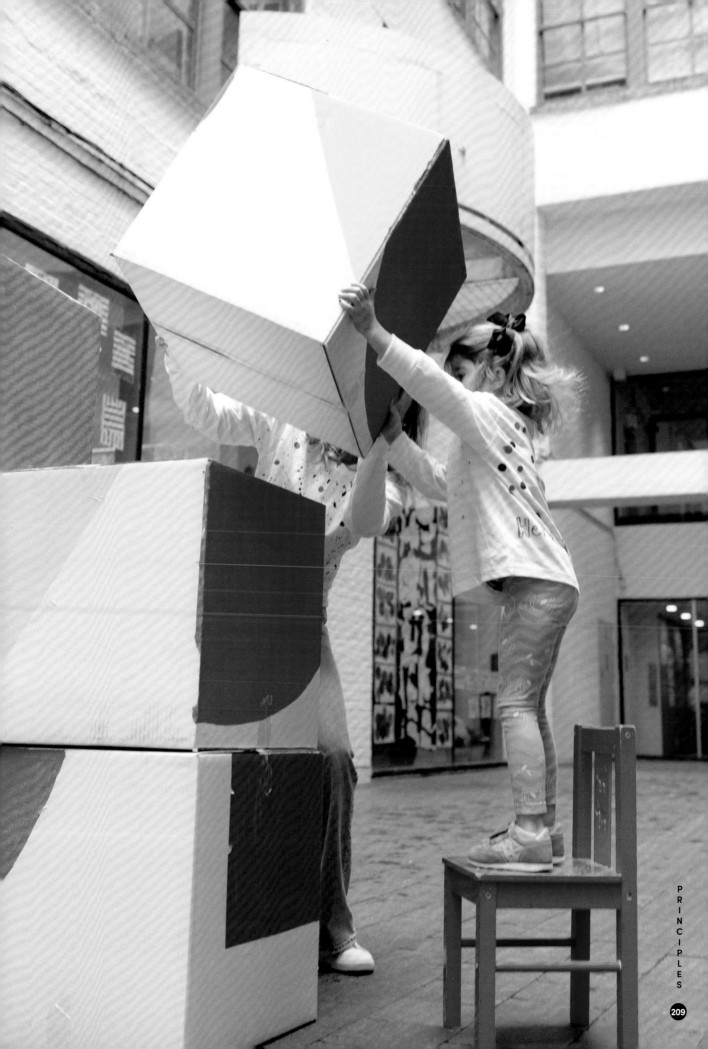

The baby is Picasso because the baby IS. It's permanently in the moment. When it looks at a radiator, the radiator is beautiful: made up of lines, rounded, textured. . . . There's also that concrete gaze at the lines on the road, the marks on the ceiling. The baby doesn't judge with notions but with values: it sees a small or big mark, a unified space or a space shaped by nuances. And it doesn't necessarily differentiate between a wall and an object in front of it. For the baby, these are shapes, more or less interesting.

I'm convinced that the baby understands everything because it understands nothing. It understands nothing because it can understand everything. There's really a special door that exists between the baby and the artist. A little one sitting in front of a Calder mobile: That's magnificent.

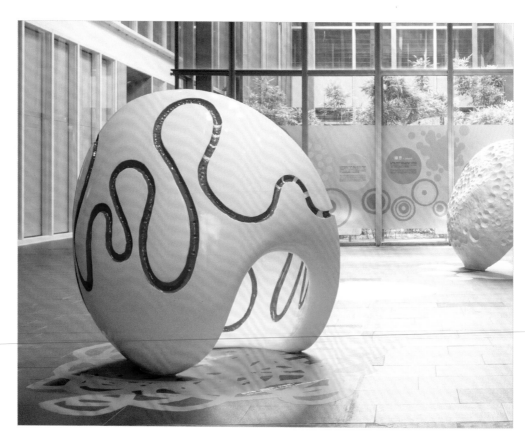

As Fun as Art, NTMOFA, 2021.

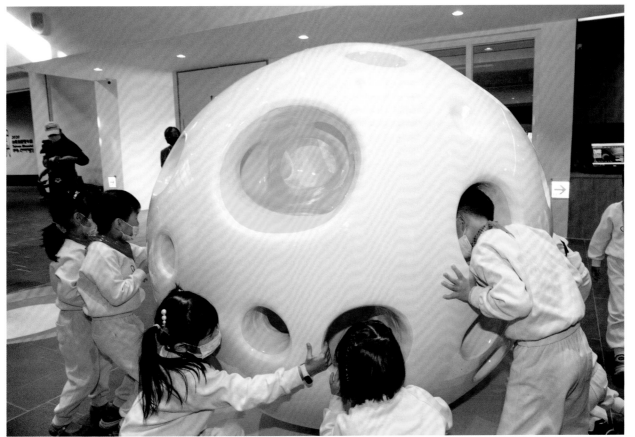

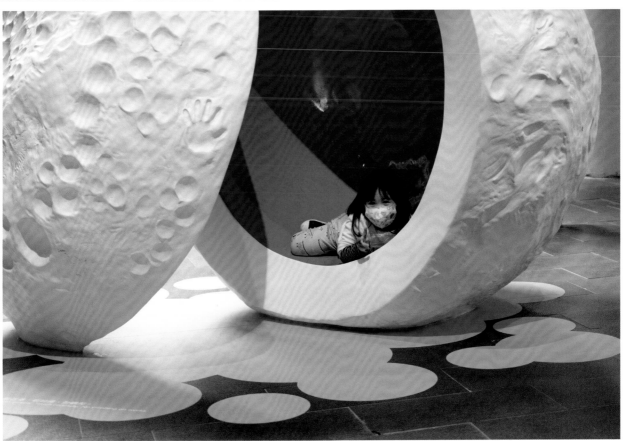

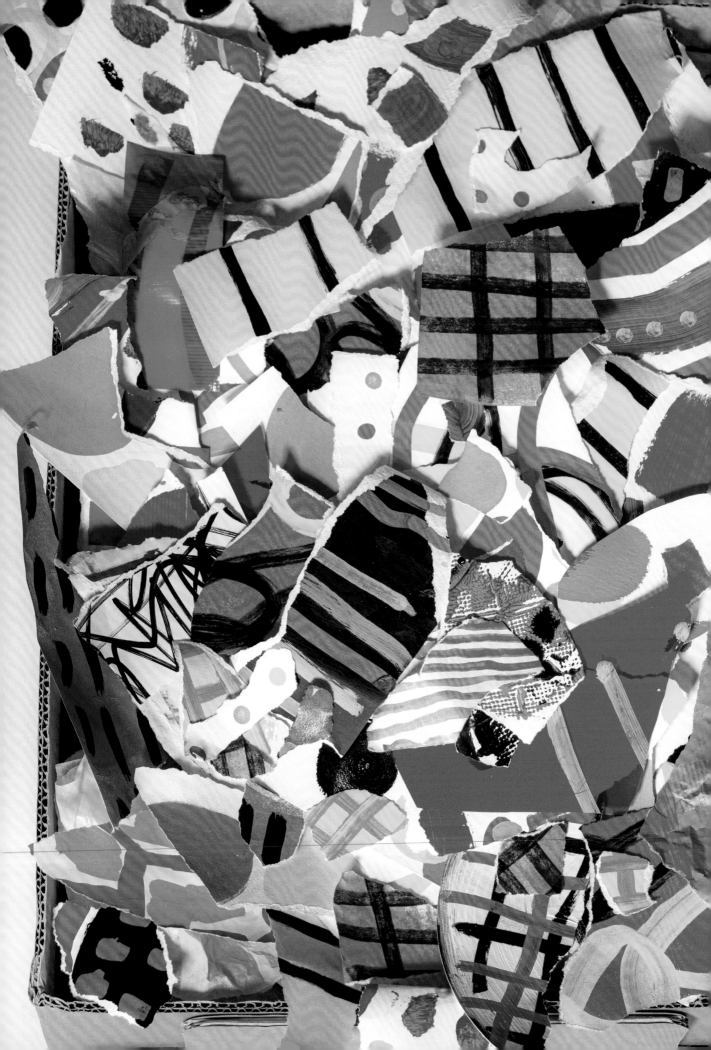

Outsider Art

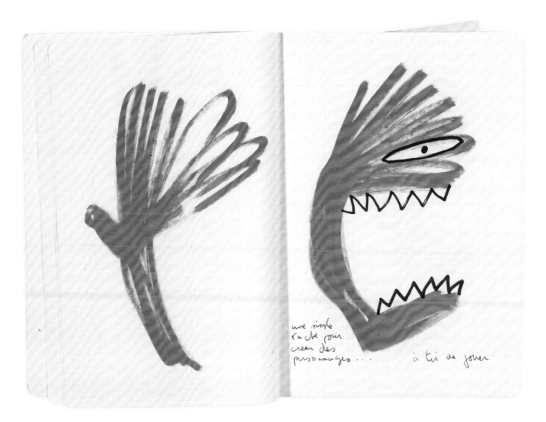

une simple
va che pour
créer des
personnages... à toi de jouer

Outsider art, also known as Art Brut, is much more than a reference for Hervé. The term *Art Brut* (literally, "raw art"), coined in 1945 by Jean Dubuffet to provoke and make people think, interrogates the status of both artists and works of art. Multiple definitions can be used, but one in particular corresponds best to the profound connection with this form of art felt by a creator born slightly more than ten years later: art made by independent people, outside of schools, which displays a great graphic power.

I've always dreamed of being an outsider artist. This is due to my relationship with drawing, its energy, which connects me to childhood drawing. Drawing in the moment, in your own world, in your own universe. Building your story as you go. To escape boredom. Being aware of the time that passes and of the pleasure you feel without necessarily expressing it.

But it is others who acknowledge artistic works as such and who dub certain people outsider artists. Having studied art, I can't legitimately exhibit in a gallery with this title. Yet I believe quite strongly in a kind of raw energy.

This also arises out of my tendency to always be salvaging, be on the lookout. From my perspective, a drawing is rarely a mistake. If I make a drawing, I use it in the sense of taking advantage of it. This is also a principle of illustration: By successive layers, you bring life to the drawing. A drawing can't be considered ruined if it unravels involuntarily. But in general, you can always redraw a drawing, reuse it, get to a surprise in the layers, in the vitality of the leap. Something interesting will always remain. If you are always careful not to cover everything up.

I always put my rejected drawings in a corner to be reused later. So I have a real economy of paper; very few pages go in the bin, because there's always an opportunity to make something of them. Over time I've established a system of two bins, one of them for unusable drawings that can nevertheless be mined.

This relationship with drawing, with all my drawings, is actually at the origin of my work with torn paper, for my exhibition at The Invisible Dog Art Center in New York. At the heart of the space, I placed a trash can. In

fact, I took the plane to the United States with the Tomi Ungerer trash can! That is to say that one day, I had gathered certain of my drawings, after an exhibit, into a box labeled "Tomi Ungerer." I had put bits of paper in there, and that's how my two-bin process had started. During the Invisible Dog exhibit, I was afraid people would mistake my trash can as a trash can that needed to be emptied. So I wrote on it "This isn't trash"—it was intended for the janitor, rather than as a Magritte reference. And that became the title of the exhibition!

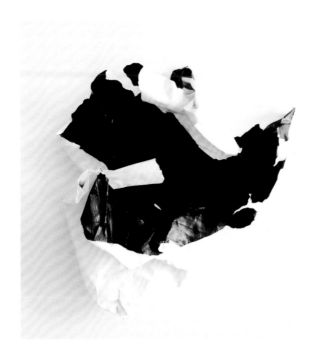

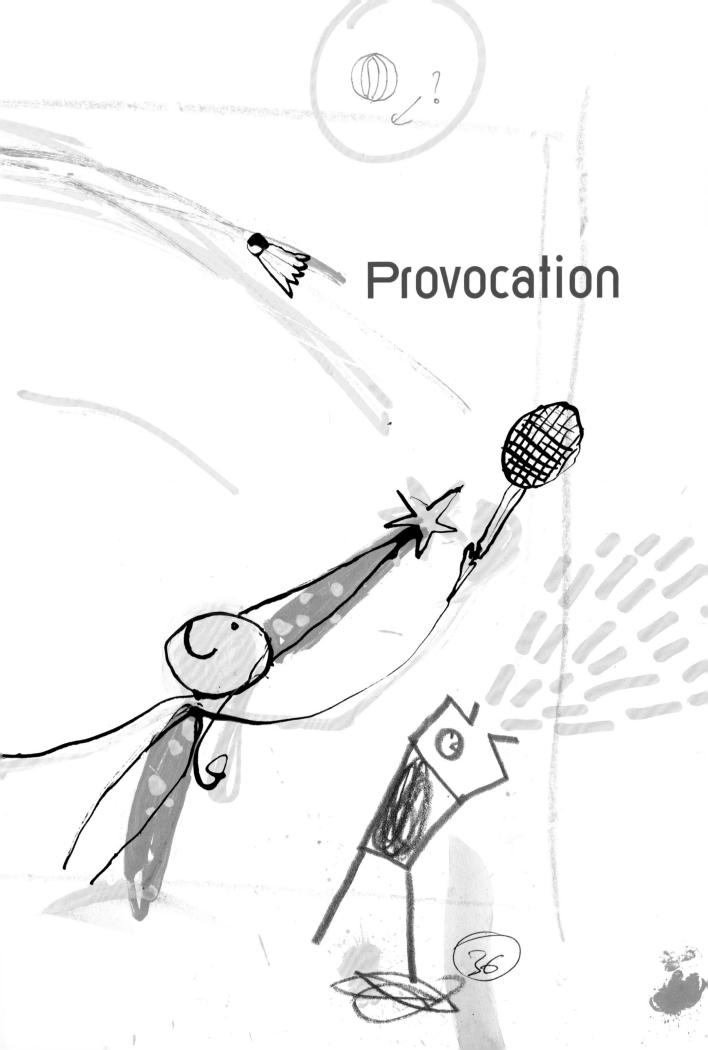

Provocation

I t's a strong word, which could have had a significant political connotation, especially at the end of the 1960s. However, when Hervé uses it, it's always in a positive sense and in dialogue with his audience. Provocation is above all the vector for putting things in motion, or making things dynamic, favoring not the reception of the finished work but the active participation in its co-construction.

I don't provoke; I offer a provocation. Which I could define as a permanent search for the instant, the surprise, the unexpected gesture, a reaction that wasn't predicted. This means: seeing the brilliance of the idea, changing direction based on the moment. Creation must be destabilizing, because the opposite is stability, and nothing can be produced there. Therefore, I must destabilize.

In workshops I need a reaction. It's a kind of warm-up that then permits each person to start making things. This doesn't necessarily happen through words. Rather it happens through the moment, through the location. It can consist of not giving instructions, or not responding to questions. "Should the green go here?" No reply. It's a benevolent provocation, a way to wake people up. Another gentle form of provocation is to be barefoot or wear stained clothes by way of a "stage costume."

And then there's a more direct form of provocation. It aims to put people ill at ease, so that this can then be surmounted. I can, for example, make an organized plan dissolve completely. Sometimes it's not easy. In China, a certain workshop had given rise to a very protocol-oriented structure. I was on a platform, it was conceived of as a performance, a sort of big demonstration of myself, since the children, lined up with easels, were making drawings "in the style" of my books. The system was so strong that I was no longer controlling anything. I felt helpless. Until the moment when I finally had the idea that saved the situation. By approaching each drawing and drawing over it, intervening without following a rule, passing quickly from one to the other, I was able to breathe collective creation back into the conditions.

In moments like these you take measure of the power of the child. There are no more rules, no more barriers, the adoption is immediate. And this always surprises the adults, who ask themselves what's going on. They're there for a reading and everything is turned upside down. The child becomes the leader of their own enthusiasm. Most of the time we don't take account of the specificity of children. We don't put value on what they know, what they can teach us.

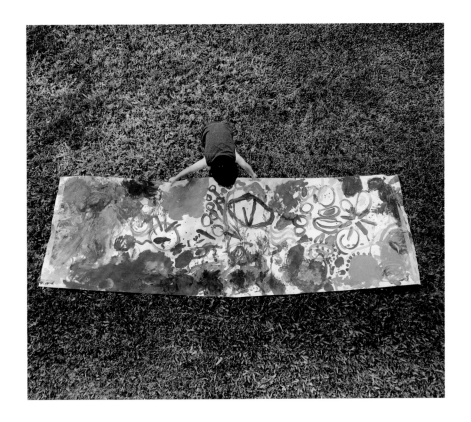

AND
Right Away
YOU KNOW IT'S good
BECAUSE IN EVERY
good idea
THERE'S ALWAYS
A SEED OF
Madness.

Writing

Given the choice, Hervé prefers speaking to writing. His relationship with writing has long been strained. Even recounting stories has proven a challenge, and his books usually feature words that echo rather than long descriptive phrases. The thing is that, in his books, the text is there by necessity. Over time, however, the artist is reconciling himself with writing, and he might, one day, reverse this relationship.

The text of a book depends on the work of a master wordsmith. It consists of communicating with the fewest words possible what you're going to do and how things will unroll from one page to another. In general, the text is written via a back-and-forth between the editor and me. It's a pretty powerful moment of exchange, of construction by rebound. We want to manage to capture the reader. And we toil over the words as we do over the images so that it works. We must be ambitious, all while advancing step by step. This depends upon scrupulous work, whereas drawing happens more in the realm of intuition.

I have a very obvious tendency to try not to say anything. It's more than trying not to say too much; it's leaving a blank, leaving a space. Particularly in Press Here *and the books that followed. But it's not always understood correctly. The foreign editors who translate my books, for example, don't always understand this way of writing. Sometimes they even try to reinsert text into spaces I left empty. Yet the texts are meant specifically for the adult who's reading the book aloud. They are texts that help, that punctuate, but they must, from my perspective, remain discreet. Sometimes I've even wished for a total absence of words, aside from the title, for example in* The Game of Shadows.

In contrast, when I write for myself, I try to get back to something like intuition. Writing can therefore work the same way as ideation; you must be in the heartbeat. This can come all at once. When Rana, a friend from India, upon seeing my personal writing, assured me that it was poetry and that I mustn't retouch it—that was the moment when I started to understand there was something there.

In these writings I formulate raw things from inside me, I try to highlight words, I really believe in the visual dimension, in the way that I see the text

on the page, as if I'm acting it out rather than writing it out. I manage the line breaks and punctuation according to my own rules. More and more, this approach is conscious, precise. This also corresponds to a moment of passage through which I accept intimacy, of unveiling the passage, of accepting my work's profound artistic value without an objective. Talking about myself or my work is a way to show the sensitivity of all this. And the truth.

Vocabulary

People often ask me questions about my interpreta-
tion of or love of color
My reply often disconcerts
When I say that I am not a lover of color,
Well, to add nuance:
I have loved color, I love color, and I would like
to spend time evaluating, thinking, feeling,
choosing, painting and letting dry,
admiring the result
But early on, I wanted to avoid
these aesthetic questions:
Which red? Which green?
Which nuance? Which proportion?
I don't want to play with color as a distraction,
I take some blue, some red, some yellow;
they come out of a tube, like the colors of a flag,
and like something obvious,
They're the colors of childhood, and I don't need
to worry about anything but concentrating
on the idea

white

White is of primary importance in my books. It's the space on the page, but also a space reserved for drawing and for the child to whom it is destined.

White has a fundamental visual value for me. And it always answers to a logic. It's not a neutral background.

The text can also be understood as a punctuation of this space. It's part of this global treatment of white. When Sandrine, the artistic director, and I are working on the layout of my books, we try lots of things. Through many attempts, I say to myself, "That's not right, that's not me . . . still no good," etc. And then, at some point, after many cuts, after paring things down more and more, it suddenly becomes obvious: "Yes, there, that's me."

When my books are adapted in other countries, editors sometimes want to modify the placement of the text, insert it differently into the page. As if this placement were the sole purview of the editor, when in fact the white space is a wonderful part of creation. The editors might, for example, want to put the text inside the image. Whereas my texts are placed at the height of the reading adult's eyeline. It's a little reserved area, a line just for the text. The text might eventually punctuate the image, to help the reader punctuate their performance, with an onomatopoeia, "oof," some small injunctions, some little indications, light nods, that invite them to modulate their voice— because the adult reader is generally in the habit of reading with a calm voice.

But the child doesn't give a fig about the texts, and neither do I. Once the book has been digested and understood, we can emancipate ourselves from the text. Which is exactly what young children are doing when we see them rereading a book on their own.

Opposite: Image from *Doodle Cook*, 2011.

Typography

Typography is the eye. An almost instinctual perception of the spaces between letters, between words, and of the balance of black and white. People often used to tell me that I was good at typography when I worked in advertising. A sensitive discipline, it demands a finesse that the readers don't necessarily notice.

My books are pretty elaborate from this point of view, with text that is generally hand lettered. And it seems important to me that everything, text and images, be made entirely by me. Even though, very early on, with the artistic director, we created a font based on my handwriting.

In a way, the words play with the image and are a part of the image because they play an important role in the layout, particularly in the transition from one page to another. Even if the text is very short, even if we're talking about only one word, I'm very attentive to its placement on the page and to its relationship with the image. It's up to me to determine that, outside any handling of the layout done by computer.

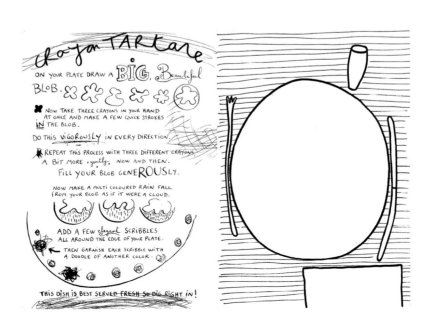

Painting

During my first years in art school, painting was the space in which I chose to express my pain. Deep inside I was profoundly sad, and I couldn't find a voice to express myself. I created heavy images on lightweight papers that tore beneath my paintbrush. I piled my weight on there, my silhouette; colors became muddled there like bodies fighting each other. My inspirations at the time were Nicolas de Staël and, above all, Francis Bacon.

Also, the canvas intimidated me. Yet, in the summer of 1979, I painted a canvas, a single canvas, very big, on which my friend Jean-Loup helped me project my silhouette. It's a figurative painting that represents me in silhouette, opening a door, but it's in a symbolic register. The register of passing from the concrete to the abstract because I'm heading toward a luminous square that is a kind of future. I called it Autobiographie and signed it H. Waston. It was shown at the Autumn Salon in Paris, at the stall of my professor Yves Millecamps, with whom I was connected to, in cahoots with, at the time.

Untitled, acrylic on polytab, 150 x 250 cm, 2021.
Held in the collection of the Albright Knox Art Gallery, Buffalo.

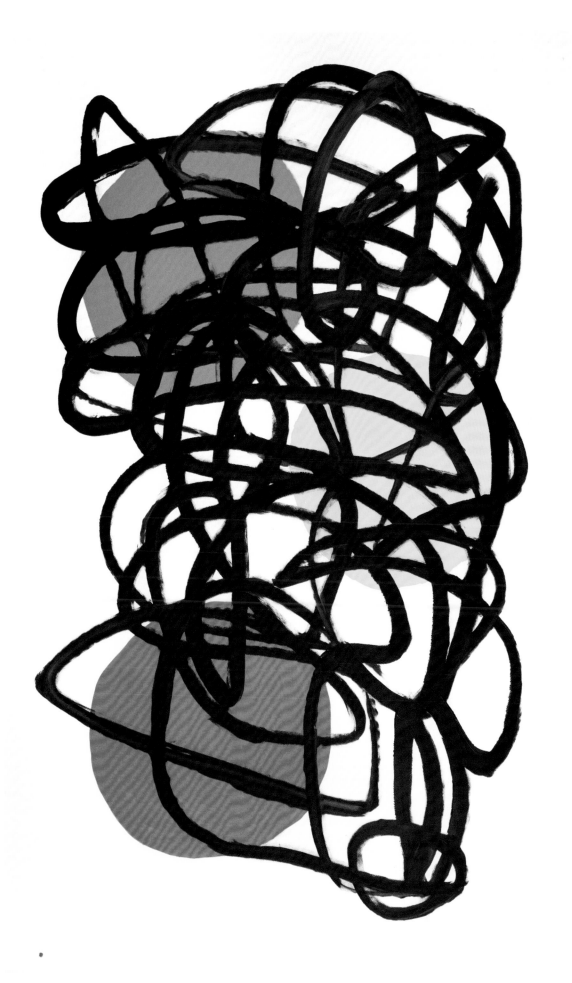

Lines

A simple stroke on a piece of colored paper can take on great value. A line can in and of itself have a narrative function. In particular in Let's Play!, since the line reappears in the wake of Mix It Up! We follow this line, passing through splotches and scribbles, to arrive at the end of the book, which is also the moment when we emerge from the book, in the sense that we exit its two-dimensional pages. The line has led to this emergence, this taking flight.

Shapes

I don't do aesthetic research on shape; I'm very referential. Shape, for me, is a square, a triangle, a circle . . . because everyone knows these figures. During workshops, if I start with a simple shape, everyone knows what I'm talking about: On the contrary, if I start with an octagon, things get more complicated, not only in recognizing the shape but also in drawing it.

What interests me in simplicity, or in making do with little, is the common minimum. Escaping knowledge to arrive at intuition. Everyone knows that it's a dot. You can make little dots, big ones, a dot on top of another, a very big dot next to another. If I announce, "Make a circle," that's more delicate. Young kids won't necessarily have tackled this figure. So I usually restrict myself to this common minimum, which engenders great confidence.

Image from *Let's Play!*, 2016.

The Dot

I see in the dot the first form. An organic shape, original even, total. It's the "o," the belly button; it brings us back to the creation of the world, to the baby. These are of course interpretations, but ones that I sometimes think about.

The square contains, in reality, four lines, and therefore four shapes; the dot is a single shape. In it, I see the pupil, the eye. At the end of the day, it's a well-made splotch.

Torn Paper

I've often thought about integrating the gesture of tearing into a book but I've never dared do it because, once the page has been torn, everything's over. It would risk turning the book into confetti.

Torn paper, cutouts, holes punched out—these are techniques, but for me they are also modes of expression, for example for passing from one page to another. They also allow certain proximities that can produce surprises, even for me: placing a circle over another page of circles, juxtaposing two pages and surprising my eyes. If it doesn't work, I can take the dots that I made separately, and juxtapose the circles and the dots.

Torn paper can be seen as a huge provocation, for example, when I tear up a participant's drawing. It has an aspect of the taboo. I'm not afraid of this provocation, and in fact it has never caused me any problems. It's a way of putting in perspective the importance of a creation. Tearing, crinkling up a drawing, or throwing a piece in the trash puts in perspective the importance of a too-often-sanctified creation. I don't do this often, only when the occasion presents itself.

For me, tearing paper is a three-dimensional version of scribbling.

When a painting or a drawing is too beautiful you can't tear it up to reuse it in other compositions. I'm not fully aware of the aesthetic gaze that could be directed toward this work. For my part, if I assign an aesthetic value to a piece, I very quickly lose interest in it: "Nice job, it's beautiful. So then what?"

Concrete/Abstract

Abstraction is the ultimate weapon for getting around the question of drawing or of illustration. Historically, that's what I've experienced in my relationship with drawing; abstraction is my escape hatch. As an illustrator you're obliged to go via the concrete, which becomes my problem: finding a way to go via the abstract and arrive at the concrete. When I manage to tip things toward abstraction I rediscover all my confidence. And at the same time, it's my freedom.

I manage to say something completely concrete with what people call abstraction. A sequence of dots must not necessarily remain in the realm of the abstract. For example, a little dot next to a big one can mean: growing. So the dots are no longer abstract. Because this is concrete abstraction. Following this pattern you can tell so many visual stories.

This dialogue between the concrete and the abstract is what caused me the most difficulty in Night/Day. On one page there's a tracery of geometric forms and a text that reads, "Don't confuse 'the abstract.'" On the following page, a cow is drawn in a field: "and 'the concrete.'" This opposition has sparked debates during my events: as if people didn't understand it, as if it posed a question.

All it takes is adding a sign, the degree zero of drawing, such as a house, a fish, a boat, a tree, or a flower, and with that you can immediately recount something, sketch a scene. Not much is necessary to bring abstraction to life. In fact, by juxtaposing a house, a forest, and a storm, you're already telling a story. The classic figures of childhood drawings have become my archetypes: the sea, a sun, a stick figure, a boat. . . .

What I like is the spark of the idea: something abstract, created joyfully out of nothing. With a circle, a square, and four lines, you can draw a stick figure and begin a story. If, instead, with just as few means, you had drawn a car, that would be a different story. The important thing is the approach. Saying to a group, "What might we do with this?" Then someone suggests, "We could make it go." The logic has been established, and all that's left is to finish the story and, in so doing, finish the book.

This is exactly the same logic at play in the Field of Flowers workshops: The participants create abstract shapes, and at a certain point I reveal to them that they've drawn flowers. To do this, all I have to do is add one sign: the stems. The sign is there to help finish things, to help give meaning, if you can't find meaning in abstraction.

Finally, the very principle of the workshop gives rise to the vocabulary. Once, in Kansas City, I launched a workshop by saying, "Draw a dot." And one participant, an artist, drew a duck. It was funny! But in workshops I have to seek out the collective energy while making certain that people aren't going to spend an hour drawing a duck.

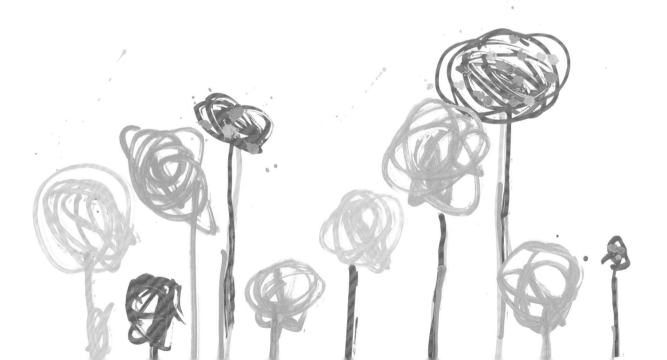

Light

My idea of light is a plastic vision that can consist of imagining projections on pieces, working with shadows and with the unpredictability they imply. Light remains for me something to conquer, through gesture, ephemerally.

Light also comes into play in the lighting of my exhibitions; it's a set design choice. Because exhibiting pieces implies highlighting them. This becomes an aesthetic approach. An Ideal Exhibition might be done all in white. So the lighting allows me to underline the relationship with volume.

In my books The Game in the Dark, The Game of Shadows, *etc., light follows from the experience of a projection in the dark. This light really speaks to me. Especially because there's something in its brutality that interests me. The prehistoric human, Georges Méliès, Charlie Chaplin: all call forth, one way or other, the rudimentary in their connection with light. And henceforth electric lights are somewhat archaic. But light is also the symbol of mystery, of enigma. It's the last moment you remember, just before you turn out the lamp to go to sleep.*

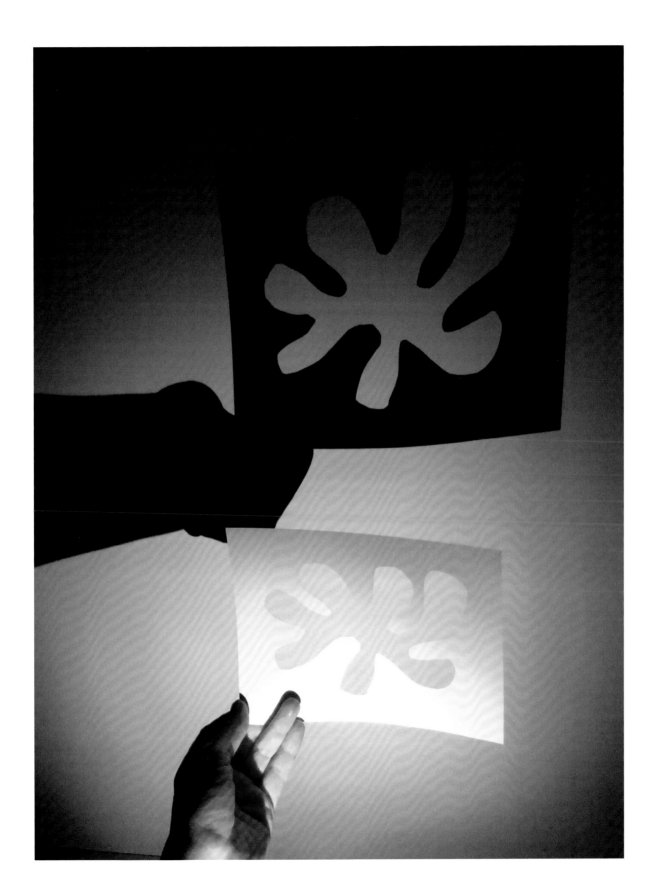

References

Katsumi Komagata

Someone showed me his books when I was just starting to publish for children. It was a shock. One page shows a little dot, and the next one a larger dot. You go from one to the other and it makes sense, just these two dots. And then, it's abstraction in a book for children. This link between childhood and contemporary art: I knew, then, that I wanted to go there.

Paul Cox

This was the first time that I saw an escape hatch from traditional children's books. Reading his books, I experienced an emotion that was a full-blown artistic emotion. In fact, he's categorized as an artist, not as a children's author. In his work I saw for myself possibility inside children's literature. He is also one of those rare artists whose work on paper, when printed, generates a very particular and very present vibration. As if his drawings were emerging from the page, with an almost magical effect.

Surrealism

Surrealism was my first contact with expression via drawing, and via poetry. This unbridled creativity, wild and multiform, was a huge discovery for an adolescent. It also set off a relationship with knowledge: From then on, I went to the cinema to see Luis Buñuel's Un Chien Andalou *or the experiments of Man Ray; I discovered poetry mixed with a political message inscribed in his story. All this took root inside me.*

Above and following page: Images from *The Big Book of Art*, 2008.

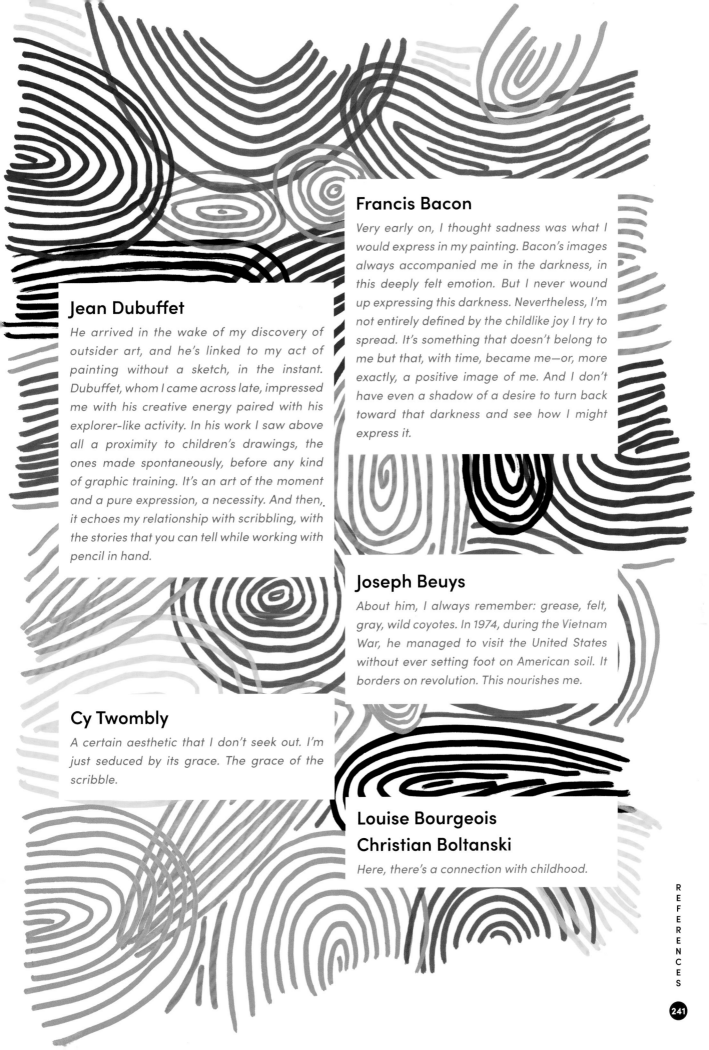

Jean Dubuffet

He arrived in the wake of my discovery of outsider art, and he's linked to my act of painting without a sketch, in the instant. Dubuffet, whom I came across late, impressed me with his creative energy paired with his explorer-like activity. In his work I saw above all a proximity to children's drawings, the ones made spontaneously, before any kind of graphic training. It's an art of the moment and a pure expression, a necessity. And then, it echoes my relationship with scribbling, with the stories that you can tell while working with pencil in hand.

Francis Bacon

Very early on, I thought sadness was what I would express in my painting. Bacon's images always accompanied me in the darkness, in this deeply felt emotion. But I never wound up expressing this darkness. Nevertheless, I'm not entirely defined by the childlike joy I try to spread. It's something that doesn't belong to me but that, with time, became me—or, more exactly, a positive image of me. And I don't have even a shadow of a desire to turn back toward that darkness and see how I might express it.

Joseph Beuys

About him, I always remember: grease, felt, gray, wild coyotes. In 1974, during the Vietnam War, he managed to visit the United States without ever setting foot on American soil. It borders on revolution. This nourishes me.

Cy Twombly

A certain aesthetic that I don't seek out. I'm just seduced by its grace. The grace of the scribble.

Louise Bourgeois
Christian Boltanski

Here, there's a connection with childhood.

Bruno Munari

People often lump me together with Bruno Munari, yet I don't think I've ever explored his work. Except the Prebooks. The very word prebook *marked me: the book before the book, the child before the child, which brings me back to babies, and everything always brings me back to babies. The ones who, not knowing—codes, language—accept everything, experience everything as a game.*

Alexander Calder

People often mention Calder in connection with my work. This doesn't bother me, even if it's not a particularly profound connection, founded mainly on colors, on an idea of innocence or lightness. For me, the key image is a baby looking at a Calder mobile. This happened with my son Léo. I'm certain that we should place children in front of Calders instead of hanging a bunch of mobiles over their cribs.

Ellsworth Kelly

Drawing on a Bus *is a book of shapes, with plays of shadows, which makes me want to draw. It's an artist book that could be shelved in the children's section. Even though as a matter of course the artist book is untouchable. Perhaps I have, simultaneously, an eye on contemporary art—shapes, lines, etc.—and a vision—putting children into my reading. In a snail-shaped sculpture by Richard Serra, I'm inside, everyone is inside, but I'm there with a child. This space of obviousness can be found everywhere in the world, and therefore also in an artist book.*

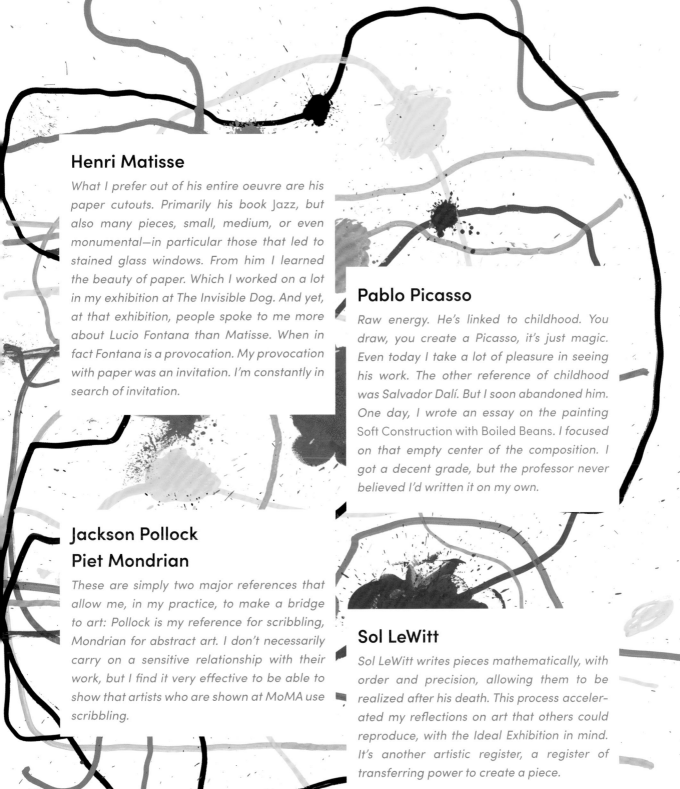

Henri Matisse

What I prefer out of his entire oeuvre are his paper cutouts. Primarily his book Jazz, but also many pieces, small, medium, or even monumental—in particular those that led to stained glass windows. From him I learned the beauty of paper. Which I worked on a lot in my exhibition at The Invisible Dog. And yet, at that exhibition, people spoke to me more about Lucio Fontana than Matisse. When in fact Fontana is a provocation. My provocation with paper was an invitation. I'm constantly in search of invitation.

Pablo Picasso

Raw energy. He's linked to childhood. You draw, you create a Picasso, it's just magic. Even today I take a lot of pleasure in seeing his work. The other reference of childhood was Salvador Dalí. But I soon abandoned him. One day, I wrote an essay on the painting Soft Construction with Boiled Beans. I focused on that empty center of the composition. I got a decent grade, but the professor never believed I'd written it on my own.

Jackson Pollock
Piet Mondrian

These are simply two major references that allow me, in my practice, to make a bridge to art: Pollock is my reference for scribbling, Mondrian for abstract art. I don't necessarily carry on a sensitive relationship with their work, but I find it very effective to be able to show that artists who are shown at MoMA use scribbling.

Sol LeWitt

Sol LeWitt writes pieces mathematically, with order and precision, allowing them to be realized after his death. This process accelerated my reflections on art that others could reproduce, with the Ideal Exhibition in mind. It's another artistic register, a register of transferring power to create a piece.

The Ideal Exhibition

What's exhibited is either the artist or the artist's energy.

The lowest common denominator allows you to redefine what's possible.

Dots/lines/splotches/scribbles permit you to liberate each person's energy without any questions being asked, without any hesitation in the execution, which happens in the moment, And even, In a kind of intuition.

Apoint of pride along Hervé's artistic path, the Ideal Exhibition was conceived of as an experience of sharing. Sharing between the artist and his readers, whom he invites to get involved in a global process, creative and community building. Sharing, which the participants are in turn invited to do themselves by spreading images of their creations. Which are none other than the results of an experience, by definition unedited and singular, while nourished from the same instructional or inspirational source. Since the advent of the exhibit, thousands of experiences have been shared on social media. Sometimes participants leave with a piece created by the collective, a new form of sharing among them all.

The exhibition relies on a certain number of gestures, signs, and styles, which are explained by Hervé in a series of videos. The exhibition consists of the results of these gestures, acted out by participants at a distance. It can be adapted to any configuration: from one to one thousand participants, from one to one thousand square meters, from one to one hundred hours ... The main idea is that each individual can create without any prerequisite technique, by combining a basic graphic vocabulary possessed by all—dots, lines, splotches, scribbles—and playful exercises with a collective energy to make original pieces. In this way Hervé has created a veritable system that, despite the time or the space, despite singular configurations or cultures, maintains its coherence and above all ends with creations that carry the mark of the Ideal Exhibition.

The best part of this project art is, for me, when you create something, not simply when you copy something. And this project has [a] few points I really feel happy about. First is: Everyone who was involved in this project is connected with each other. It's not someone is doing something and someone else is doing something else. We need this in today's world; we need people to work together on a single thing. They should not have single ownership but collective ownership—that's the beauty of this project. That is one thing.

Second thing is even when there is a connection, there is a society, there is a group, a team which is working on this project. It is not bounded, [you] still [have] open freedom to do, individually, what you want but in your own space. Such a beautiful communication of a boundary, but a loose boundary. It's not a jail. But still it is a protection, a protection of a group. A really sweet balance of . . . the things you are in a group. But you are still free, you are together but you are still alone. You are doing what you like. That's the most beautiful thing about this project, I think.

Video testimony from Priyanshu, coordinator of the Bal Prakash school in Rajasthan, India, where an Ideal Exhibition project was conducted.

These handful of words from Priyanshu constitute, for me, the truest testimony of the Ideal Exhibition experience.

Bruna Ferrazzini, since the beginning of the project, has been the Swiss ambassador of the Ideal Exhibition. Along with a few other persons and organizations, situated at the four corners of the earth, she is one with whom I can trust the development of a project with total confidence.

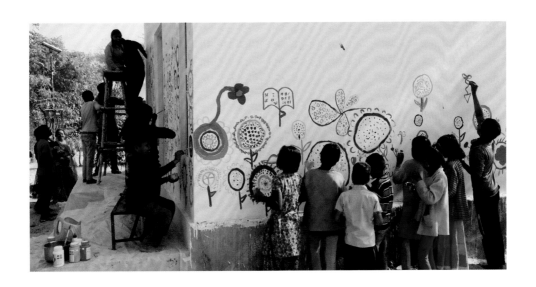

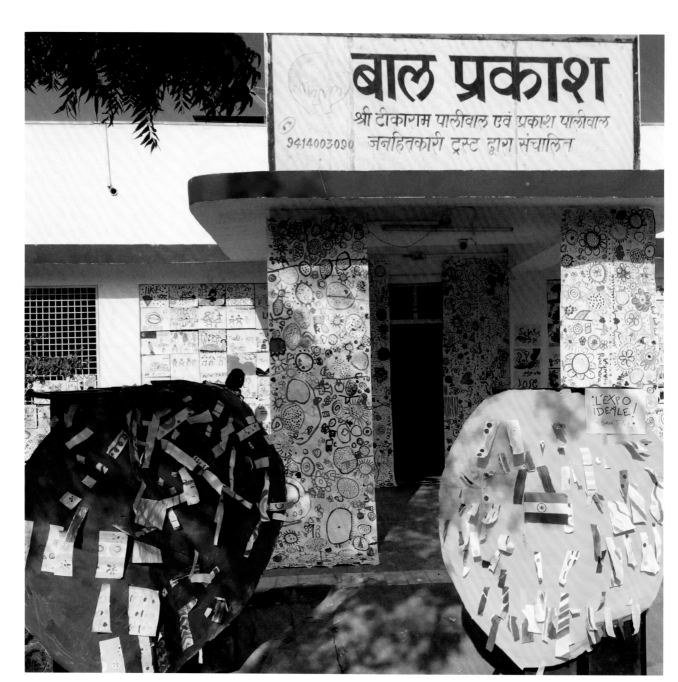

School Bal Prakash, Ajmer, India.

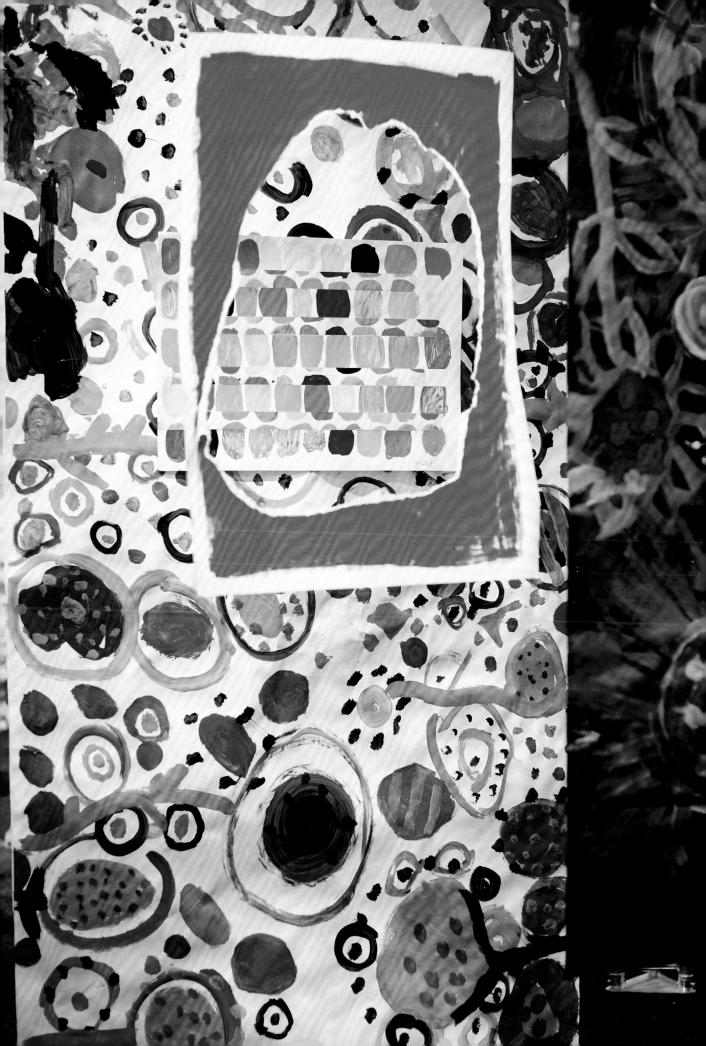

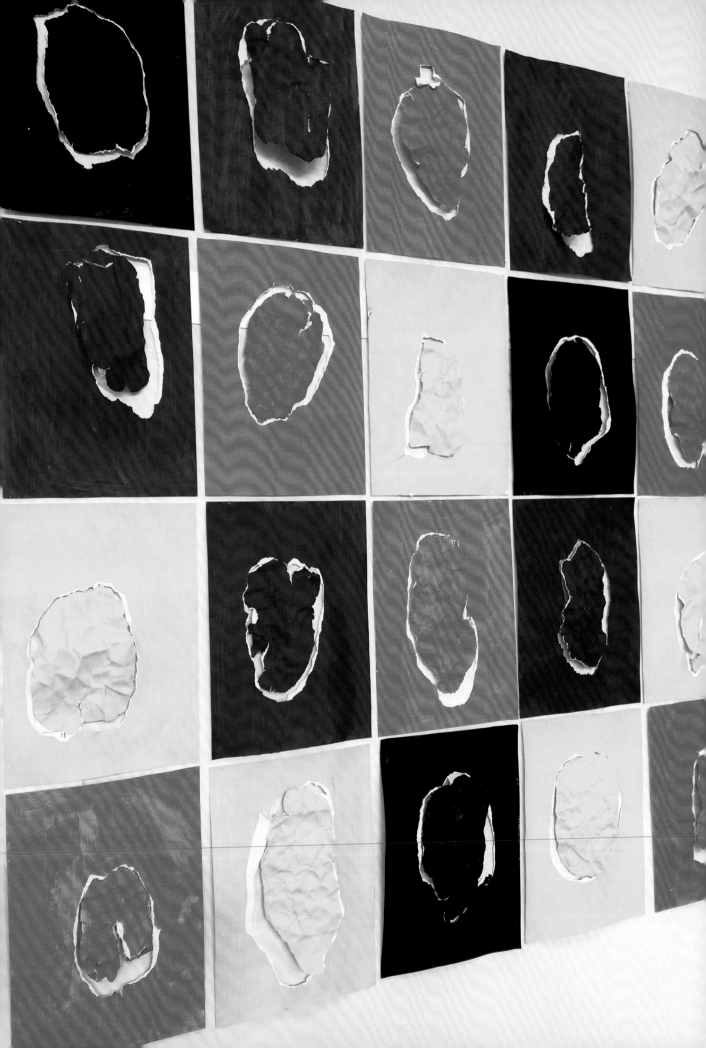

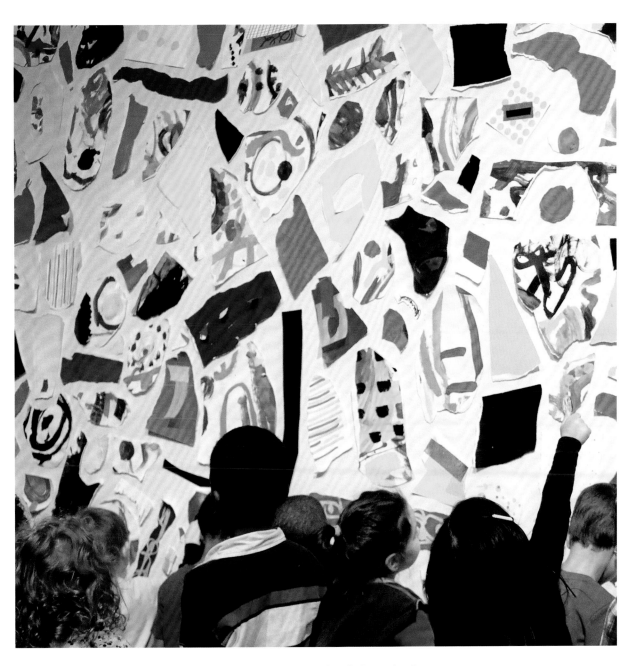

Children's Museum, Pittsburgh, Pennsylvania.

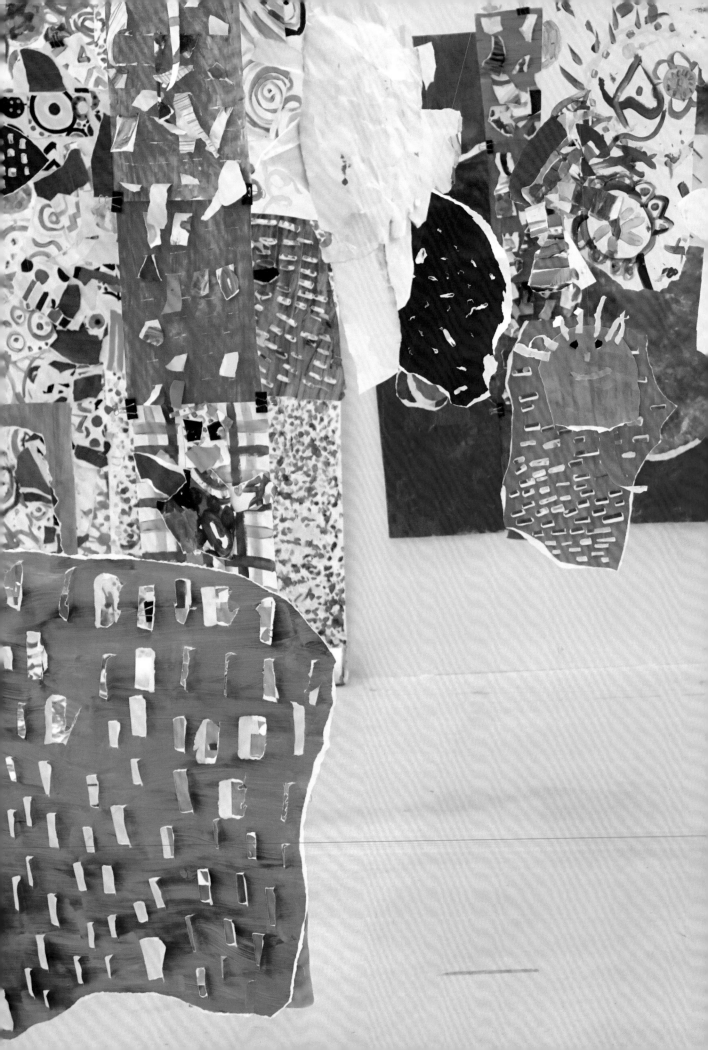

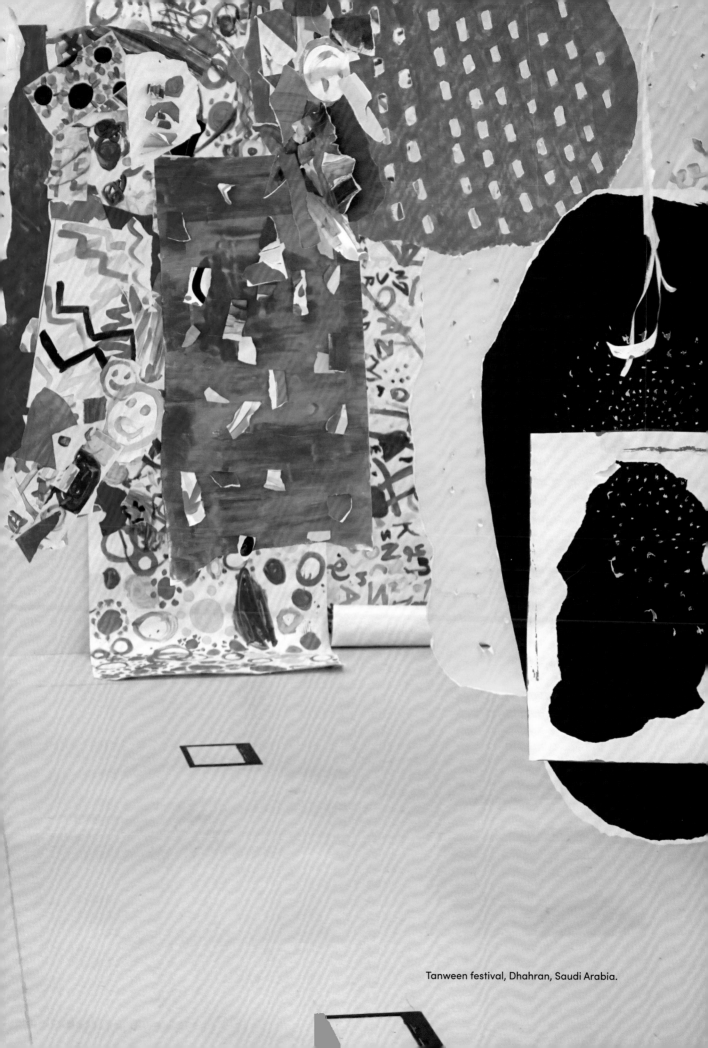

Tanween festival, Dhahran, Saudi Arabia.

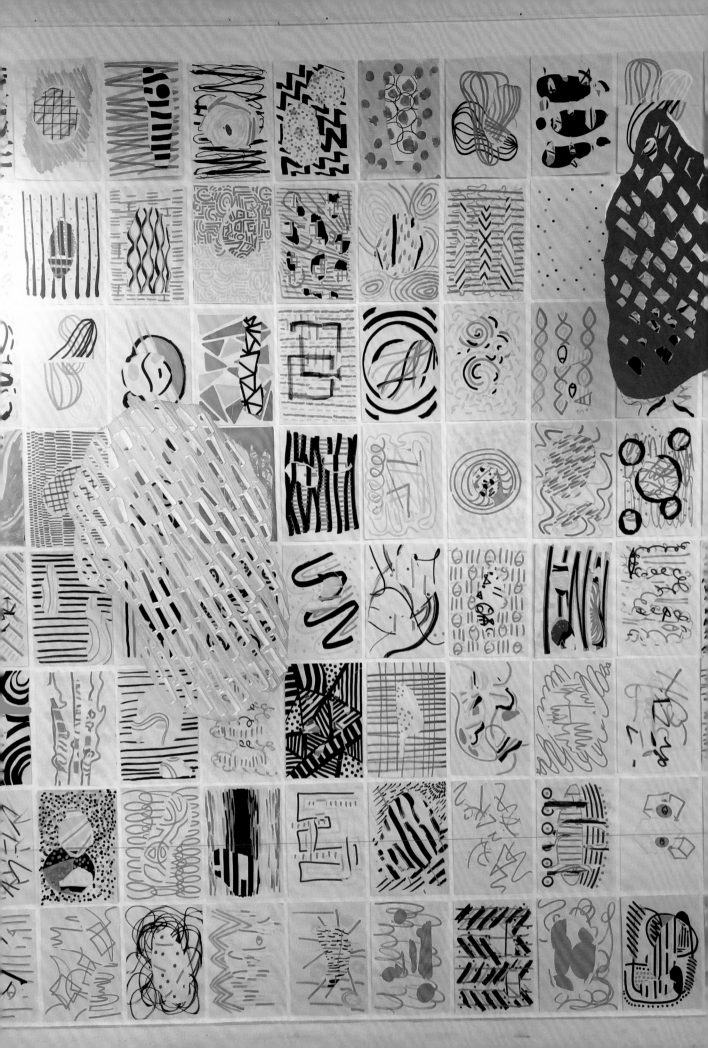

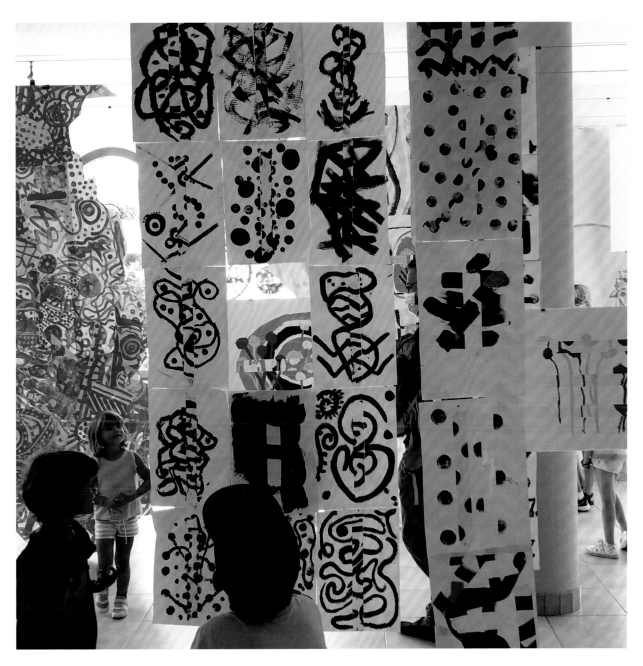

Above: Lauco, Italy.

Opposite: ENSAMAA Olivier de Serres, Paris, France.

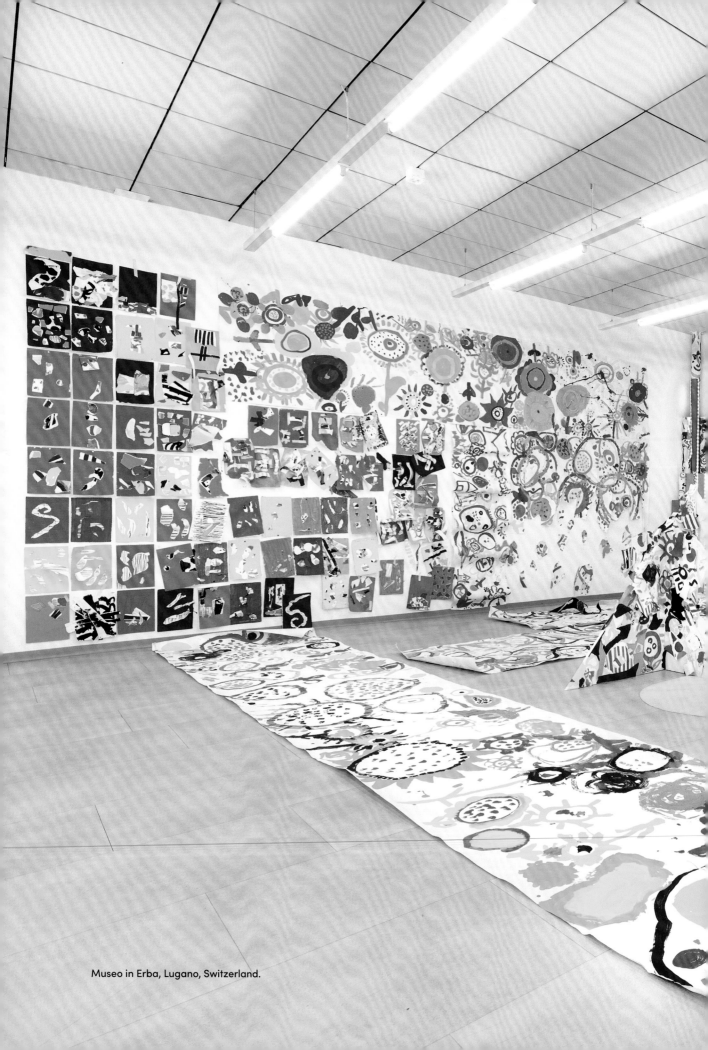

Museo in Erba, Lugano, Switzerland.

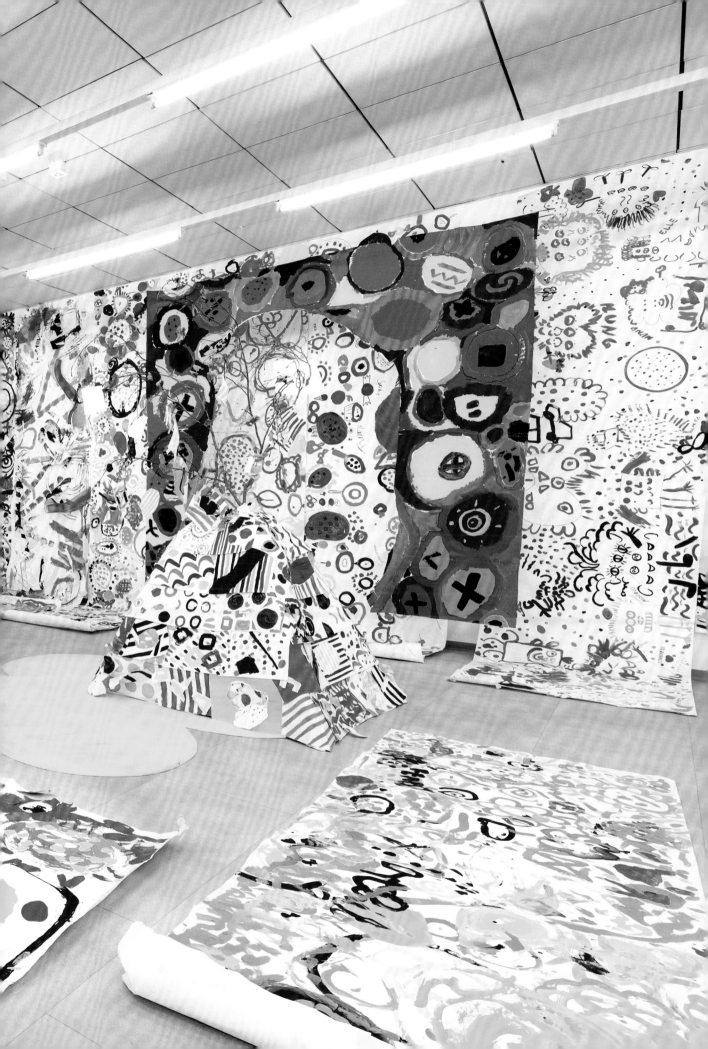

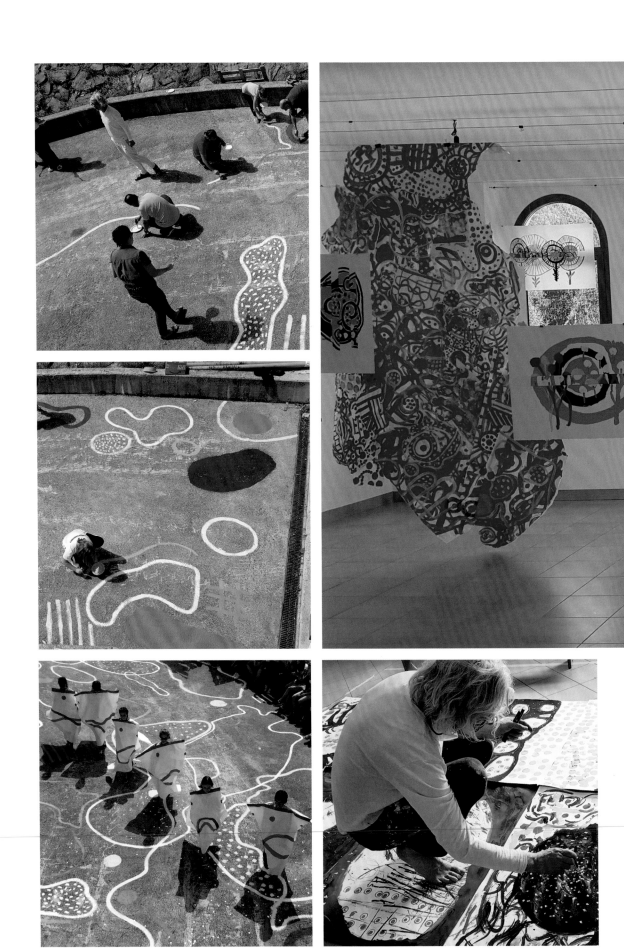

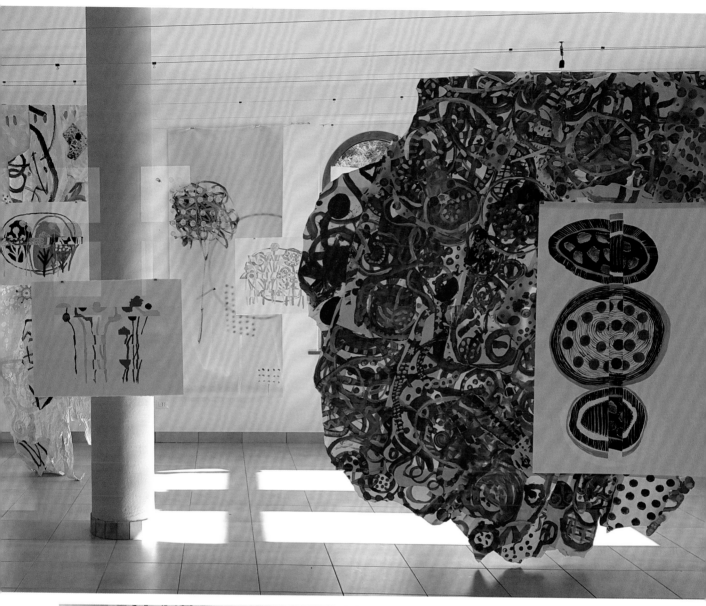

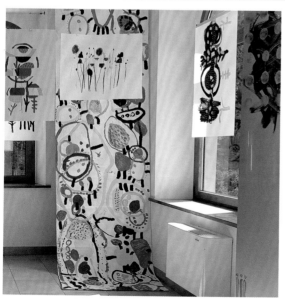

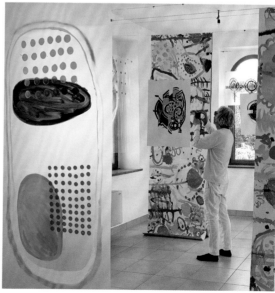

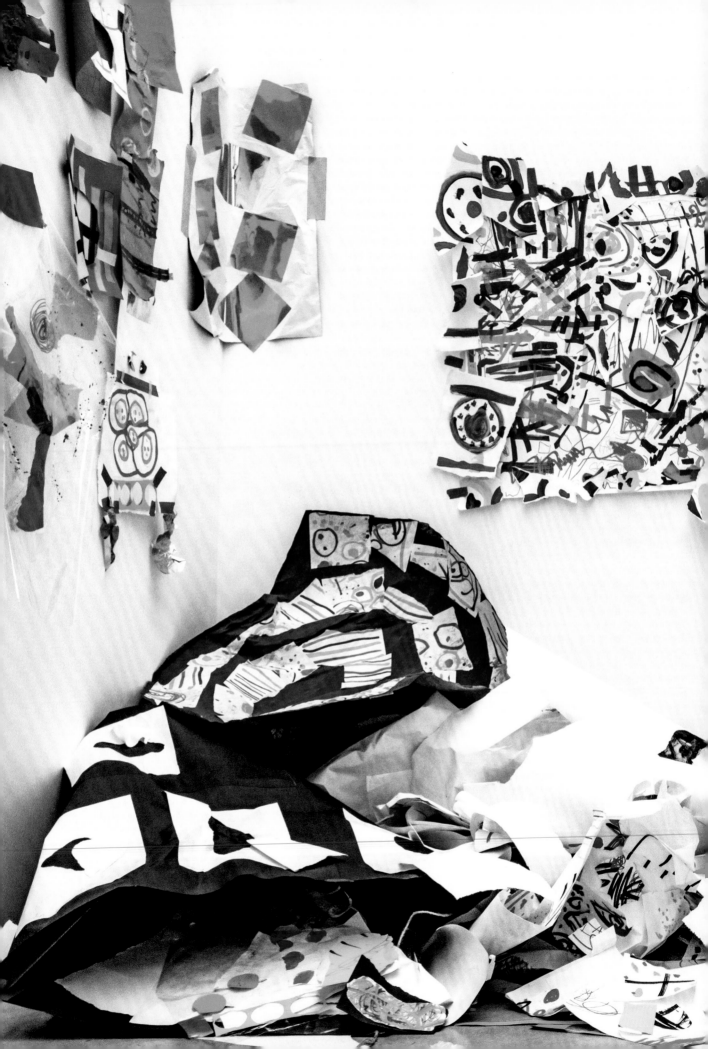

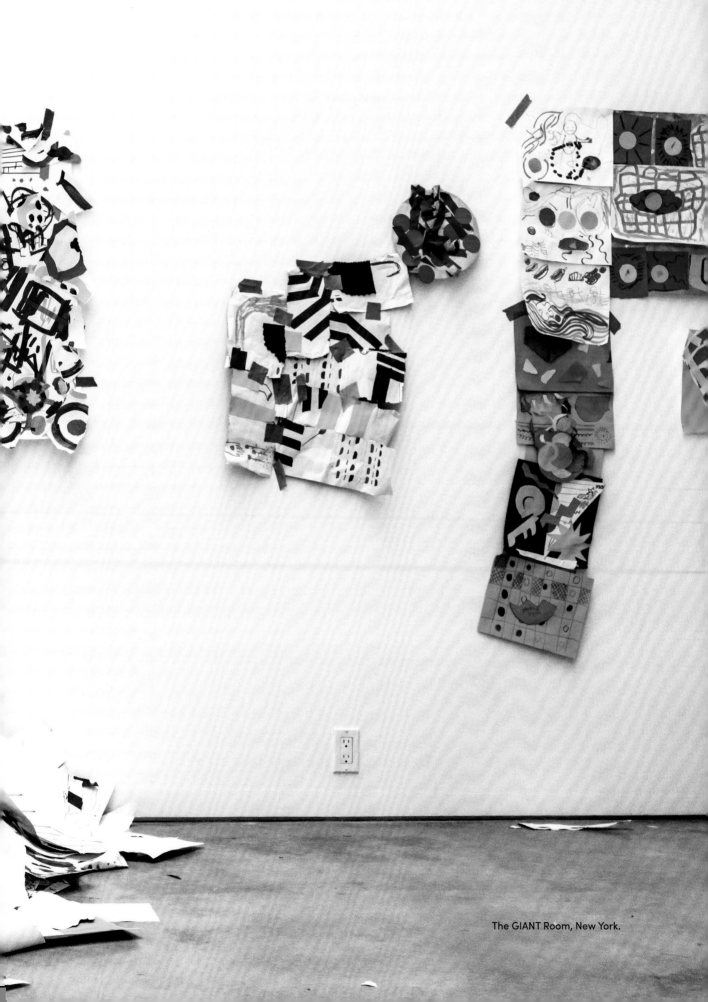

The GIANT Room, New York.

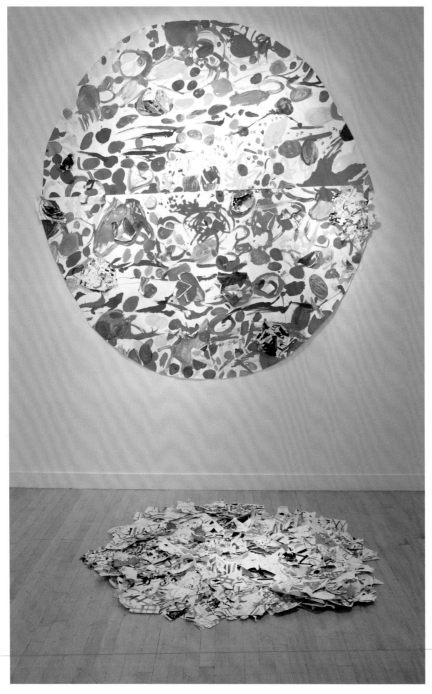

Princeton, New Jersey.

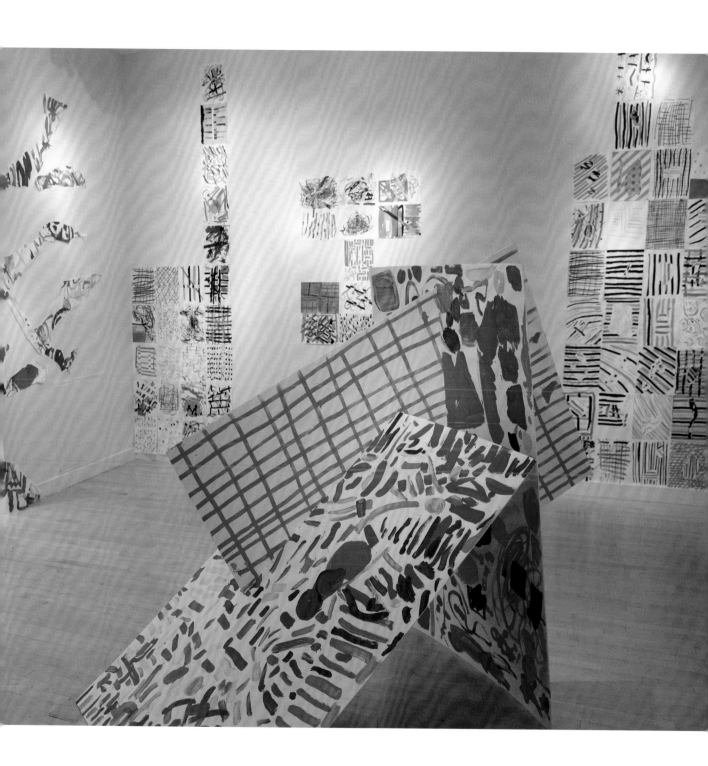

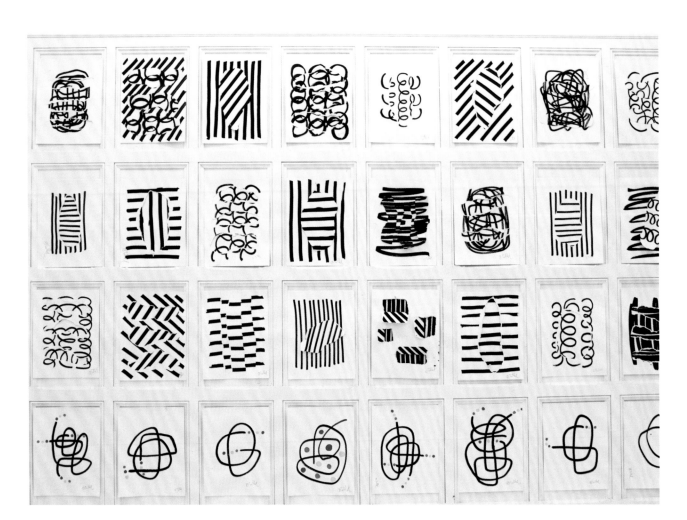

Le Livart, Montréal, Canada.

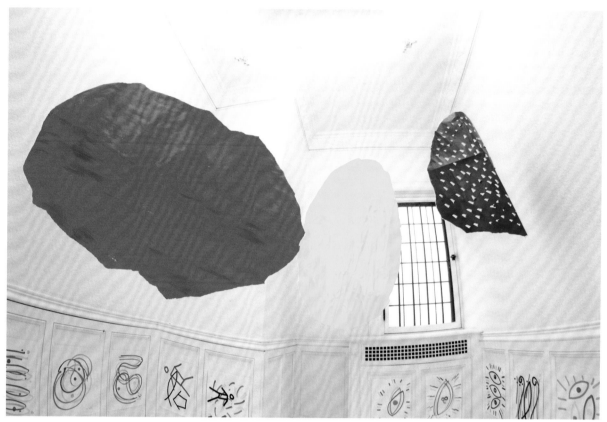

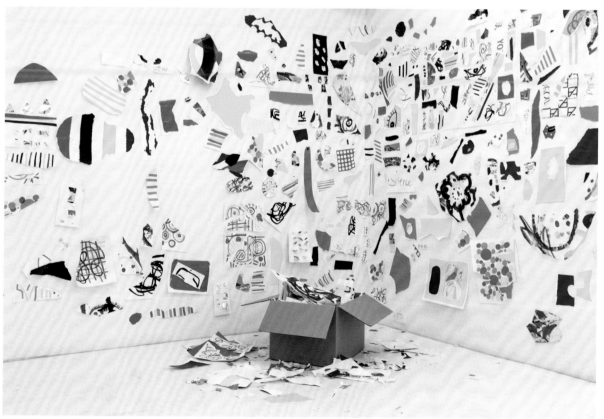

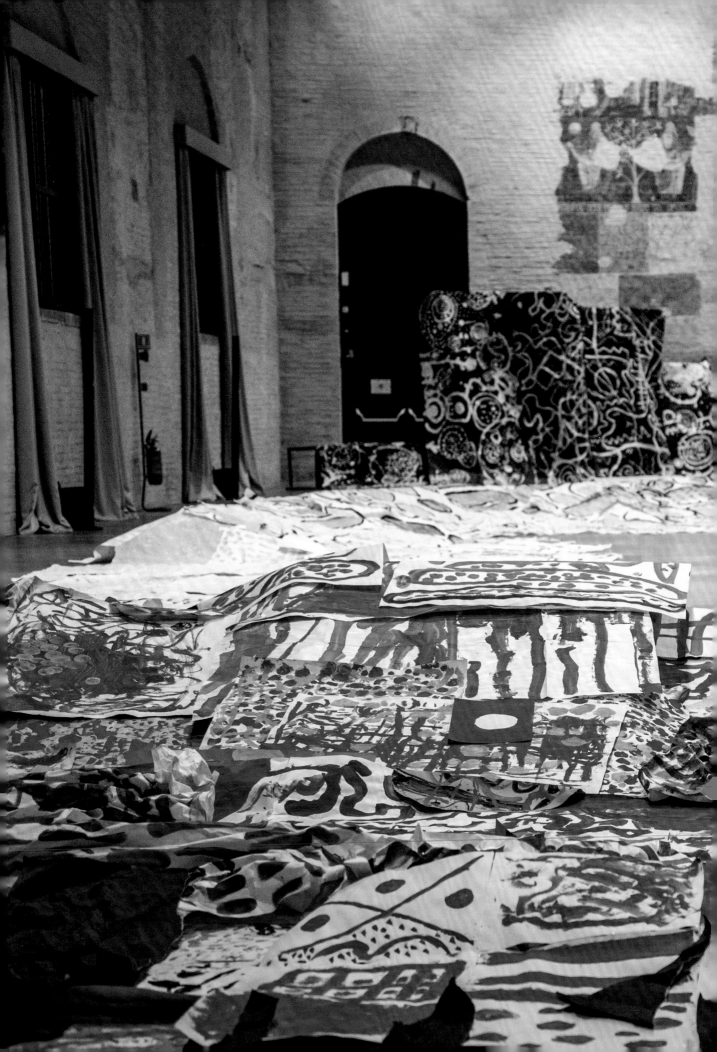

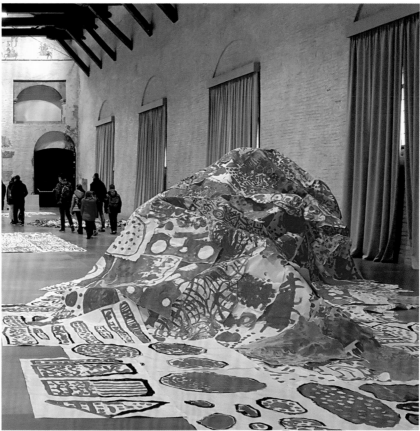

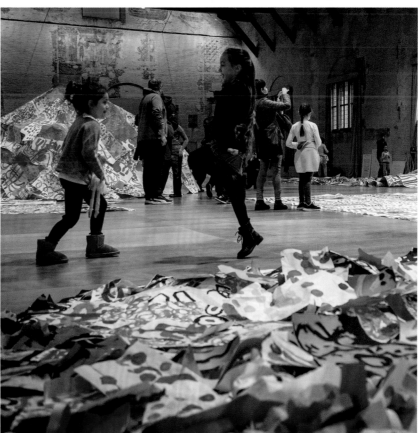

Palazzo della Ragione, Mantua, Italy.

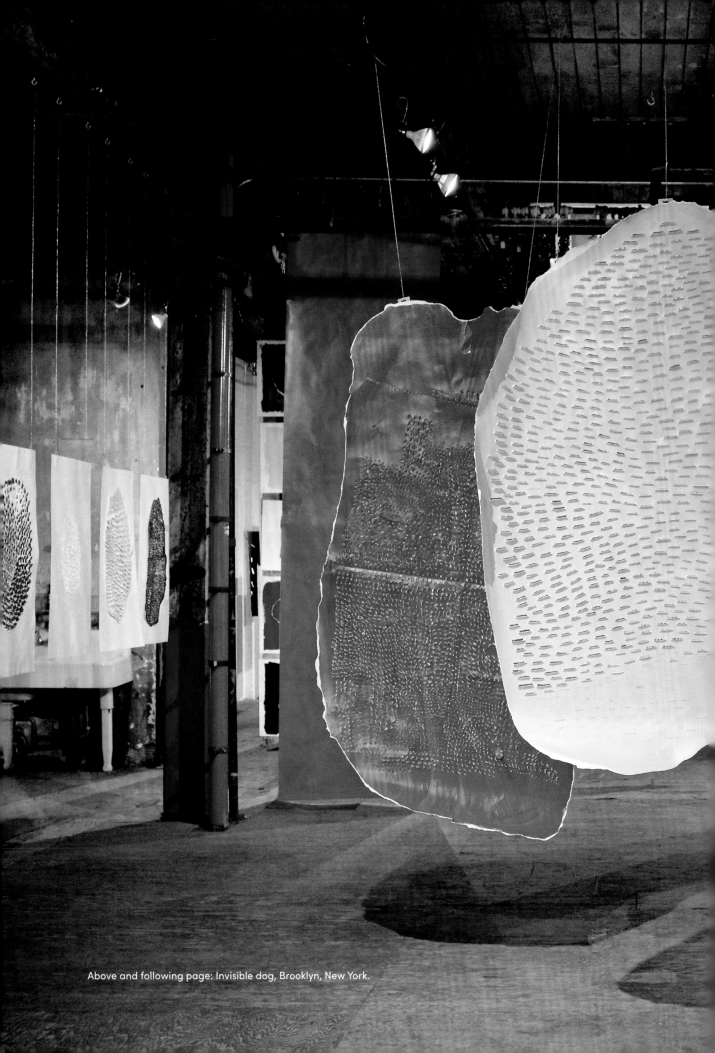

Above and following page: Invisible dog, Brooklyn, New York.

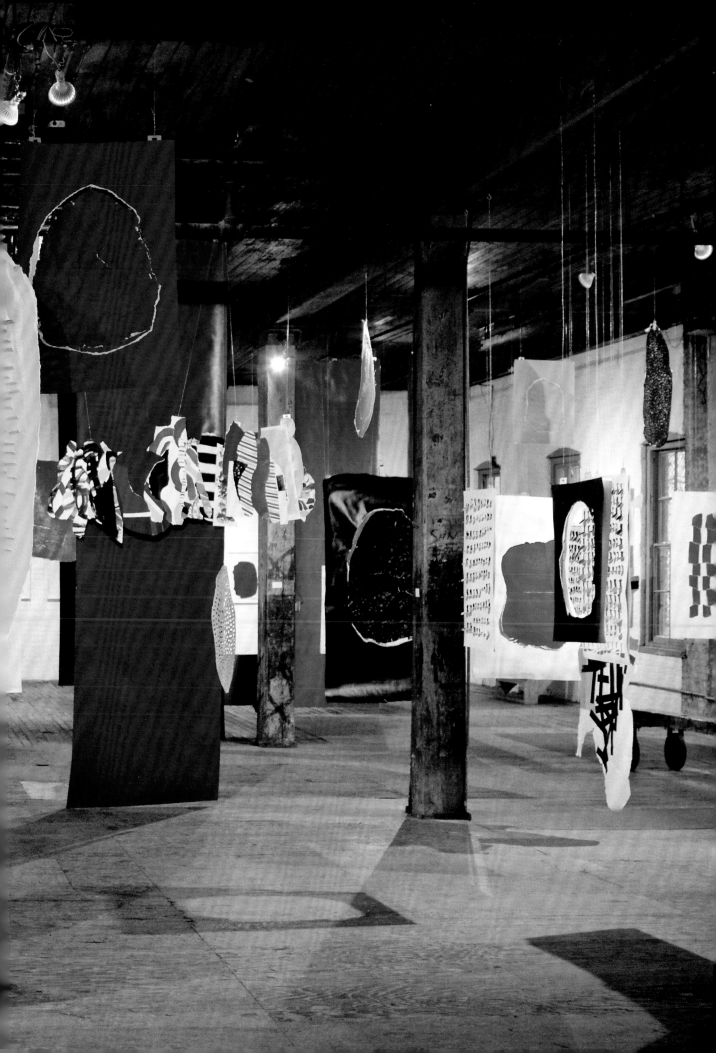

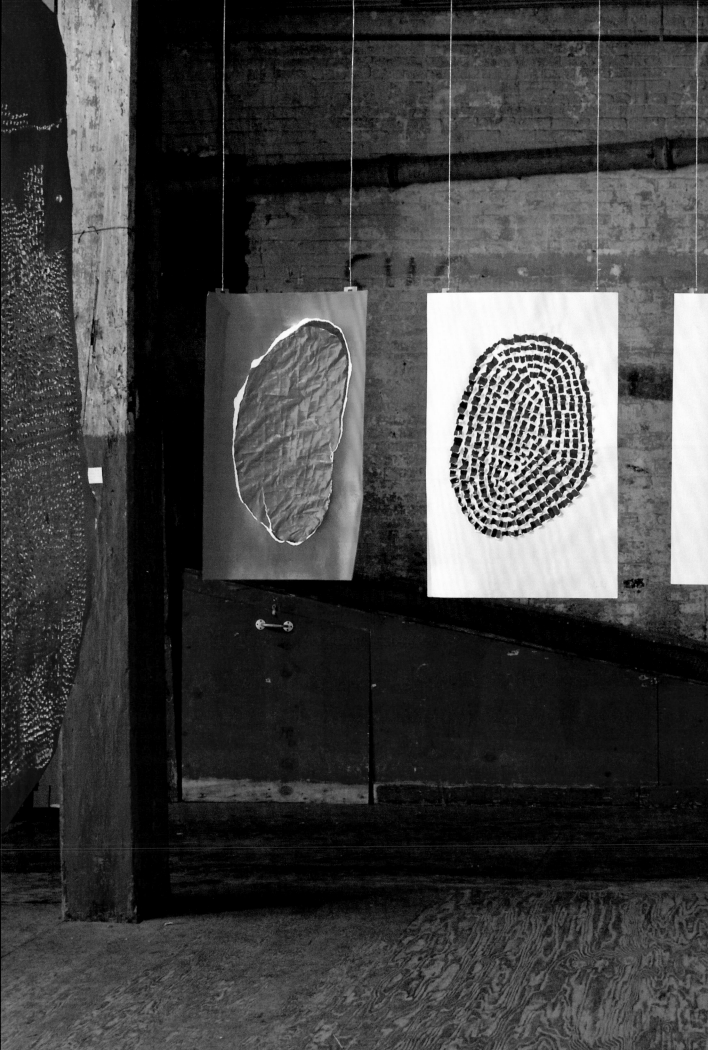

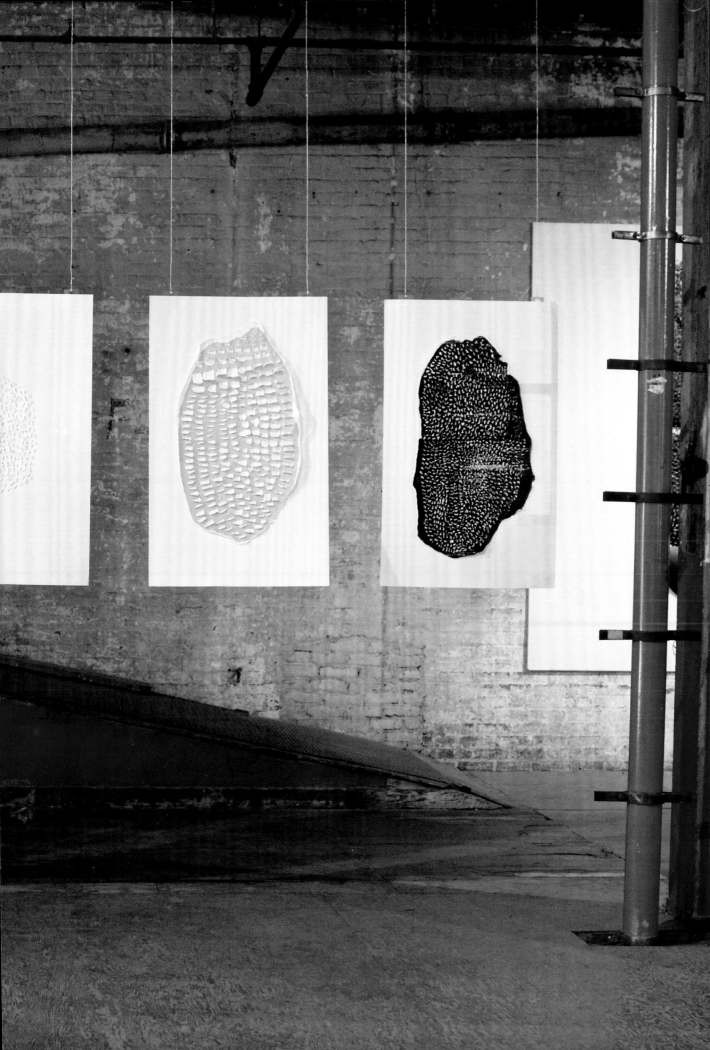

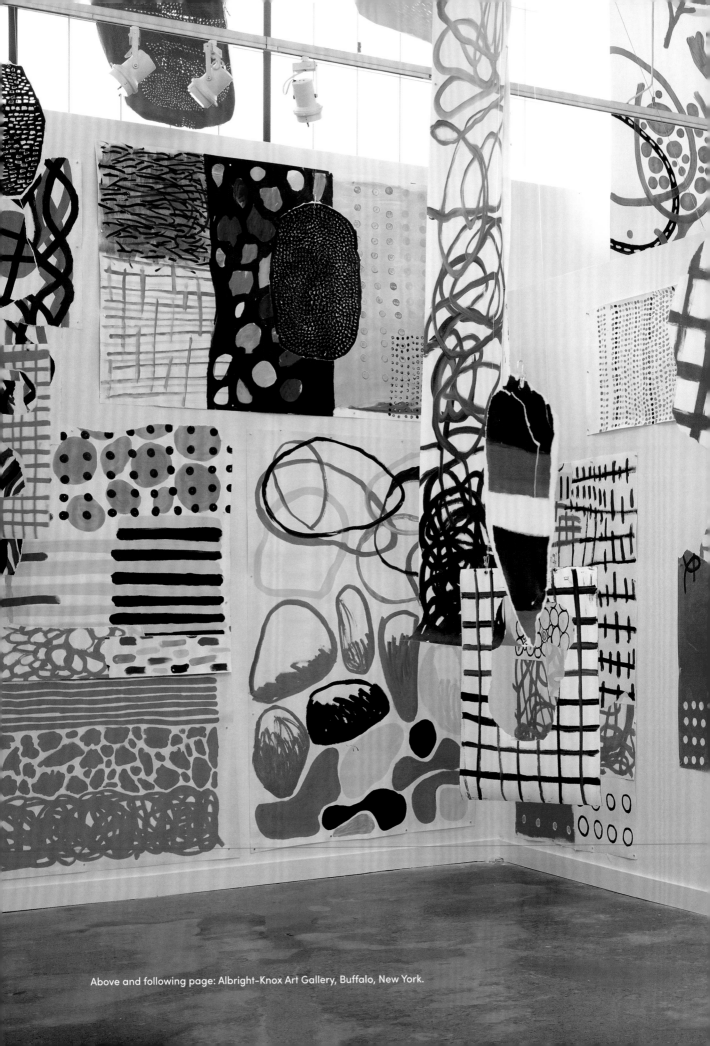

Above and following page: Albright-Knox Art Gallery, Buffalo, New York.

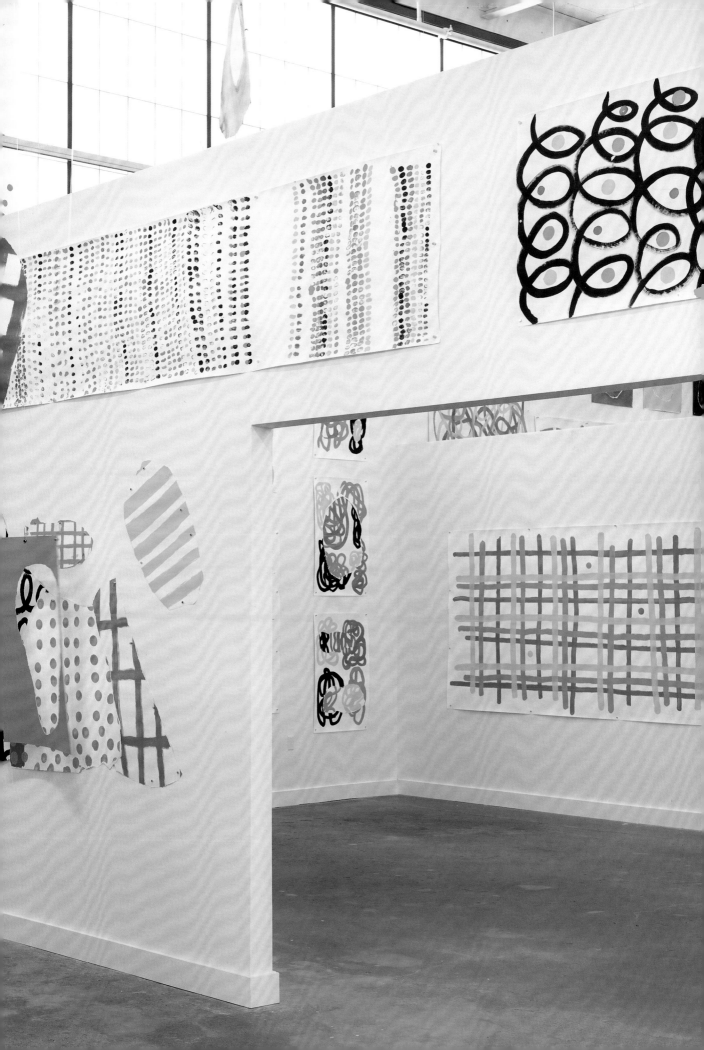

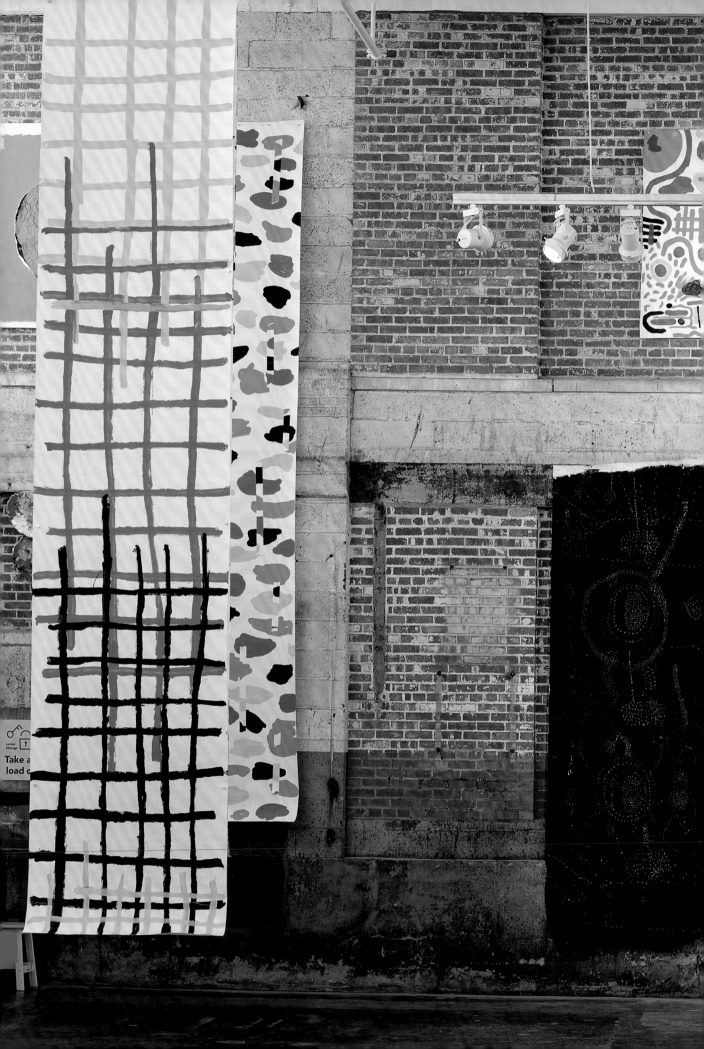

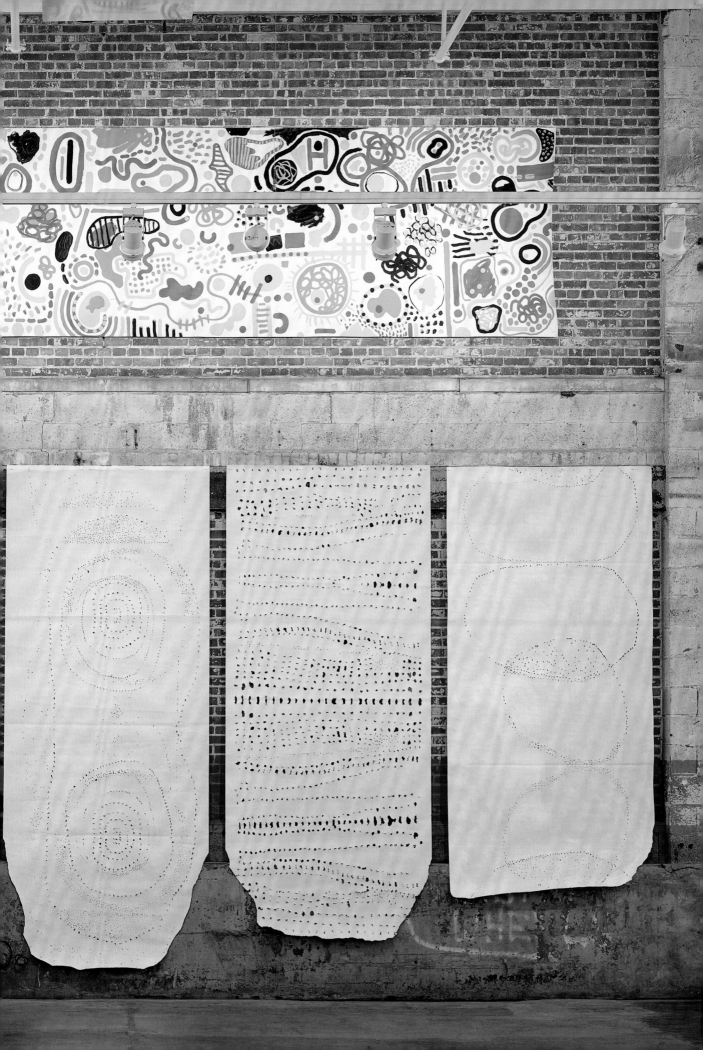

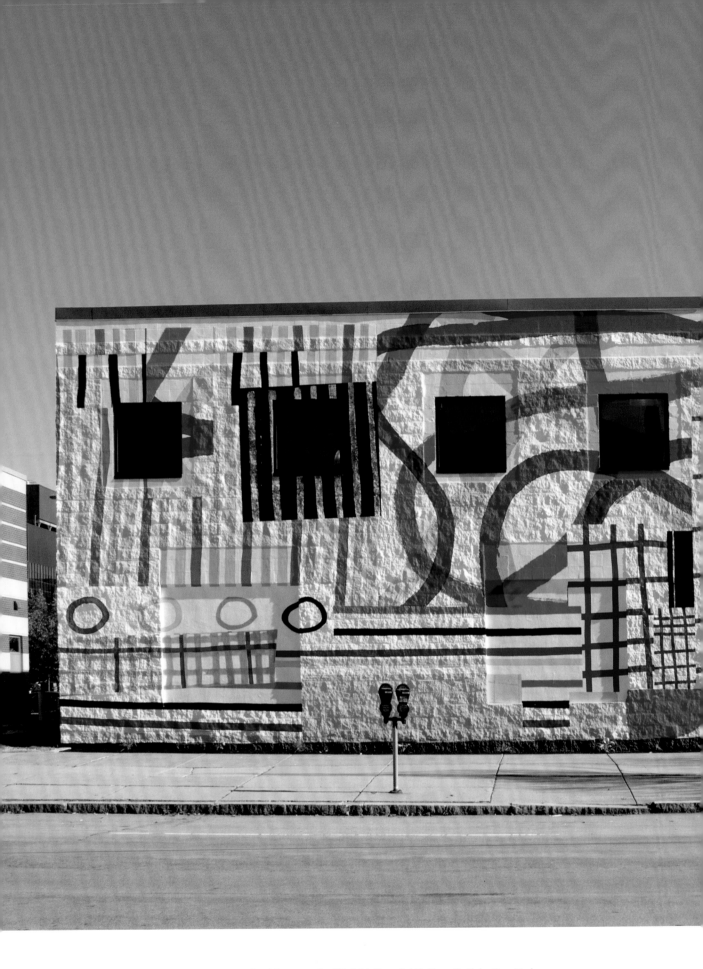

Above: Mural, Buffalo Niagara Medical Campus, for Albright-Knox Art Gallery, Buffalo, New York.

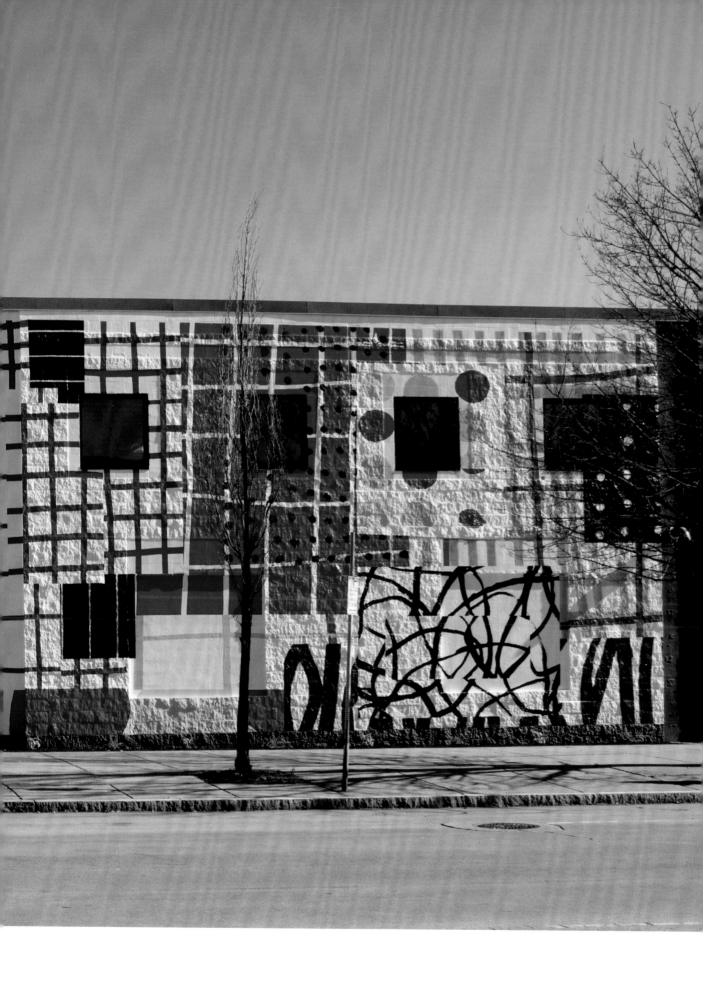

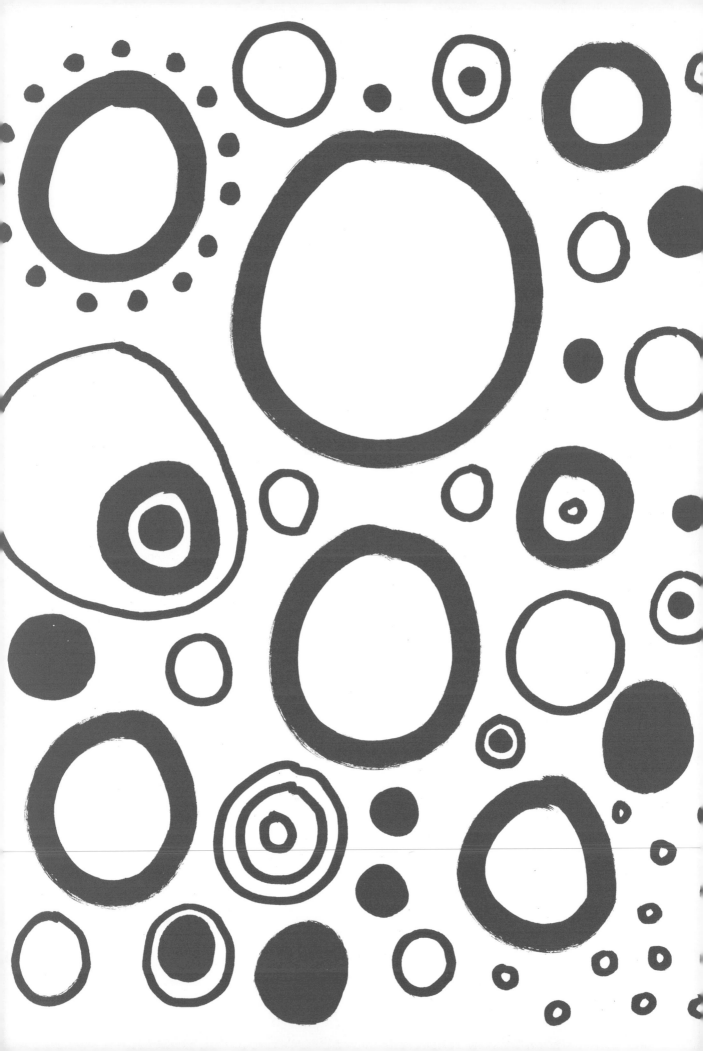

A Field of Flowers

All right, all right, are you ready?

Here we go! I'd like to see a very small dot.

Stop! Let's switch places.

I'd like to see a slightly bigger dot.

Switch places.

I'd like to see an even bigger dot.

Draw it a little farther away than the end of your nose!

There's plenty of space, use all the space!

How and when was the first Field of Flowers workshop held? Memory has swallowed all traces. Or perhaps the force of inevitability consolidated it step by step, from encounter to encounter, from idea to idea. Field of Flowers is really the ideal workshop. Taking place under any conditions, all over the world, with participants of all origins, it always, always leads to creations that are as coherent as they are singular.

This workshop, the first among them all, is a perfect mechanism because it is paradoxical: Although the instructions articulated to create it are injunctive, it consists of all the human and sensitive material that the participants invest in it. Starting with "I'd like . . . ," it inevitably ends with a mute, moved appreciation of what the sum of liberated individuals has been able to produce in a leap of creative energy.

For a long time now, the inflorescences of the Field of Flowers have spread across the globe. Everywhere, pieces of paper have raised themselves up, almost all consisting of dots, circles, splotches, and stems to bloom in a dynamic harmony. Everywhere they are different, everywhere they assemble themselves to join the rare and precious space of a creation as free as it is powerful.

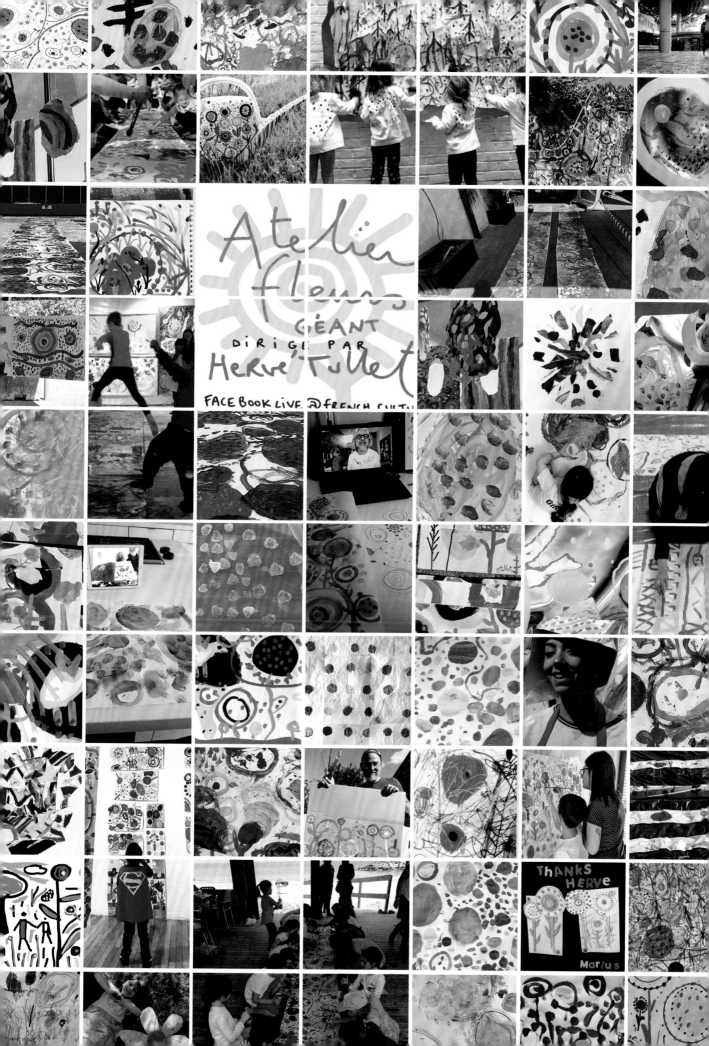

Atelier
fleurs
Géant
DIRIGÉ PAR
Hervé Tullet
FACEBOOK LIVE @FRENCH CULTURE

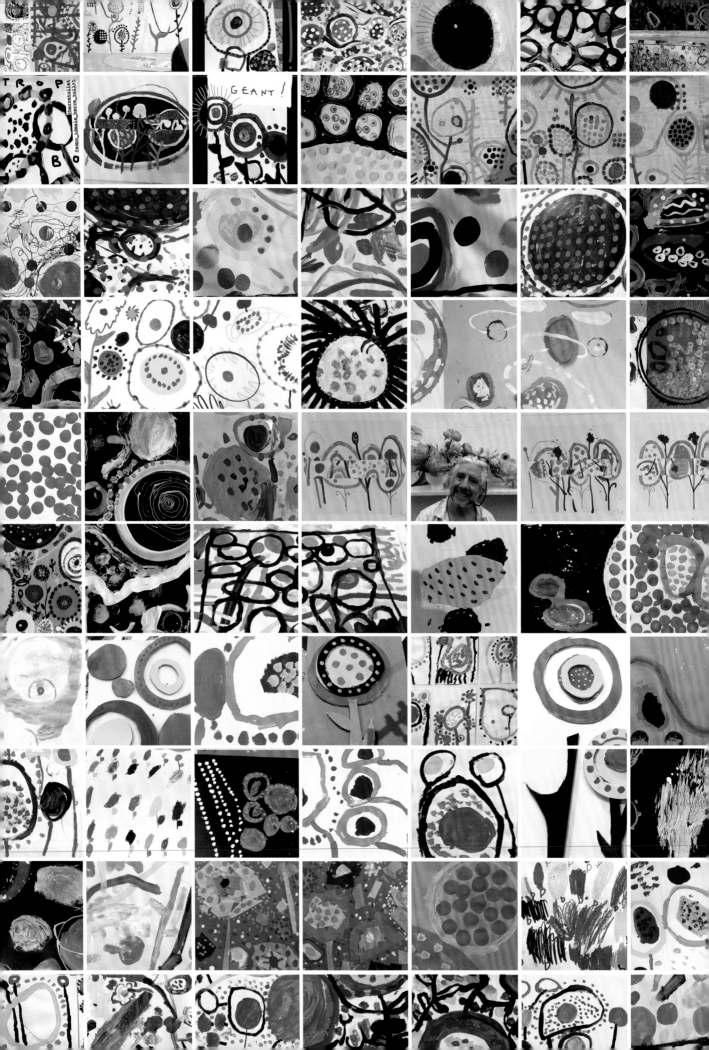

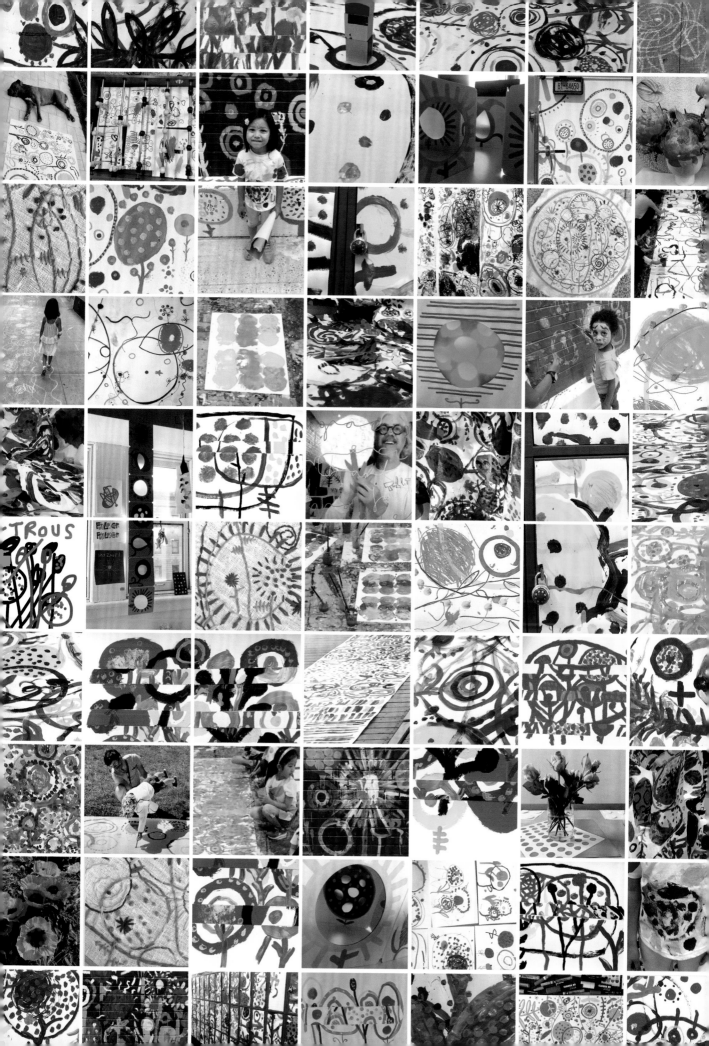

About the Authors

Hervé Tullet is a multidisciplinary artist, performer, and renowned children's book author with more than 75 internationally acclaimed titles. His iconic books include *Mix It Up!*, *Let's Play!*, and *Press Here* (translated in over 30 languages). He also runs large-scale interactive workshops involving up to one thousand people, both adults and children, in libraries, schools, art centers, and museums around the world.

From 2015 to 2020, Hervé lived in New York, where he focused on his art. He's appeared at events, performances, and readings at prestigious venues such as the Guggenheim and MoMA. He also pursued exhibitions of his personal work in New York (Invisible Dog Art Center) and around the world. In 2018, the Seoul Arts Center invited him for a retrospective of his work.

The same year, he also launched the The Ideal Exhibition, an Hervé Tullet exhibition you can put on without him being present thanks to a series of videos. This worldwide collaborative project based on his art and philosophy generated hundreds of exhibitions of all sizes: in shoe boxes, bedrooms, classrooms, libraries, art centers, or even in museums.

With this project, Hervé Tullet reaffirmed his vision: as an artist, he aims to "encourage audiences to become cultural producers of their own: and to bring communities together. For the *Shapes & Colors* exhibition at the Albright Knox Gallery (Buffalo, NY, 2021), for instance, he invited numerous people to paint large scale artworks in his Parisian studio. For a residency in Italy (Terre d'incanti, Lauco), he created from scratch a series of exhibitions including paintings, installations, sculptures, public art, a choregraphy, and a fashion parade with more than a thousand participants from the whole region.

In parallel, Hervé continues to create and share his art through all channels: murals, online workshops, conferences, videos such as the boredomdomdom series, and more.

Born in Paris in 1973, Sophie Van der Linden is a specialist in children's literature, and picture books in particular. Her essays, some of them translated in Italian, Portuguese, Spanish, Chinese, or Korean, are acclaimed as preeminent references in the field of children's literature. She is the founder and the chief editor of the magazine *Hors-Cadres* (2007), which is the only publication focused on picture books in France, with translations in Spain (*Fuera de Margen*, Pantalia) and China (*Within Pictures Beyond Texts*, TBH Publishing) in collaboration with Leonard Marcus.

She currently gives courses and conferences in France and abroad, for librarians, teachers, professional readers, authors, and illustrators. As a teacher and speaker, she gives courses for students in universities. She also writes books for adult readers.

In 2001, she received the children's literature critics award from the Institut International Charles Perrault. Since then, she has frequently served on international juries of the Fundacíon SM, Chen Bochui Award, Prix Vendredi, and other illustration and literary awards at the Bologna Children's Book Fair and the Frankfurt Book Fair.

Leonard S. Marcus is an author and children's book critic, as well as a professor at New York Univeristy and the School of Visual Arts.

Aaron Ott is the curator of public art at the Albright-Knox Art Gallery.

Image Credits

Page 3: *I Have an Idea!* © 2018 Bayard Éditions Jeunesse

Pages 8–13: *Let's Play!* © 2016 Bayard Éditions Jeunesse

Page 25: Reproduced from *I Am Blop!* © 2013 Phaidon, with permission from Phaidon Press Limited

Page 36: *Les cinq sens* © 2003 Éditions du Seuil

Page 61: © Une Saison Graphique, Le Havre

Pages 64–65: *The Scribble Book* © 2007 Bayard Éditions Jeunesse

Page 66: *Press Here* © 2010 Bayard Éditions Jeunesse

Page 69: Reproduced from *The Big Book of Art* © 2013 Phaidon, with permission from Phaidon Press Limited

Page 70: *Press Here* © 2010 Bayard Éditions Jeunesse

Page 72: © Alessandro Serravalle for Museo in Erba

Page 75: © The Little Bridge, Shanghai

Page 76: © Filip Wolak

Page 82: © Las Zapatillas de Venus

Page 85: © Artcenter IDA

Page 87: © Fantastik Projects

Page 93: © Amanda Renshaw

Page 99: *I Have an Idea!* © 2018 Bayard Éditions Jeunesse

Pages 106–7: *Help! We Need a Title!* © 2013 Bayard Éditions Jeunesse

Page 108: *Mix It Up!* © 2014 Bayard Éditions Jeunesse

Page 109: Reproduced from *I Am Blop!* © 2013 Phaidon, with permission from Phaidon Press Limited

Pages 110–14: *Comment papa a rencontré maman, Comment j'ai sauvé mon papa, Comment j'ai sauvé ma maman* © 1994–1998 Éditions du Seuil

Pages 115–18: *Faut pas confondre, Le jour et la nuit* © 1998–2000 Éditions du Seuil

Pages 119–22: *Les cinq sens* © 2003 Éditions du Seuil

Pages 123–25: *Turlututu: C'est magique!* © 2003 Éditions du Seuil

Pages 126–28: Reproduced from *I Am Blop!* © 2013 Phaidon, with permission from Phaidon Press Limited

Pages 130–35: Reproduced from *The Finger Sports Game, The Finger Travel Game, The Good Morning Game, The Game of Lines, The Trail Game, The Game of Top and Tails, The Game of Sculpture, The Eyes Game, The Ball Game, The Countryside Game, The Finger Circus Game, The Game of Shadows, The Game in the Dark, The Game of Let's Go!, The Game of Mix-up Art, The Game of Light, The Game of Patterns,* and *The Game of Finger Worms* © 2011–2015 Phaidon with permission from Phaidon Press Limited

Pages 136–38: Reproduced from *The Big Book of Art* © 2013 Phaidon, with permission from Phaidon Press Limited

Pages 141–45: *Press Here* © 2010 Bayard Éditions Jeunesse

Pages 146–53: *Mix It Up!* © 2014 Bayard Éditions Jeunesse

Pages 154–57: *I Have an Idea!* © 2018 Bayard Éditions Jeunesse

Page 158: *La Danse des mains* © 2022 Bayard Éditions Jeunesse

Page 159: *Say Zoop!* © 2017 Bayard Éditions Jeunesse

Pages 160–63: *La Danse des mains* © 2022 Bayard Éditions Jeunesse

Pages 166–67: © Grégoire Déroulède, La Fabrique

Page 169: © Grégoire Déroulède, La Fabrique

Page 174: © The Little Bridge, Shanghai, © La Petite École, New York

Page 175: © Brooklyn Public Library, © Une Saison Graphique 2013

Page 176: *I Have an Idea!* © 2018 Bayard Éditions Jeunesse

Page 177: *Les cinq sens* © 2003 Éditions du Seuil
Page 180: © Centre Culturel, Centre de Créations pour l'Enfance, Tinqueux
Pages 182–85: © Tom Powel (Tom Powel Imaging Inc.)
Page 188: © Centre Culturel, Centre de Créations pour l'Enfance, Tinqueux
Page 191: © Filip Wolak
Pages 194–95: *Help! We Need a Title!* © 2013 Bayard Éditions Jeunesse
Page 196: © Children's Museum of Pittsburgh
Page 196: © Jacaranda Foundation
Page 200: © La Petite École, © Bayard Bridge
Pages 201–2: © Jacaranda Foundation
Pages 206–7: © 1101 Museum
Page 208: © Areaware
Page 209: © Perry School, New York
Pages 210–11: © NTMOFA
Pages 216–17: *Help! We Need a Title!* © 2013 Bayard Éditions Jeunesse
Page 219: © Aska Kirby
Page 221: Reproduced from *The Game of Mix-up Art* © Phaidon 2011, with permission from Phaidon Press Limited
Pages 230–31: *Let's Play!* © 2016 Bayard Éditions Jeunesse
Pages 234–35: *I Have an Idea!* © 2018 Bayard Éditions Jeunesse
Pages 240–43: Reproduced from *The Game of Mix-up Art* © Phaidon 2011, with permission from Phaidon Press Limited
Page 248: © Bruna Ferrazzini
Page 249: © Children's Museum of Pittsburgh
Page 250: © Mathilde Bordignon
Page 251: © Children's Museum of Pittsburgh
Pages 256–57: © Museo in Erba
Pages 260–61: © The GIANT Room, New York
Pages 262–63: © Shoshana Rosenberg
Pages 264–65: © Tarek al-Nosir
Page 267: © Comune di Mantova, © Centro Zaffiria
Pages 268–71: © Simon Courchel
Pages 272–77: © Brenda Bieger for Albright–Knox Art Gallery
Pages 284–85: *Let's Play!* © 2016 Bayard Éditions Jeunesse

Other credits and special thanks:
© Bayard Éditions Jeunesse
© Sandrine Granon
© Léo Tullet
© Eric Fovo
© Artcenter IDA (reproduction of the artworks)

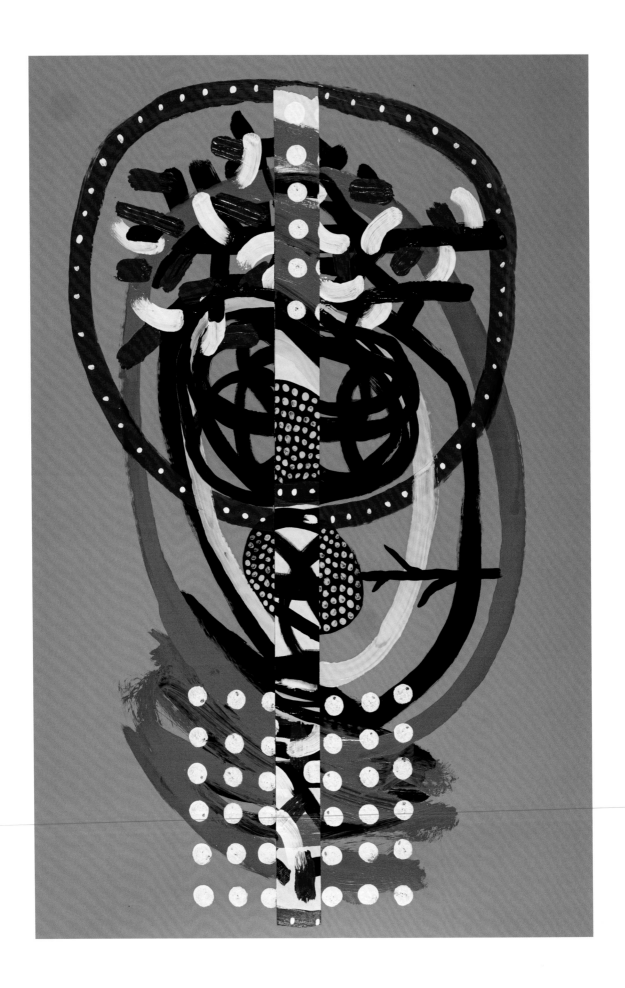